JEWELS

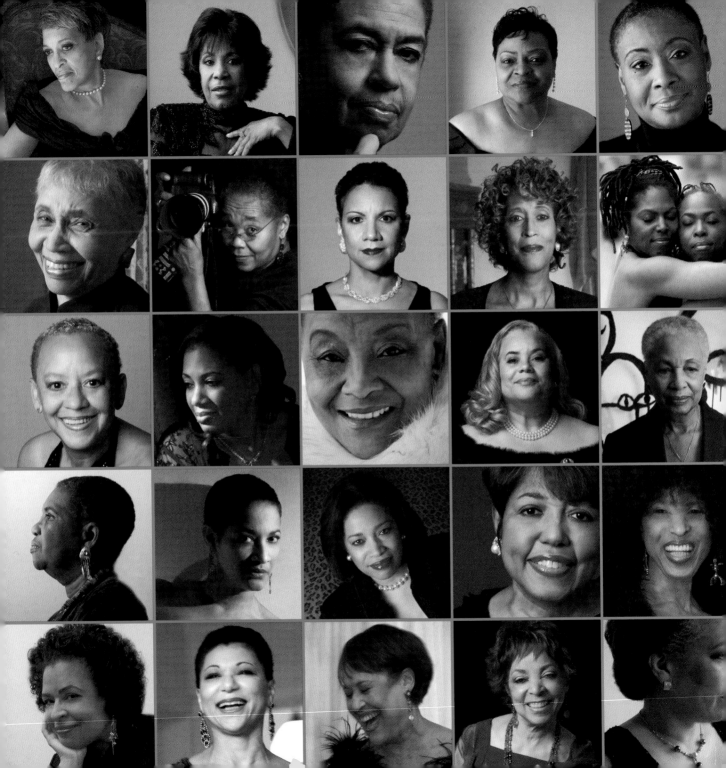

50

PHENOMENAL

BLACK WOMEN OVER

50

JEWELS

MICHAEL CUNNINGHAM
& CONNIE BRISCOE

WITH AN ORIGINAL POEM
BY NIKKI GIOVANNI

Little, Brown and Company
New York Boston London

Little, Brown and Company
Hachette Book Group USA
237 Park Avenue, New York, NY 10169
Visit our Web site at www.HachetteBookGroupUSA.com

First Edition: April 2007

Library of Congress Cataloging-in-Publication Data
Cunningham, Michael.
Jewels : 50 phenomenal black women over 50 / Michael Cunningham and Connie Briscoe; original poem by
Nikki Giovanni. — 1st ed.
p. cm.
ISBN-13: 978-0-316-11304-5
ISBN-10: 0-316-11304-2
1. African American women—Portraits. 2. African American women—Biography. 3. Middle-aged women—
United States—Portraits. 4. Middle-aged women—United States—Biography. 5. Successful people—United
States—Portraits. 6. Successful people—United States— Biography. I. Briscoe, Connie. II. Title.
E185.86.C985 2007
920.7208996073—dc22 2006021574
[B]
10 9 8 7 6 5 4 3 2 1
Printed in Singapore

Preface

When Michael Cunningham and I first came up with the idea of featuring black women age fifty and older in a photo-essay book, we both knew immediately that this was long overdue. I naturally thought of my mother and grandmothers, three women who defied enormous obstacles during a time when racism and sexism were anything but subtle and carved out rich lives of service, hard work, and dedication to their families, often without recognition or reward. My mother opted out of being featured in *Jewels,* but she is here with me in spirit, along with many other deserving women. Reluctantly, I myself agreed to be featured in these pages when friends pointed out that I fit the profile and had a story worth telling. Perhaps in revealing a bit about myself I can soften the line that usually separates an author from her subjects.

Michael and I decided to include celebrities and noncelebrities, and thus we have women here who successfully reared children as single mothers as well as women who fought tirelessly for justice and opportunity in our schools, communities, and theaters. These are fierce, gutsy women who bucked the odds during especially trying times, and I feel honored that they've allowed me to help them tell their stories. I was also excited about the opportunity to work with Michael, who is an amazing photographer. We interviewed and photographed the women in *Jewels* over the course of nearly a year and a half, between the spring of 2005 and the summer of 2006. The age given with each profile is the age at the time of the interview.

As I began talking to the women, a few things stood out immediately. First, they give a lot of credit to their upbringing for making them who they are. Whether raised by a single mother or father, both parents, grandparents, or someone else, they found a loving, stable home with someone who taught them to aim for the stars. Second, although many incidents of racism, sexism, and discrimination are described throughout the pages of this book— some of them blatant and others more subtle—the women never viewed the incidents as

insurmountable. Whether fifty or eighty, on the stage or in the boardroom, whether for themselves, their children, or for the world, these women seized opportunities when they were available and created them when they weren't. They are all thoroughly modern women who have taken the promise of America and made it a reality for themselves and others.

Could it be that we've come far enough that black women can be lawyers, doctors, businesswomen, performers, artists, and mothers first, without race, gender, or handicap intruding constantly upon our progress? Whether or not you believe that to be true, there can be little doubt these women and countless others like them have made it much more likely for our children and grandchildren.

—*Connie Briscoe*

I Am the Ocean

I am the ocean ... it is not the moon that calls me to the shore ... it is I who awaken the moon ... and call him down ... and rest in his light ... that I may dream

I am the sand ... I hold the ocean in my arms ... I gently rock this planet ... smoothing the rough places ... leveling the high ... raising the lowly ... always ... singing a love song

I am glass ... you can see through me ... I'm easily hurt ... any little pebble can cause a scratch though it takes a diamond to cut ... I can stand against the storm ... laugh at lightning ... let the rain sheet down ... why don't you stay here with me ... safe and warm

I am more than your past

I am not cotton ... to be picked and picked and picked until some crazy boll weevil destroys me ... I am not peanuts grown underground ... harvested raw ... made into many things ... nor am I taffy ... to be pulled and pulled and pulled ... made acceptable by artificial sweetener

I am my own me

If you stand in back ... stopping the light ... I become a mirror ... I reflect who you wish you were ... and think you ought to be ... I show you who you are not

If you open me I become a window ... I bring a fresh breeze ... to caress you ... to calm the fears

I am a cloud ... I float above all else ... I bring shade from the sun ... I cool your coffee ... I make shapes to form your stories

I am your future

When the waters embrace me ... when the moon glows down ... you clearly see me shining ...
I ... Am ... A Jewel ... I shine

I am

Priceless ... Incomparable ... Undeniable ... Wonderful

Me

Forever and Always Dreaming

Of You

—*Nikki Giovanni*

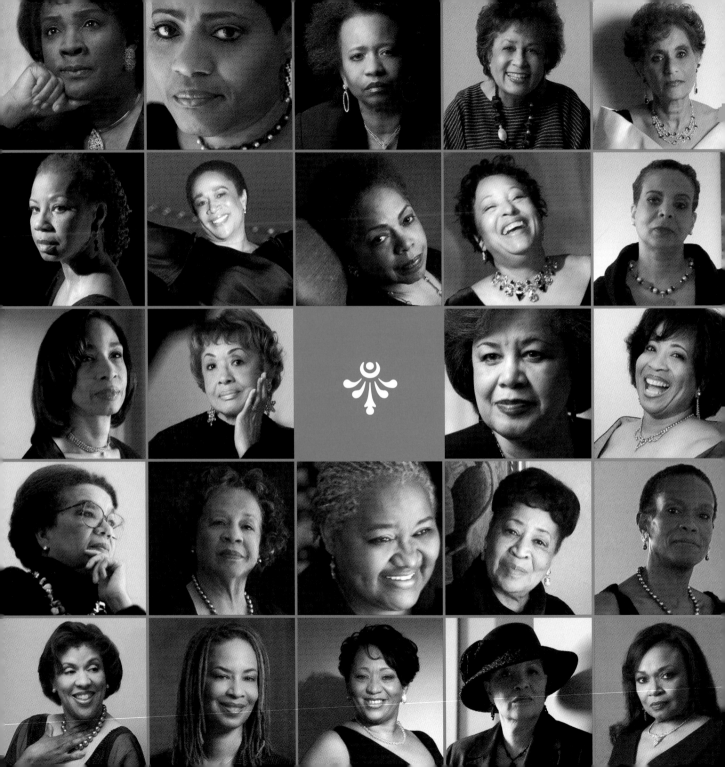

JEWELS

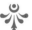

Johnnetta Betsch Cole ◆ 69

PRESIDENT OF BENNETT COLLEGE FOR WOMEN;
PRESIDENT EMERITA OF SPELMAN COLLEGE

T here's a proverb that goes, "You can't know where you're going if you don't know where you've been." I'm going to change that to say, "You can't know who you are if you don't know how you grew up." When I look at who I am today, I can see direct paths back to where I was born and who my family was. When I go back and look at my family and my community, I see, in bold letters, "Because you have been given so much, much is required of you." And so the idea of being of service strongly motivates me.

I grew up in the 1940s in a family that was in some ways atypical for that time. My mother and father were both college graduates. My mother went to Wilberforce University, my father went to Knoxville College. I had a sister eighteen months older and a younger brother. No one posed the question, Would we go to college? The only question was, Where would we go to college? We were taught that you can't live a fulfilling life without a good education, and so we wanted a good education.

In some ways I was programmed to be an educator. Dr. Mary McLeod Bethune and my great-grandfather, Abraham Lincoln Lewis, were close associates and friends. He served on the board of Bethune-Cookman College, and Dr. Bethune gave the eulogy at his funeral. I remember going to Daytona Beach, Florida, where the college is located, and sitting on Mrs. Bethune's lap. She was fascinating to me as an educator, but I was also fascinated with her hats. She could wear some hats.

My mother had two careers. She began as a college professor at Edward Waters College in Jacksonville, Florida, where she taught English and was the registrar. After my father died, when I was fifteen years old, my mother left the college and worked as an executive at the Afro-American Life Insurance Company, our family insurance business, which was founded in 1901 by my great-grandfather and six other black men. My grandfather became the president of the company. My uncle was also an executive in the company, and my father served as head of the

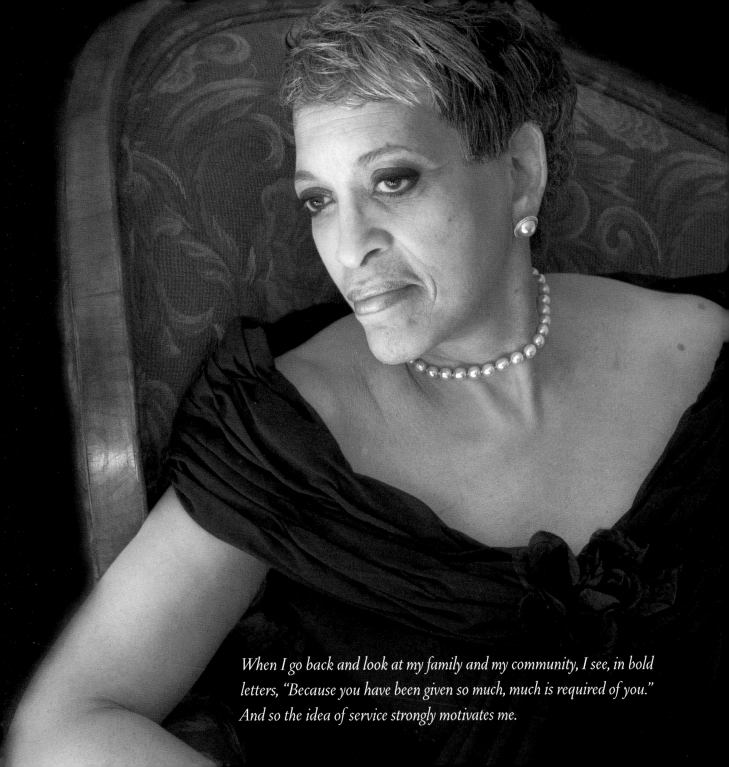

When I go back and look at my family and my community, I see, in bold letters, "Because you have been given so much, much is required of you." And so the idea of service strongly motivates me.

insurance agents. My mother always worked outside of our home. Yet she also gave my sister and me and later my brother, who is nine years younger than I, quality time.

Another message that I certainly learned from my parents is that women are capable of doing just about any task that men can do and vice versa. My father could braid our hair as well as our mother could. He would take us shopping for our school clothes, and he was a far better cook than my mother was. The book that I coauthored with Dr. Beverly Guy-Sheftall, *Gender Talk: The Struggle for Women's Equality in African American Communities*, is dedicated to our fathers because they instilled in us the notion that women and men can and should be equal.

I see being the president of Bennett College for Women as an act of service. Of course it's a job, but it's more than a job. I am in service to these young women. When I think about my career, I can also see a direct path back to the emphasis on education in my family. I've written about it, but I can repeat here an experience I had in first grade when a teacher asked us all to stand up and give our names. When I mumbled my name, Ms. Bunny Vance said to me, "Stand up straight, speak clearly, never mumble your name, and get ready to help to change the world." What an impact that had on the direction of my life.

I was strongly encouraged to come to Bennett College for women by Dr. Maya Angelou, a member of Bennett's board of trustees, and I have never regretted that I did. It has been an amazing experience and, I would say, so often full of grace. It is intensely rewarding to be able to work with others in revitalizing a highly important institution that is one of only two historically black colleges for women in our country.

My greatest challenge has been dealing with other people's stereotypes and misperceptions about who I am as a black woman. There is a pervasive assumption that black folk can never be as smart as white folk and that women can never do anything as well as men. When I became the president of Spelman College in 1987, I was the first African American woman president in the 107-year history of that black women's college. Also remarkable is the fact that last year I became the first person of color to chair the board of United Way of America. I was also the first woman to sit on the board of directors of Coca-Cola Enterprise, the largest bottler of Coca-Cola. So what do you learn when you're in this position of being the first? The first thing I hope you learn or know is that many other black women are also qualified to hold that

position, so don't get too hung up on yourself. Second, you better know that your responsibility is to make sure that although you're the first to hold the post, you must help to guarantee that you are not the last.

I often say that my greatest work is represented by my three sons, each of whom is truly a decent man who respects women and honors the need to do something to help make this world better. Certainly my greatest accomplishments in the professional world are associated with the presidencies of Spelman College and Bennett College for Women. Sometimes I chuckle and say that I should have a citation in the *Guinness Book of World Records* because I am the only person who has served as the president of the only two historically black colleges for women in the United States.

These days, the word *retirement* needs to be redefined, because what it has traditionally connoted is not something I and many of us who are over fifty can imagine doing. For me, retirement will not be about ceasing to work. It will be about changing the rhythm of my work. I see myself not working as intensely, not traveling as much, not enduring the same amount of stress.

How wonderful and intriguing the role of a grandmother is! Stitched onto a pillow in my bedroom is an Italian proverb that says, "When a grandchild is born so is a grandmother." One discovers another side of oneself as a grandmother, for it is a role that is not comparable to any other.

Becoming a grandmother is a relatively recent joy in my life, but over the years I have been a mentor to many young women and men. Being a mentor and being a grandmother have something in common. In each case you are ensuring that your influence will continue beyond your own lifetime.

Being a grandmother and a mentor are among the countless reasons why I enjoy aging. You can be a grandmother when you're thirty, but you do it so much better when you're over fifty. You can be a mentor to someone when you're twenty, but you have so much more to teach and share when you're over fifty. In short, I'm having a wonderful time being exactly who I am at the age that I am.

My first time on Broadway I starred in a play called *The Mighty Gents,* and I received a Tony Award nomination for best featured actress for my portrayal of Rita. I appeared alongside Morgan Freeman, who was nominated for best featured actor. I was shocked by my nomination. I thought I would have to work a lot longer for that kind of recognition. But I had really wanted the role of Rita, because I knew that woman, and I auditioned vigorously for the part. They must have had me come back, I'm sure, ten times. But it didn't matter how many times they called me back. Rita's spirit just came to me. I discovered later that there were people who didn't want me to get the part. When I did *A Raisin in the Sun,* the same thing happened. I had to win people over. But that's fine. People have their favorites. When the reviews come out, it proves to have been well worth the struggle.

After I was nominated for the Tony Award, I was mentioned as a rising star in *Ebony* magazine along with Debbie Allen and others. I moved to Los Angeles and got work, but not on a regular basis as I had in New York, and not as much as white actresses who were nominated for a Tony and then went on to TV series and film careers. No question there is racism, but that's the nature of the business I chose. Of course I deal with it.

In 1988 I had just finished shooting *A Raisin in the Sun* for American Playhouse Theater and had started touring in August Wilson's play *The Piano Lesson* when my dad became seriously ill. I left the production and went home to care for him for two years. He died in my arms. August Wilson was our Shakespeare, and some would say that I sabotaged my career by leaving this production, but I don't see it that way. I honored my dad. I also left Los Angeles to take care of my mother, commuting back and forth between LA and New York from 1992 to 1994.

Although I love my work and plan to do it forever, fame and fortune aren't as important to me as family, faith, and my word. As a young girl I watched my mother leave her family for her work as a performer. She was a dancer with her own act, and I remember seeing her in the

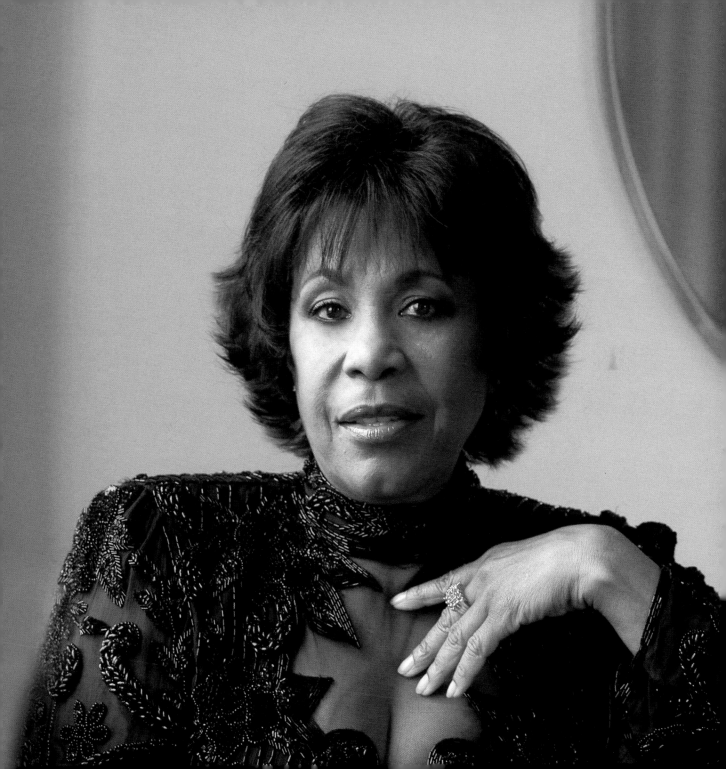

film *The Glenn Miller Story.* When I was about two, my father told her to choose him or the stage, and my mother took him up on it and left. I don't think she expected my father to follow through, but he did and he won custody of us. I try to have more balance. I don't sit around in Los Angeles waiting for a job. I teach. I speak at universities. And I often put family first. I have a life outside of all this.

I still strive to be a better actress, even after all these years performing. I remember starring in my first play in my junior year in college. It was *Medea,* and I had no idea what I was getting myself into. I was studying biology and planned to go to medical school. My grandmother, who raised me along with my father, was a nurse, and I wanted to be like her. But starring in *Medea* was an incredible experience, and I was hooked. After college I decided to go to New York to study acting instead of going to medical school. I was about twenty-two or twenty-three years old and started getting stage work immediately. I did a number of plays with the playwrights Ron Milner, Ed Bullins, Richard Wesley, and others. *What the Wine-Sellers Buy* toured all around the country, and I began to get recognition as an actress.

I hope I'm just beginning to come into my own. I'm inspired when I look at the long careers of actresses like Cicely Tyson, Ruby Dee, and Eartha Kitt. I love all the mediums—television, film, stage—and have had the opportunity to do lovely roles in each of them. Right now, though, my passion is the stage because of the wonderful characters I've portrayed. Television and film can be edited, but onstage it's right there for all to see. Either you have it or you don't. You have to trust your cast and they have to trust you. It's scary, and I still get ner-

vous when I audition. I still get butterflies when I first go onstage. Once I make contact with the audience and get into the role, it gets better.

I remember being thrown into six feet of water at camp when I was eight or nine to learn to swim. I went to the bottom, but I didn't panic. I just swam to the top. When I visited my mother in Atlantic City, we would swim in the ocean. I was like a little fish. I love the water, and I'm becoming certified as a scuba diver. I think that helped me learn to conquer my fears. I'm not a quitter. I have passion, drive, and talent. The word *no* is like a vitamin to me. I'm going to find a way to do it.

I watched my parents go on despite obstacles. My dad was a dental technician during the Jim Crow era. He would train white men, and they would go on and become his supervisor. But it didn't affect the way he did his work. He still always gave it his best. My mother became paralyzed as the result of a fall onstage, and because of her will and determination she learned to walk again. She went on to found the Hearts and Hands Foundation for the Handicapped to assist the physically and mentally challenged.

I asked God for this and it's wearing me out, but it's a good wearing out. I'm not going to let a few slights throw me off. I'm going to perform artistically with all the love and passion I can muster until I close my eyes.

I was a child of the civil rights movement. I have always sought social and economic change, and therefore always regarded myself as oppositional. I've somehow been able to serve in ways that were consistent with my opposition, to represent people who are in opposition. In my work as an attorney with the American Civil Liberties Union, chairing the Equal Employment Opportunity Commission, and now my seat in Congress, I have been able to continue working against the grain from the inside.

I did not intend to run for Congress. It was hardly something I could have aspired to when I was going to Bruce Monroe Elementary School in Washington, DC, in the 1940s. This was a segregated town. It had no elected officials of any kind, no city council, no mayor. The District of Columbia was one of the five or six *Brown v. Board of Education* cases and did not integrate its schools until the Supreme Court made it do so in the 1950s. I still remember when the decision came down, and the principal at my school, Dunbar High School, rang the bell and made the announcement.

I lived and breathed opposition to segregation as a child but not in a way that made me feel it would be a burden on me. I do not remember any sense of inferiority based on my blackness. We looked around and saw white people who often were less well educated and thought something must be wrong with them that they would segregate us. We saw them as the problem. I never thought of being black as something I had to overcome.

What was cultivated by segregation was a sense that achievement was important and that the only way to achieve was to get as much education as you could. That was the lesson that was not lost on black children of every economic group growing up in a segregated city where the opportunities for black people were limited.

My parents had a lot to do with this, but I got it by deduction. We were never pushed. They taught by example. My mother was a teacher in the DC public schools. My father graduated from law school but never practiced. The desire to achieve was passed to us by osmosis,

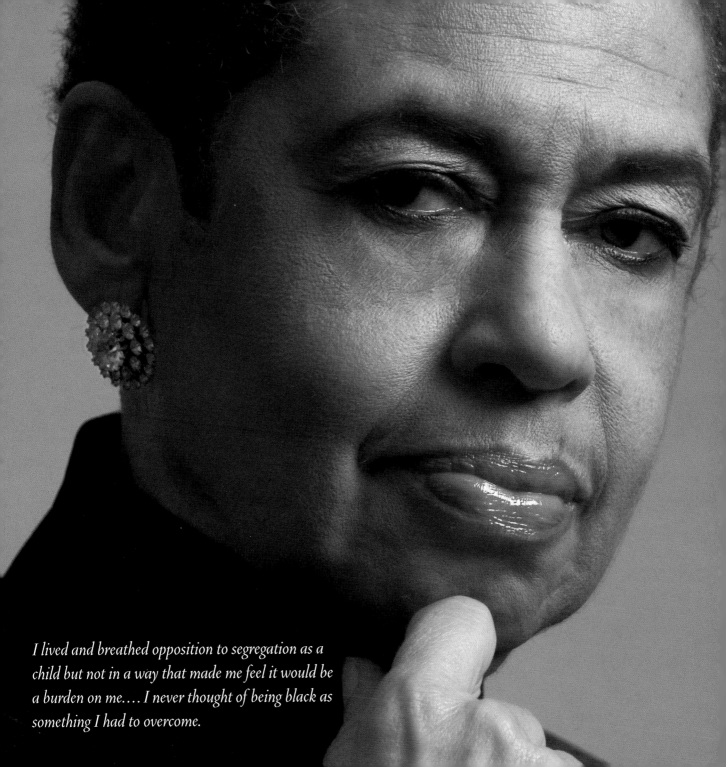

I lived and breathed opposition to segregation as a child but not in a way that made me feel it would be a burden on me.... I never thought of being black as something I had to overcome.

by watching the way my parents lived. The stimuli were all around my sisters and me. I recognized the importance of education from the time I was a kid and saw how highly education was viewed in our family and in the black community.

The atmosphere of Washington was also very important. Although Dunbar High School was segregated, some of the country's most prominent intellectuals and achievers attended Dunbar. Howard University—the flagship university of black America—was also here. Howard was regarded as a great university, and people strived to send their children there. People with low-level government jobs, without much education, could send their children to Howard and aspire to see them get ahead.

If that is your background, the one thing you know as a kid about freedom is that education is freedom. What was left for you? To accept the status quo or to get an education and get *your* version of freedom.

I was in college before I knew I wanted to be a civil rights lawyer. The anticommunist McCarthy period was still hanging over America then, and a group of us drove from Antioch College in Ohio to DC for the 1957 March on Washington. This smaller march, held before the one in 1963, is not much noted. Martin Luther King Jr., Harry Belafonte, Sidney Poitier, and Adam Clayton Powell Jr. spoke. The march was typical of my activism at Antioch, where the atmosphere was politically charged and academically geared toward producing intellectuals and social activists. I began to think of law as a way to help overcome racism and segregation.

But at bottom I am a writer and intellectual, and I read deeply into the social criticism of the time, including critiques of the values of American middle-class society and the black bourgeoisie, which accepted the American status quo. My role models were Michael Harrington, an intellectual and a socialist who wrote *The Other America,* and Bayard Rustin, the talented black master strategist of the March on Washington. Harrington would travel from college campus to college campus. I loved it when he came to our campus, because he epitomized the intellectual as activist. You can understand what a master Rustin was when you realize that prior to the 1963 march there had never been a protest on that scale by blacks in the history of the United States.

We had just come out of the largely silent fifties of my parents' generation. The 1963 march was a huge, groundbreaking event and has been a model for every march since.

I decided to go to Yale Law School because it allowed me to fulfill both my professional and intellectual desires. Yale had two of America's greatest historians: John Morton Blum and C. Vann Woodward. I attended Yale Law School and also got a master's degree in American studies from the graduate school at the same time. When I left the Equal Employment Opportunity Commission, I became a law school academic. The natural thing for a federal agency head was to go into private practice rather than academic law. But for me it was natural to bring forward the other part of me, the part that is an intellectual and writer. I became tenured as a professor of law at Georgetown University Law School.

When the congressional seat became vacant in 1990, people began to suggest that I run, but I hesitated. I had tenure, I spoke around the country, I served on three corporate boards, I had a family and two kids. But then I thought about who I am—a third-generation Washingtonian. DC has been my life and my family's life for three generations. With no voting members in Congress, it was the only part of America left without full representation in Congress. Also Donna Brazile, uniquely known for her ability as an organizer, offered to run my campaign. I said, If Donna will do it, I'll do it. After I won, she served as my chief of staff for ten years, until she left to manage the Gore presidential campaign.

I've never had a moment's regret about leaving a wonderfully fulfilling career in academia to serve in Congress. For me nothing is more fulfilling than representing the congressional district where I grew up. Sure, I learned to love the spirit of New York when I was head of the New York City Commission on Human Rights and lived there. But I'm a native Washingtonian. This is where my heart is. The unique challenge for me in Congress is not just getting more resources. It's getting full voting representation and statehood. It's getting to the point where Congress treats this city with full respect and no longer intervenes in local affairs. I find that extraordinarily motivating and rewarding.

My father taught himself to read from the Bible until he could stand up and read the Bible in church. He was a driven, proud man. He always told me, "The only person who can hold you back is you." I believed it.

I was born and raised in the Benning Road area of Washington, DC, in a working-class area. I was one of five children, next to the baby, and the only girl. You would think I was spoiled, but for some reason I wasn't.

My dad attended school up to grade seven. Mom may have finished the fifth. Throughout my childhood, they both always had two jobs. Dad was a laborer and cab driver, and Mom cleaned offices. Even with our modest standard of living, we had a live-in housekeeper-nanny. We were always clean and well taken care of, and our house was filled with love and encouragement. I remember waking up on the weekends to the smell of fried apples, smothered pork chops, chicken, hot rolls, and grits.

Even though our parents weren't well educated, they learned the value of a good education through their personal struggles, and they encouraged us to finish school and absorb knowledge. They always said to us, "We want you to do better than we did, to decide who you want to be and not allow the world to make that decision for you." They had dreams that I would go to college.

That's why the day I had to come home at age sixteen and tell my parents that I was pregnant was the hardest day of my life. I was in tears, and I get emotional just thinking about the look of disappointment on their faces. My mom asked a lot of questions, as mothers do, but my father sat down and bawled like a baby. I had never seen him cry, and I was shaking in my boots. He never said a word to me that day or the next, but I knew he was deeply hurt and disappointed in me.

If you believe, you can achieve, I always say.

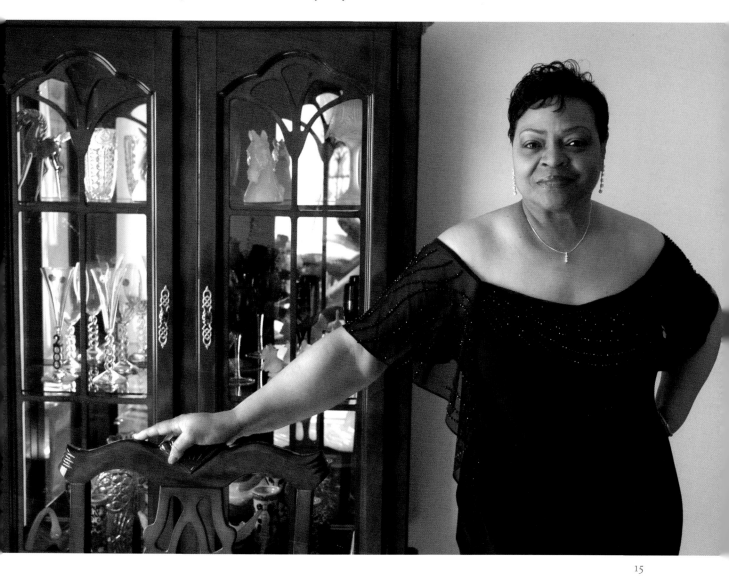

Even during my pregnancy, my mother insisted that I hold my head up high. I gave birth to my daughter Monica, then went back and finished high school. My parents didn't push me to get married, because they wanted me to go to college. But in the summer of 1963 I married Monica's father, and we had a second daughter. One year after Lisa's birth, I left him and moved back in with my parents. I got a job as a GS-2 clerk in the federal government, and about a year later I had saved enough to move out on my own and took the girls with me. I was in and out of college but never finished because of the pressures of working and taking care of my girls. I regret that now, because I'm a big fan of education.

That was a tough time for me, and my parents were very disappointed. But they still supported and encouraged me every step of the way. They still told me, "You can do or become anything you want. Don't settle." Those words helped me to keep going, and that's why I've always been driven and was never insecure about my potential. If you believe, you can achieve, I always say.

I worked my way up in the federal government to a GS-14 manager, and while at the Department of Commerce, I became interested in real estate. Not to sell it but to buy and invest in it. I bought a couple of pieces using an agent and thought, I could do this. I got a real estate license so I would understand the market better. I was still only interested in buying for investment purposes.

My friends began to ask me to find houses for them and I did. Eventually I began to sell real estate for Century 21. But I had always wanted to work for myself, and I thought, If I know how to do this so well, why work for someone else? In my second year as a real estate agent, I bought a Century 21 franchise with the money I made selling real estate. I didn't tell anyone I was going to do it, because I didn't want anyone to talk me out of it.

I hired a manager to run the franchise, and I went to the office every evening and week-end. After a while I began to think that I really needed to run my business myself, and in 1989 I quit my government job, seven years before I was eligible for full retirement. Again I didn't tell anyone, because I didn't want them to talk me out of it. I couldn't wait to get into real estate full-time.

Eventually I took on a business partner, and we moved from Century 21 to another fran-chise. We were paying enormous franchise fees, and in order to keep going, we had to con-stantly train new agents. We had in excess of one hundred real estate agents, and I know I've trained five to six hundred agents. We would work, work, work. I was exhausted. Nine years ago we sold the franchise and opened our own agency in Largo, Maryland, called Broker's Realty. We trimmed down to twenty-five very experienced agents, and I now deal with refer-rals and repeat clients only. I remarried in 1999, and my husband and I plan to semiretire to our home in Florida.

Mom passed away first and then my father. I miss them both. When my father died I became the matriarch of the family, and everyone looked up to me. Sometimes when I look back, it amazes me how far I've come. But I know I was able to do it because of all the love and encouragement from my parents. They encouraged me to take calculated risks, and I encour-age my daughters and granddaughters to do the same. We don't grow unless we take risks.

Marita Golden ◆ 54 Author; Founder of the Zora Neale Hurston/ Richard Wright Foundation

I think that women are naturally resilient and that African American women are especially so. In many countries women are the bearers of the culture, the spiritual leaders, and our religious and spiritual faith is a force to be recognized throughout the world. A lot of people in the church are women, and I *know* prayer works. I know black women who have prayed their children out of jail.

I like to think that resiliency is one of my strongest traits, and I know that I got it genetically from my mother and father. My mother was the definition of resilience. She migrated from North Carolina to Washington, DC, in the 1920s, and through determination and hard work rose from being employed as a domestic worker to owning three boarding houses. I grew up in those houses and witnessed my mother's full-steam-ahead drive, which resulted in expensive rugs on our floors and lamb coats for her and nice clothes for me.

I was reared in a three-story house that we shared with boarders, so I grew up around a diverse group of people and early on learned to appreciate that wisdom and intelligence could be found in a construction worker or a teacher. My mother loved life and all people no matter who they were or their station in life, and she threw great parties in our houses. From her I learned that life was a gift and that it was to be lived fully. Even in her later years, when she had lost much of her financial independence and was in poor health, she still enjoyed herself and had few if any regrets.

My first novel, *Long Distance Life*, was inspired by my mother, for that is what she lived. I could literally hear her speaking to me as I wrote. Some days, as I was taking dictation from heaven, her spirit was very, very real and present. I am also a long-distance runner in my life. Whatever I do, I do with my whole heart, or else what's the use? My mother told me over and over to get a good education. "Nobody can take it away from you," she would say, and the older I get the more right I see she was. She taught me to be self-reliant, and that quality has helped me through many a crisis.

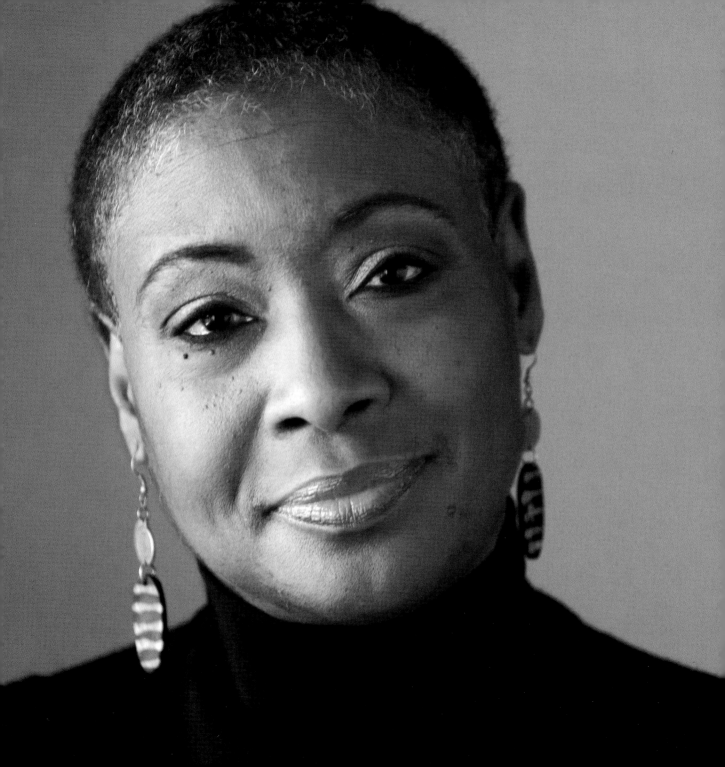

My spiritual journey has become very important to me over the past decade. Spirituality gives me a sense of inner peace and helps me accept who I am. It allows me to age with grace, and it's made growing older very satisfying.

When I left my first husband and literally escaped from Nigeria with my son, fearing I would lose custody of him, I called forth the self-reliance my mother had instilled in me. When I returned to the United States and had to start my life over from scratch as a single mother, resilience and faith brought me through every day. When the apartment we lived in was broken into, when the day care provider took off for Florida without telling me, when I taught full-time at one college and part-time at another while writing books, resiliency allowed me to do it all for my son and the life I wanted us to have. I became a "guerrilla mom," fighting for the best of everything for my son, wanting to give him the world in the same way my parents strove to give the world to me.

When my son was thirteen and lost two of his friends to gun violence, he asked me why God let that happen. I wrote *Saving Our Sons* as a way of answering that question and reaching out to our community as my son and I grieved together.

I fought just as hard for my son to be reunited with his dad. After the bitter years of our divorce and estrangement were behind us, I took my son to Nigeria to see his father. I felt I had to take him back to see his dad and his legacy in Africa. He was welcomed like a prince. The good relationship that my son now has with his father and his father's family is partly a result of my resilient nature, which made it possible for me, with the prodding of my son, to bounce back from anger and disappointment.

When I got a very bad review of one of my books, I was upset for about three days. But then I used the review as a springboard into looking at my definition of success and realized that what I really wanted from writing was for more than one person to say that I was great. I then began a journey that involved a lot of soul-searching—a lot of time spent in retreats and in silence and prayer—as I sought a way to live a creative life that would nourish me more deeply. During that time I developed habits of emotional nurturance that I rely on to this day.

When my current husband was diagnosed with cancer several years ago, I allowed myself one twenty-minute breakdown in the shower during which I cried beneath the stream of water. Then I got out of the shower and vowed that my husband wasn't going anywhere and that I was not going to lose him 'cause I wasn't through loving him. That served notice to the universe that this was one we were going to win. And we did.

My spiritual journey has become very important to me over the past decade. Spirituality gives me a sense of inner peace and helps me accept who I am. It allows me to age with grace, and it's made growing older very satisfying. I've probably never felt better in my adult life.

Sandy Mann Michael ◆ 70 RETIRED RETAILER, MERCHANDISER, AND MANUFACTURER

In 1968, a week after Dr. King was assassinated, my husband, Bill, and I opened Ashanti Bazaar, one of the first African-inspired boutiques in New York City. It was in Harlem, on Seventh Avenue and 132nd Street, and we sold and manufactured clothes of our own design as well as jewelry, accessories, and art. Bill was an engineer working in construction, but he was frustrated because of the ups and downs of employment in the industry, and he had always said that we should run our own company. I was a teacher, but I was quite politically minded. Whatever movement was going on, I was sympathetic, and after I saw Miriam Makeba and Odetta perform, I knew something big was going on. The women wore their hair in beautiful Afros, and we realized that there was a need for clothes to complement the look. I let my hair go natural, and we set out to dress the "black is beautiful" revolution.

We lived in Manhattan then, and we sent our children to take lessons with LaRocque Bey, a popular dance teacher in Harlem. He had a troupe that performed African dances, and I would go and study the clothing the dancers wore. I also looked in magazines, at people who came to the United Nations, and at Africans walking around New York City. There are so many people in New York from around the world.

Then I started searching for African fabric similar to what I was seeing. In the beginning I created the designs myself and had the clothing made by dressmakers. As we progressed we used other African American designers. At first we did this working out of our house and tried to sell the garments wholesale to black-owned stores. But African American store owners didn't understand what we were trying to do, and we ended up giving the garments out on consignment. That didn't work well, because we couldn't keep track of who was buying the clothes. So we became partners with a store in Harlem and finally opened our own shop across from Count Basie's Club and Wells Restaurant.

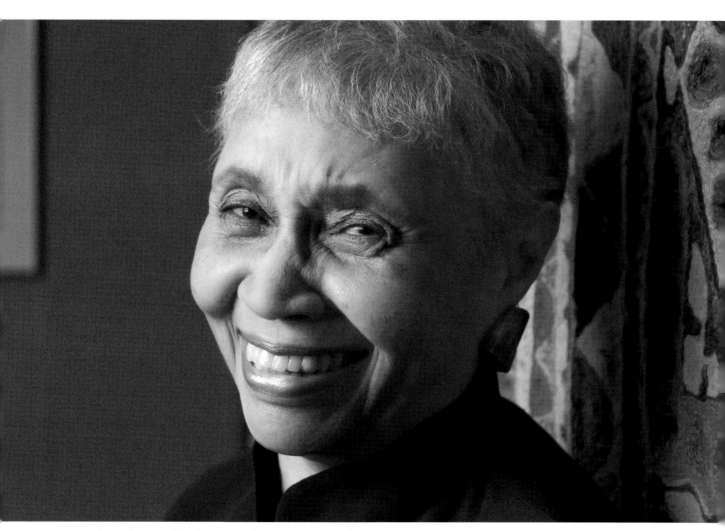

A number of young black women have positions of power in the garment industry today.
I can't help but think that Ashanti helped to make that possible, and I'm very proud of that. 23

One of our first customers was Kareem Abdul-Jabbar. He was just out of high school then and starting to be talked about, and I'll never forget when I first saw him. He was the tallest person I had ever seen. Others who came into the store were Abbey Lincoln, Art Blakey, Amiri Baraka, Nikki Giovanni, Charlayne Hunter-Gault, Nina Simone, and Jesse Jackson. You see lots of African-inspired clothing now, but at the time it was unusual. We advertised in the *Amsterdam News, Ebony,* the *New York Times, The New Yorker,* and *Vogue.* People came from all over the country, and they were really excited about the store. People wanted to make a statement, and we helped them do that through their clothing.

I think the enterpreneurial spirit comes from my childhood. Both of my grandparents had their own businesses in Ossining, New York. One grandfather sold coal and ice, and my grandmother had a little store on the street where they lived called the Busy Bee, and she sold food. My grandmother also took in several foster children and raised her nieces and nephews. She was a very hard worker and a pillar of her church and community. My father was an independent carpenter, cabinetmaker, and boat builder, as well as an accomplished sax player. In 1948, after a gargantuan struggle with the neighbors, he built our family house in Croton-on-Hudson, New York, which I still own today.

My parents experienced a lot of injustices, and that influenced me. Whenever I saw injustice, I did what I could to try to right it. I remember when my husband and I were looking for an apartment in New York City after living in Puerto Rico for a year and a half. This was in 1961, and I was pregnant with my first child. We liked an apartment in Brooklyn that we knew was available, but when we went in to ask about it we were told there were no vacancies. So we had a white friend go in and ask, and he was shown a number of vacant apartments. We took the owners to court and won the lawsuit. The judge declared that they couldn't rent to anyone else until they rented to an African American. That apartment complex is integrated today, and I'm really proud of that. We never moved into the building. By the time we won the lawsuit, we were living in upper Manhattan.

When President Nixon cut funds from the War on Poverty in 1971, a lot of people who worked in the program lost their jobs, and Ashanti began to lose business. We knew we had to

change things if we wanted to survive, so we decided to move downtown into a very upscale area. This was the early 1970s, and the idea of a black business in the middle of Manhattan was unusual to say the least. But we were determined. I always find myself thinking of a quote attributed to Goethe at moments like this. It goes something like, "Whatever you can do or dream you can do, begin it. Boldness has genius, power, and magic in it."

The building we wanted to move into was at Lexington and 65th Street, just a few blocks from Bloomingdale's, but the rental agent wouldn't show it to us because of our Harlem address and the type of business we owned. We did some research to find out who the owner was and then contacted the lawyer. It turned out the owners lived in France, and we had no problems moving in. We eventually occupied three floors in the building and stayed there for thirty-two years.

Our focus this time became more multiethnic rather than African-inspired, and we sold imports from all over the world. We also sold a lot of jewelry designed by African Americans. They had no other outlets for their creations, and later on I decided to concentrate on that. One of our most prominent customers was Dr. Johnnetta Cole. She was teaching nearby at Hunter College then, and we dressed her for her job interview at Spelman College.

By the mid-1970s the market for our products was drying up, but we had noticed that large women continued to seek us out, and we decided to focus on them. We sold really beautiful clothes, some with African accents, for women in sizes fourteen and up. Our designs were carried by Bloomingdale's, Neiman Marcus, Jacobsen's, Sears, and others. In 1980 we opened a second store, in the upscale Short Hills area of New Jersey.

We got into the clothing business as a political move. We wanted to make a statement and to help others do the same. But we learned that styles come and go, and over time Ashanti evolved into a more traditional fashion business. I think our ability to adapt to the times was what helped us to stay afloat for nearly thirty-five years. Over that period, we employed many, many people, and some of them have gone on to open their own businesses. A number of young black women have positions of power in the garment industry today. I can't help but think that Ashanti helped to make that possible, and I'm very proud of that.

Sharon Farmer ◆ 54

I was a nineteen-year-old music major at the Ohio State University in Columbus and loving my bassoon, piano, and clarinet when a fellow student, Mallory Stoudenmire, asked me to accompany him to the darkroom on campus to make prints for a class. That first darkroom experience changed my life. Seeing images appear in the trays of chemicals reminded me of alchemy and of the magical things that occurred in all the books I had read on mythology and Merlin and in fairy tales. I was fascinated, and I vowed to myself to take a photography course as an elective as soon as I could. The very next quarter, I took Professor Harry Binau's Science of Photography course and loved it. I was fascinated that all of the students could have the same camera yet see nothing alike. I asked my parents for a camera, and they sent me the money to buy a Nikkormat.

Professor Binau inspired me to take more photography courses, and I began to shoot for *Our Choking Times,* the black student newspaper at the university. The black students on campus were very active in compelling the university to be fair to all of its students. I was inspired by the racial and political climate of the time, and I photographed political, cultural, and scholarly events. One of the assistant deans of students, Charles "Chuck" Williams, inspired me to work hard for change through my photography. He was the adviser to many black student groups on campus, and he encouraged us to establish *Our Choking Times* as a rival to the university journalism department's daily paper, *The Lantern.*

Women on campus were not allowed to be a part of the university marching band at that time, so I focused more on photography. I quit grilling burgers in the student union and began to make money photographing things around campus and working for a community paper, the *Columbus Call & Post,* run by editor and journalist Amos Lynch. I also worked for the Ohio State University yearbook. They sent me to my first Rose Bowl to photograph the football game. In my final years of college, I was vice president of the undergraduate student govern-

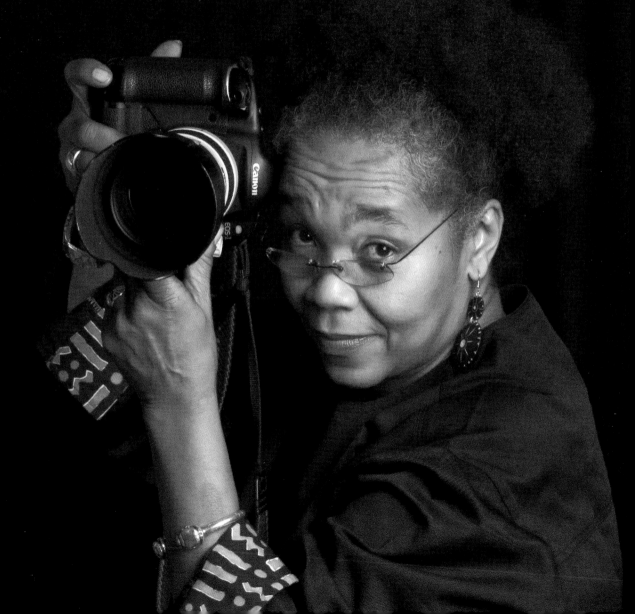

I've encountered both racism and sexism in this business, but I'm strong and I know that many before me followed their dreams despite obstacles.

ment, managing editor of *Our Choking Times*, and a photojournalist intern at the Associated Press in Columbus.

After graduation I returned home to Washington, DC, and freelanced with many publications and organizations in my off time, as I worked in a camera store until I knew I could work for myself. I became the photographer for the DC mayoral campaign efforts of Walter Washington, former Housing and Urban Development secretary Patricia Roberts Harris, and Sharon Pratt Kelly. I also exhibited my fine art photography and photographed activists, musicians, actors, dancers, and other visual artists in my community. For more than twelve years I did three to six photographic assignments a week for the *Washington Post*.

When photojournalist Bob McNeely was appointed by incoming president Bill Clinton to be his photographer, McNeely selected me, Ralph Alswang, and Barbara Kinney to document the Clinton administration with him. For years I had insisted that I be given credit adjacent to my photographs whenever they appeared in print, and that's how McNeely and others were aware of my work. That led to me becoming the first black woman to be an official White House photographer. Bob didn't complete the second Clinton term, so I threw my hat into the ring and became the first black woman to be director of White House photography and chief White House photographer.

I've encountered both racism and sexism in this business, but I'm strong and I know that many before me followed their dreams despite obstacles. My parents, Winifred and George Farmer, taught us that education is everything. They retired as elementary and junior high school principals and neither one of them allowed sexism or racism to hinder their pursuit of excellence in any school they administered. My brother and I learned how to deal with difficult situations as we sat around the dinner table with our parents and discussed our days at school and work.

As I read black history written by black folks, I began to understand that some white folks had a great fear that we would one day pay them back for their years of inhumanity toward us. This country has passed racism around the world by trying to paint us as "minorities," when actually we are the "majority" on the planet. One of my favorite reality checks now is to read a book entitled *A People's History of the United States,* by Howard Zinn. I read the poetry and prose of June Jordan, Audre Lorde, E. Ethelbert Miller, Noam Chomsky, and Dr. Cornel West to keep myself grounded and levelheaded. I've always believed in nonviolence, civil disobedience, and the Golden Rule.

My parents are my role models along with Dean Chuck Williams, my Epsilon chapter of Delta Sigma Theta sorors, who persevered at Ohio State University, and Valentine, a Columbus, Ohio, community photographer who helped everybody. I also greatly admire Dr. Bernice Johnson Reagon, historian and founder of the a cappella group Sweet Honey in the Rock, as well as each and every woman who has been a member of the group. It takes tremendous courage to sing of injustice, racism, and the changes needed to ensure that our rights to pursue life, liberty, and happiness continue.

Since the end of the Clinton administration, I've been freelancing with my photography and practicing my music. I'm displaying my photographs at exhibits. For three years I worked as a photo editor for the Associated Press in Washington, DC, and then left to serve as photographer for the presidential campaign of Senator John Kerry.

Every day is exciting for me as I view the world through the lenses of my cameras. Some days are how I planned them and some are not, but I'm never bored with this life.

My great-great-grandmother's life was one of the great American rags to riches stories. Madam C. J. Walker was the daughter of former slaves, but by the time of her death in 1919 she was a millionaire. Some say she was the first African American woman millionaire; others say she was the first self-made female millionaire in America.

I have to admit that as a teenager growing up during the late sixties and early seventies, I was ambivalent about my famous ancestor. Here I was during the black power era with my big Afro, and most people associated Madam C. J. Walker with the straightening comb. I really was uncomfortable with that, though I later learned that she hadn't invented the hot comb. But as much as anything, I just didn't want to be defined simply as the descendant of someone famous. Like most kids, I wanted to be like everyone else, so I rarely mentioned that she was my great-great-grandmother.

My opinion of her began to change when I was in college at Harvard and researching a paper in the stacks at Widener Library. I came across an old issue of *The Crisis* magazine that had an obituary about her written by W.E.B. DuBois. Now, DuBois was my intellectual hero at the time, so it made a huge difference to me that he had such great things to say about her. I thought that if he believed she was great, then maybe I needed to reexamine her life and my views about her.

Years later, as I searched for a topic for my master's paper while at Columbia University's Graduate School of Journalism, my adviser, Phyllis Garland, said to me, "Your name is A'Lelia. Do you have a connection to Madam C. J. Walker?" Phyl wasn't aware of the connection— A'Lelia was the name of Madam Walker's daughter—because I'd never made a big deal about it. But I said yes, and she said to me, "Well, *that's* what you're going to write about." Here was someone else outside the family, a journalist and someone I really respected, who also had positive opinions about my ancestor.

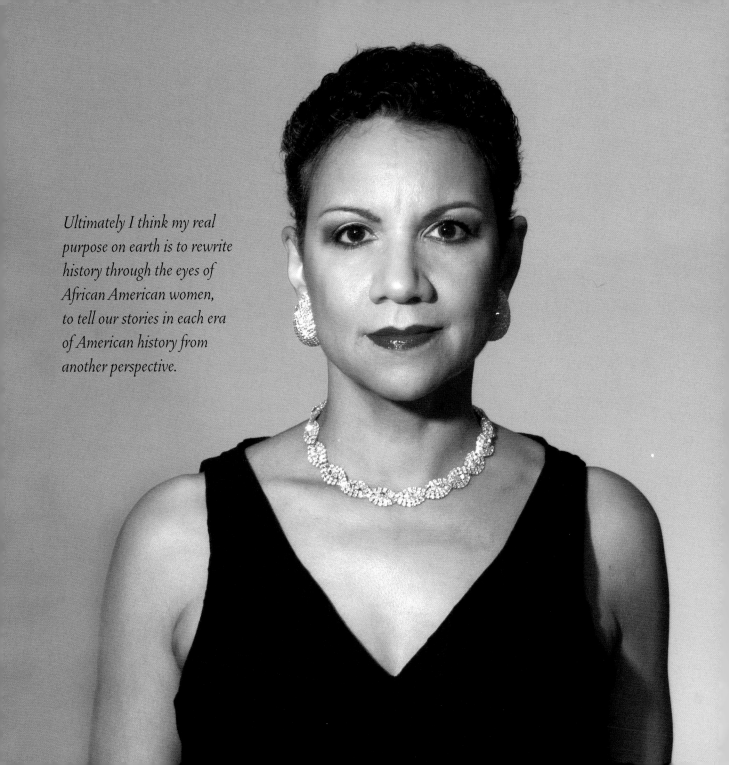

Ultimately I think my real purpose on earth is to rewrite history through the eyes of African American women, to tell our stories in each era of American history from another perspective.

As I began to research Madam Walker's background, I learned many things about her to be proud of that I hadn't been aware of before. Initially she was more concerned with healing the scalp disease that was so rampant among black women in the early 1900s and with growing hair through a system of improved hygiene with shampoos and curative ointments. It's true that she popularized the hot comb, but she did not invent it. She was also a pioneer of the modern hair care and cosmetics industries and was an early advocate of women's economic independence. She created an international network of sales agents and held her first national convention the year before Mary Kay was born.

Probably less well known is that she was also a great philanthropist and political activist who used her wealth to make a difference. She contributed to the NAACP's antilynching fund and donated money to the National Association of Colored Women to help them purchase Frederick Douglass's home in Washington, DC. She contributed to the YWCA, YMCA, and many other groups. At her estate in New York, Villa Lewaro, where her neighbors included John D. Rockefeller and Jay Gould, she hosted race leaders to discuss issues of the day. That home and the Madame Walker Theatre Center in Indianapolis are national historic landmarks today.

As I dug deeper into my great-great-grandmother's life and the life of her daughter, A'Lelia Walker, I also uncovered things that didn't fit the image, like multiple marriages and lawsuits and a scandal here and there. I wasn't sure if I should write about those things, or how I should handle the life of my grandmother Mae, who was adopted by A'Lelia Walker. How would I write about Mae's Cinderella-like life as a student at Spelman College and as president of the Walker Company, but also about her very unhappy and arranged first marriage?

In the midst of writing my master's paper, I learned my mother had been diagnosed with lung cancer. We knew she was terminal, and when I returned to Indianapolis for Christmas vacation, she was in the hospital and really too ill to talk about the details of her family's history. But I had to get her advice. "Momma, what should I do about these things that I'm finding?" I asked as I sat on her hospital bed. I knew she was feeling weak, but she managed to find enough energy to grip my hand and say, "Tell the truth, baby. It's all right to tell the truth."

That was one of our last conversations before she died. It was an incredible gift that has allowed me to continue to truthfully tell the story of the women in my family.

Some of the lessons you learn when researching your ancestors are not heroic. Even though Madam C. J. Walker was changing the world, she wasn't perfect, of course. But that humanness made her more believable and likable to me. I do believe that you get a different sense of yourself when you know about your ancestors.

From the lessons of my parents and grandmothers, I learned to navigate the corporate world during my thirty years as a producer and executive at NBC News and ABC News. I have had the good fortune to receive awards for my work and to accomplish many things that I'm proud of. But ultimately I think my real purpose on earth is to rewrite history through the eyes of African American women, to tell our stories in each era of American history from another perspective, and I plan to leave ABC to do that.

Many people can't understand why I'd leave what is considered a very prestigious job. But I left once before, to write *On Her Own Ground*, the first truly comprehensive biography of Madam Walker's life. At this point, I think that writing books and public speaking are better outlets for telling the stories of the struggles and triumphs of African American women. No matter how well I do my job as a producer at ABC, network television news just doesn't have much room for these stories. I was frustrated with the coverage of Hurricane Katrina and of Rosa Parks's death and funeral. It always seems to come back to a matter of perspective, emphasis, and nuance.

As I was deciding to leave ABC, it really helped to be able to look back at the strengths and weaknesses of my ancestors and to see how they survived despite the ups and downs. Madam C. J. Walker still inspires women today, from businesswomen to prison inmates. I want to use my platform as her great-great-granddaughter to encourage others to follow their dreams and to research their ancestry, because I believe that there is power in knowing about your ancestors.

In fact I had a dream last night where someone asked me, "Are you sure this is the right thing to do?" And I answered, "Yes, I know it is." And in part, I owe that confidence to my great-great-grandmother, who left me with an amazing story to tell.

I grew up in Bel Air, Maryland, during the time of the H. Rap Brown trial, which was transferred from Cambridge, Maryland, on the eastern shore, to my little hometown, Bel Air. H. Rap Brown was an influential member of the Black Panther Party, and he was charged with inciting a riot in Cambridge. There was all this media attention surrounding the transfer of the trial, and I was fascinated by it. I was fourteen or fifteen years old, and I snuck out of school, slipped into the courtroom, and sat on the floor. I wasn't thinking of becoming a lawyer at that time. I just wanted to see a trial. But I didn't get to watch long. I was kicked out.

Before the trial I had thought I wanted to be an airline stewardess or a ballet dancer or veterinarian. The H. Rap Brown trial perked my interest in the law, and by high school I felt that law school was my calling. I liked studying history and the Constitution, and I wanted to make a difference. I knew even then that the law is very important. I always say that discrimination ends because of the law, not because of the goodwill of men. You have to change the law first, and then hopefully attitudes will follow.

My school counselors didn't encourage me. In fact they suggested I become a teacher or social worker, and I didn't know of any black or women lawyers back then except Justice Thurgood Marshall, who was a famous lawyer at that time. But my parents were supportive. They always said you can do whatever you want; you just have to work hard and be better at it than the white kids.

After graduating from Macalester College in St. Paul, Minnesota, I came home and attended the University of Baltimore School of Law from 1976 to 1979. Only 15 to 20 percent of the students were women, and my first-year class had four African Americans. It was very difficult for us. But I was determined to get through it, and I even ran for president of the student bar association and won. I was the first woman or student of color ever to become president of the student bar association.

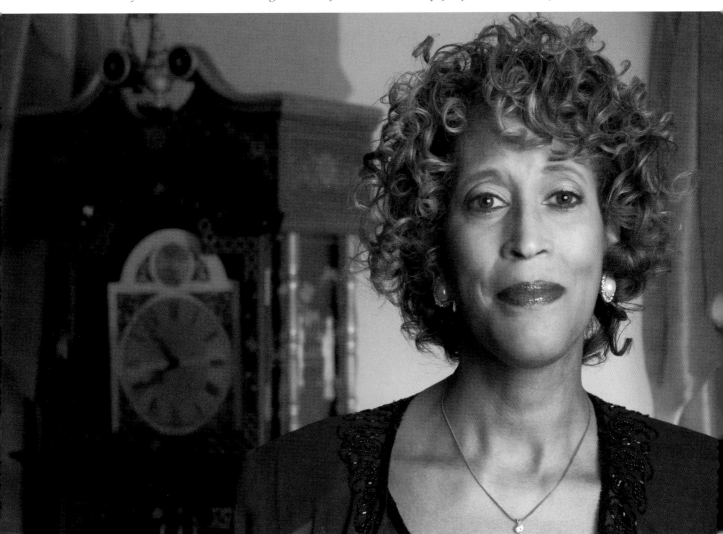

I always say that discrimination ends because of the law, not because of the goodwill of men. You have to change the law first, and then hopefully attitudes will follow.

After law school I became director of Inmate Legal Services at the Baltimore City Jail. I also held several other posts over the years in the Maryland attorney general's office and Baltimore city solicitor's office.

I love being in the courtroom, but other lawyers were sometimes condescending toward me during those early years, especially white men. I don't know if it was my age, gender, or race, but they would ignore me in court, call me by my first name, or say "little lady." One judge refused to acknowledge me. In chambers meetings he always looked past me to the left or right when I spoke. I would bend way over to place myself in his line of sight, and he would just turn his head away further. It was tough. I sometimes asked myself, Why do I want to be here? My eyes would well up, but I refused to cry in public.

A couple of people mentored me during those years and were very helpful. Judge Benjamin Brown and Elise Jude Mason were both my supervisors, and they encouraged me to become more active in the community and to hone my craft. Another was Charlie Dorsey, an extraordinary man who ran the Maryland Legal Aid Bureau and was the only African American on the Board of Law Examiners. We would have huge debates, and he would tell me things like, "If you're not in the mix, how do you expect to effect change?"

Partly because of their advice, I became more active in the bar and the community. I joined the Baltimore YWCA and later became president. I also became active in several bar associations. When I became president of the Baltimore City Bar Association in 1997, I was the first African American woman to serve as president, and it was such an honor. People became deferential then, but I earned that respect. I had served as treasurer of the bar association and as secretary twice. That's more than others who had been elected president before me.

I had a goal of becoming a judge. I saw that as the highest calling in serving the public as a jurist, and that's what I aspired to. I first applied to be a judge in 1996, and I made the list of candidates but wasn't selected. I made the list again in 1997 but still wasn't chosen. When I wasn't selected for the third time in 1998, it was a real low point for me. I'm an excellent lawyer and a very well rounded person. I know the legal issues and felt I had the temperament, experience, and knowledge to serve. But if you want to be a judge, you have to campaign for

the position. You have to get out there and sell yourself, and that didn't come naturally to me. After that third failure, I thought, Why am I putting myself through this?

But I decided to try one more time. I've always believed that if you really want something—and I really wanted this—you have to do whatever you can to get it. When you finally give up, you have to be able to say to yourself that there was nothing else you could have done. I went after it that fourth time like

never before. I had my spiel down by then, and I went out and delivered it to everyone with vigor and asked for their support.

When I was told that Governor Parris Glendening was on the line at the office, I thought he was calling about something I was working on in the attorney general's office. I picked up the phone, and Glendening told me that he was appointing me. I was so excited. I must have said thank you 50 million times. My family, friends, and colleagues were all very happy for me. When I was sworn in, in May 2002, my father and husband held the Bible, my mom and children robed me, and my husband escorted me to the bench. That was the proudest moment of my career.

A challenge for me in being a judge is not having a public voice and not being able to express my opinions on the issues to anyone. For so many years, I was an advocate and active in the community, oftentimes being very vocal on social issues. I can't be that way anymore. Also, it can be lonely and isolating in this position. As you get further up the pyramid, you have fewer colleagues to talk to and interact with.

But the reward is in making a real difference in people's lives every day. That's what I've always wanted to do, and I like doing that. This is certainly a welcome change from the days when I had to bend over backward to get the judge's attention in the courtroom.

Once you serve and do a good job, you get called on all the time. That's nice, but sometimes I feel like the poster child for women of color. In the eighties and nineties I served on countless boards and commissions, oftentimes accepting positions for fear that they would look for no other black candidates. I want them to look beyond me to other African Americans and other races. I want to see a great infusion of women of color in positions of power in the law.

Diane Singleton ◆ 54

ASSISTANT DIRECTOR, PREVENTATIVE SERVICES AND FAMILY
SUPPORT PROGRAMS, SOCIAL SERVICES AGENCY

I think a lot of the black women in our generation thought about things other than getting married when they were young. Doing my own thing was what I thought about. Looking for the perfect mate was not. While my friends were thinking about getting married and having kids, I thought about being independent and having a career. Besides, how can you be with the same person that long?

My parents divorced when my sister and I were young, and I definitely think that had an influence on us putting marriage at the bottom of our lists. To me, our parents never looked all that happy even when they were married. Other family members, an aunt and uncle, also didn't look very happy. In fact, most married couples didn't seem all that happy or all that compatible to me. So marriage just didn't look like something I wanted to do.

When you're single, you can be more of your own person. I can make my own decisions without having to think of another person. I don't have to put my goals on the back burner, which basically sounds pretty selfish. But if those things are important to you, you're probably better off not getting married. When I went back to school to get my master's degree at Smith College, I quit my job, lived on campus, and was able to attend full-time. If I had been married, I might not have been able to do that.

If I had met someone when I was in my twenties or thirties and gotten married, I honestly don't think I would still be married to them now, because I've changed a lot. I work with families, and a lot of the people have partners, but that doesn't mean it's good for you. I think it's hard to meet someone you're compatible with who treats you with respect.

I went to a conference last week and met a woman who was about my age who had never been married. She talked a lot about being an African American woman and growing up in her family environment and the church and how she had been under a lot of pressure to get mar-

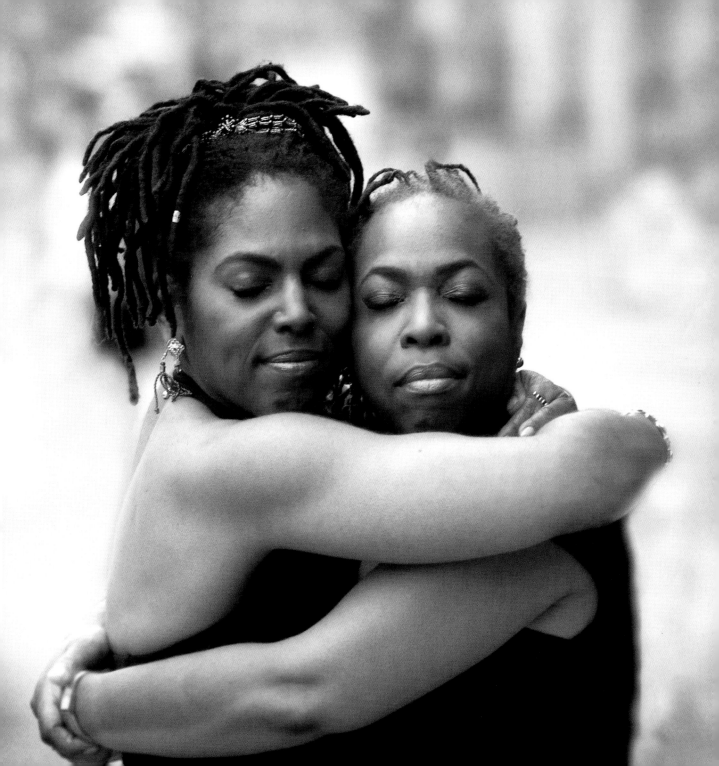

ried and have children. People do look at you funny when you never marry, like, What's wrong with you? What are you waiting for? But you learn to live with that.

It wasn't a conscious decision not to have children. Time just slipped by. I thought maybe later, maybe later, and then the chance was gone. Actually, when I was in my twenties, I didn't want kids. I was changing too much, and I wanted to be in a position to give kids at least what I had if not more. I probably wouldn't have been ready to have kids until I was in my forties. You have to be ready to have kids, although some people say you're never really ready.

I do think it's nice to have a partner to share things with. I enjoy being in a long-term relationship. I'm even open to the possibility of marriage, but I'm not looking for it. I have a full life with my work, my family, and good friends.

Karen Singleton ◆ 53 ACCOUNTS PAYABLE MANAGER, LAW FIRM

When I thought about the future as a young girl and woman, I never pictured a husband. I pictured a wedding dress but no husband. I thought the dresses in the bridal magazines were beautiful. I still do. But I really don't see marriage in my future. My boyfriend is a great guy and I love him and everything. We've been together for ten years and I know he has my back. That's enough for now.

For me, marriage is not the end of everything, and I've always focused more on other things. I always wanted to be in a relationship—and generally have been—but not necessarily married. I just couldn't see being with one person for the rest of my life. Maybe that's because I didn't meet the right person at the right time. When I had the opportunity to get married, he wasn't the right man. When it was the right man, it wasn't a good time, meaning that I wasn't ready.

Meanwhile, I'm enjoying the advantages of not being married. I don't have to compromise about what I want to do or when I want to do it. I don't have to check in with someone

While my friends were thinking about getting married and having kids, I thought about being independent and having a career. DS

When I had the opportunity to get married, he wasn't the right man. When it was the right man, it wasn't a good time, meaning that I wasn't ready. KS

to see how they're feeling about whatever it is that I'm doing. And I don't have to check with anyone about how the money is spent. It's up to me and my finances. Women these days can support themselves. We don't need to depend on a man.

The flip side of that is that when I get old, I may be old and alone. Also, I don't have someone who has my back forever, someone who's there for me no matter what. It's nice to have that. Although now that I think about it, some *married* people don't have that either.

I think black women have a harder time meeting men because we limit our choices. There are a lot of good men out there, but we want a professional black man, so we overlook policemen or firemen or whatever. I also think it's harder to find black men in a big city like New York, because we're more spread out. New York is very polarized in certain aspects. You can go into a restaurant in Midtown and be the only black person there. In smaller cities like Atlanta and Washington, you see lots of black people walking down the street. But in New York everyone is spread out.

My one regret is that I didn't have children. I don't think you need a husband to have children, and I regret not doing something about that when I could have. But fear stopped me, fear of giving in to the stereotype of having a child and not being married. Looking back now, I see how stupid that was. I still think about adopting. Although at this age I would probably have to adopt a teenager, I think I have so much to offer a child—knowledge, experience, maturity.

I started writing because I was determined to be heard. I grew up in the age of segregation, when black people and women did not have a voice, so finding my voice and my place in the world was important. I think everyone wants to be heard.

You don't control success. What you control is, "I am not afraid to fail." I decided early on that I wanted to write for a living, and that meant I had to do everything I could to reach that goal. There weren't many other black writers at the time, but Harriet Tubman didn't have a role model either. What she had was a desire. She said, "I can be free or I can die." I could write or I could fail.

I didn't have much money, which meant I had to look for ways to survive with my writing. I went to graduate school on a fellowship and that bought me time. I'm not a big fan of struggle. I don't think that way. We have obstacles, but I see them as opportunities. Somebody you love dies, you try to buy a house and can't—these are opportunities to learn about yourself and the world.

I developed a lot of my attitudes and beliefs from my grandmother. Although I was born in Knoxville, Tennessee, my family moved to Cincinnati, Ohio, when I was two months old. I spent my summers in Knoxville with Grandmother. She was my biggest supporter and she was very politically active. If you were around my grandmother, you were politically active. That's why much of my poetry deals with political and social issues. She taught me that you always have time, even if you don't always have money, and to give what you have. I'm a big fan of volunteerism. Two teachers also supported me, and now I have this thing about little old ladies. I realized that they often have stories to tell. They have lots of experience and love, and if we don't get their stories written down no one will know them. For me, writing is a way of recording voices for the future.

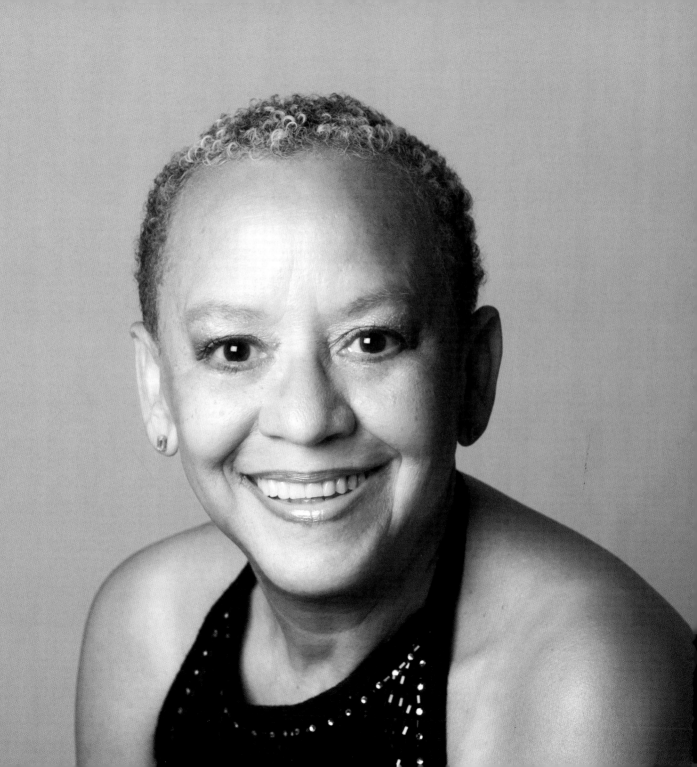

If you were around my grandmother, you were politically active.
That's why much of my poetry deals with political and social issues.
She taught me that you always have time, even if you don't always
have money, and to give what you have.

I am a pioneer. Nobody was out there doing what I was doing when I started to write in the 1960s. The first black person I remember coming along was Ntozake Shange, author of *For Colored Girls Who Have Considered Suicide When the Rainbow Is Enuf.* Her publisher called me and said that they had this wonderful young poet and needed to find out what sales might be if they published her book. In my day, that was all I could do to help a young author. Now authors like Zane and Nikki Turner are able to help other authors get published. They can go to a publisher and say, "I want an imprint." They have input and they bring along other people. Some of these young authors are great businesswomen and they tell good stories. I'm really very proud to see how they have seized the moment to make good business deals. Like that old Negro spiritual, "We Are Climbing Jacob's Ladder," we're all slowly building this ladder. It's wonderful to see.

When I was nominated for the Spoken Word Grammy in 2004, I was thrilled. It was a reflection of the times and how much has changed. Thirty or forty years ago, the people who make those nominations were not old enough to be in positions to nominate someone like me. Now they dominate the Grammys. Even though I didn't win, I enjoyed that very much. We had a Grammy party, and a friend of my mother's baked a cake. People on the streets were blowing their horns. It was a good time.

Writing is what sustains my heart and my soul. I even relax by daydreaming about what I could be writing. I'm a pretty good cook and I also play tennis. I'm trying to learn to swim. One of the things that makes me upset is that I didn't learn to swim. It's easier to learn to swim when you're young, but black people couldn't go to the pools when I was a girl. If not for segregation, I know I would have learned to swim. So now I'm taking swimming lessons in my sixties. I see it and envision it but just can't quite get it.

I am happy with my life. The life of the mind is a good life. I think it's important to enjoy it and to evolve. If you find yourself doing the same thing you've always done, something is wrong. You need to keep pushing the envelope. I'm still too young to look back. There's too much life ahead. A bad habit people get into is eulogizing themselves. I just try to stay alive and take care of myself. And I write. I'll be writing when I die. I'll be at my desk or at my laptop in my bed saying something.

Gale LeGrand Williams ◆ 51

Life has a way of presenting challenges in the most unusual ways while perfecting us. After my first marriage ended in divorce, I married a man named Claude. I loved that man. He was a wonderful husband and an excellent father to my daughter from my previous marriage and to our son. But after we were married for five years, Claude died suddenly and I became a single parent.

That was one of the darkest times of my life. I felt lost and completely alone. I thought, God, what am I going to do? My kids were asking what we were going to do without their father. I remember sitting at the graveside after the funeral and my mom saying, "Gale, we need to go." I didn't want to leave him.

Just before Claude died, I had accepted a career path internship as a contract specialist/negotiator in the Department of the Navy in Norfolk, Virginia. I had signed up for a thirty-day training program that was to start the Monday after the funeral. That Thursday before the funeral, my boss called and told me that I didn't have to go. But I insisted on going. I had to keep moving.

On the trip, I remember sitting in the hotel and just crying, night after night. Finally I found a book called *Tough Times Never Last, But Tough People Do,* by Robert Schuller. That book helped to change my life. I grew up in the church, but during my early adult years I stopped going to church regularly. After reading that book, I rededicated my life and reestablished a daily relationship with God.

When I returned from the trip, I started going to church every Sunday, and during altar call I would go up and pray, "God, I need your help to raise these children." God answered my prayer by giving me the faith, strength, and wisdom to go on. I had people in my life who I thought were my friends and when this happened I found I couldn't always count on them. My renewed faith in God brought new friends into my life, friends I could depend on. My family

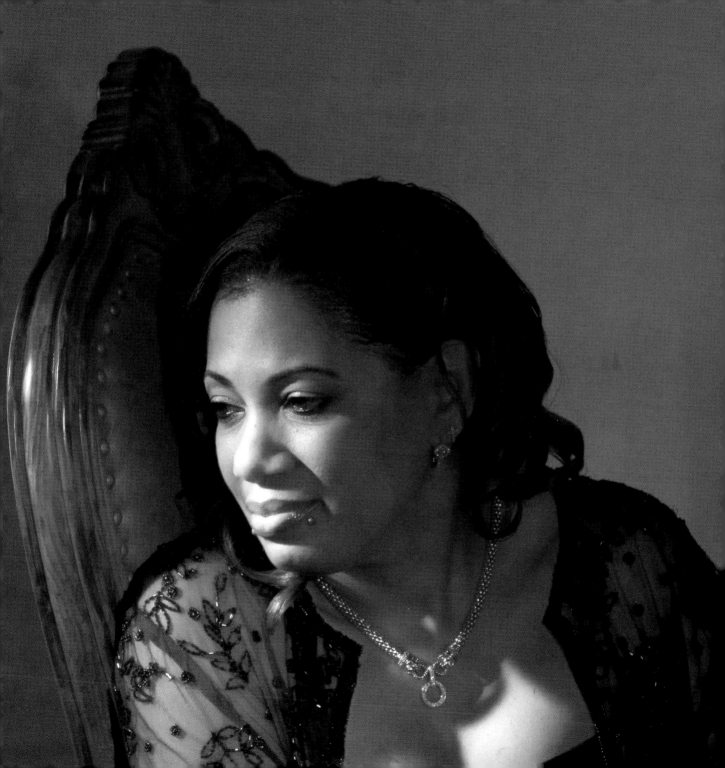

was also supportive. My mother and mother-in-law helped with the kids when I had to travel. They looked after me, too. My father, always a hard worker, told me never to depend on a man to support me. I took that to heart.

A navy contract specialist negotiates and purchases supplies and services for navy organizations. This was in the mid-1980s, and the position was occupied predominantly by whites, but I knew I could do it and I wanted the challenge. I would take the contract regulations home at night to study. One day I came into the building to begin my workday carrying all my books, and someone I considered to be a good friend laughed loudly and said that I looked stupid. I also had to deal with ridicule and isolation from other minorities who had not been accepted into the program. I was hurt but still determined to excel.

I began as a GS-5 contract specialist and eventually rose to a GS-12. But when I tried to go above that level, I couldn't. I believed I had hit the glass ceiling. I think management thought I was always going to be there and that they could take advantage of me. They thought I should be happy as a GS-12. They were wrong.

I applied for a job as director of contracts at the GS-13 level at another navy command, in Portsmouth, Virginia, and got the job. When I told the people at my command in Norfolk, they offered me a GS-13. I declined. I thought, You could never give me a GS-13 before, and suddenly when someone else gives it to me, you can? *No*. If I'm going to give it my all, I want it to be appreciated. I wasn't looking for anyone to give me anything, but I wanted what I was due.

The job in Portsmouth opened so many opportunities. I worked under a man who was very supportive. One day he called me into his office and said he had attended a board meeting for a Naval Warfare Center, chaired by an admiral, and that the board wanted me to be their new acquisition manager. That meant I would be responsible for policy and oversight for all of the contracting offices (East and West Coasts and Hawaii) that reported to that warfare center. I was stunned.

In 1997 I was selected by the navy to be a legislative fellow for the Brookings Institution. I did that for a year, working with Senator Carl Levin, then went back to the navy. I returned

I can't tell you the number of times during my career that I've walked into a meeting and someone asked, "Are we ready to get started?" Then someone else would say, "We're waiting for Mrs. Williams...." I don't think they were expecting me to be black.

to find that the admiral I had worked under had left and they wanted me to transfer to San Diego. I was a GS-15 by then, and I did not want to move to San Diego. I found other jobs in the navy and eventually decided to retire.

Even though I've had good jobs in the navy, some were very stressful. My last position in the navy was deputy CIO for navy manpower and personnel. I can't tell you the number of times during my career that I've walked into a meeting and someone asked, "Are we ready to get started?" Then someone else would say, "We're waiting for Mrs. Williams," and I would say, "*I* am Mrs. Williams." I don't think they were expecting me to be black. Numerous times I was the only black and the only female in a meeting of senior government officials.

There were always challenges during my career. Some of my biggest challenges were unfortunately from other black people. But in most cases, I really didn't care as long as the person I worked for supported me.

When I retired from the navy, I had reached a point where it was stressful more often than not due to internal and external pressures that changed the work environment completely. I began to develop medical problems, so I decided to retire early.

I now own my own business doing consulting work, and I love it. I remarried several years ago and have four grandchildren: Kiara, Taiya, Christian, and Edward Jr. I met my husband, Ronald, when I moved to Washington, DC, for a promotion. I wasn't looking for anyone when we met. I had taken my father's advice, and with God's help I had learned that I don't need a man to survive. I can take care of myself. But it is a blessing to have someone to love and share my life with.

BISA has been an important part of my life for longer than twenty-five years. More than that, it's been important in the lives of many young African American women by helping them go to college and realize their dreams.

I think the way BISA came about is fascinating. In December 1979, I was working for the federal government and I attended a conference called Blacks in Government. After the conference, a group of the women met for a debriefing on Capitol Hill. We wanted to form a permanent support group to help each other, and we met again in January 1980. Now these were very successful women in government, so I suggested that instead of forming a group to help ourselves, we form a group to help other people who really need uplifting. They discussed the idea and decided that would be great.

I offered my house for the first meeting, which was held on January 10, 1980. Unfortunately it snowed that day—and snowed and snowed and snowed. Some of the women started calling me at work to make sure we were still going to meet that evening. I said yes, not knowing how bad it was snowing outside. It took me an hour longer than usual to get home from work, and I worried that no one would show up for the meeting. I didn't need to be concerned. Every last woman in the local group showed up.

We sat in front of the fireplace and discussed what we would do and planned until twelve-thirty that night. Finally we decided that the group would raise money for college scholarships for young black women. We named the new group BISA, Black Women in Sisterhood for Action. I was so impressed with those women. I still am today.

Since that night, BISA has helped more than 160 inner-city black women through its national scholarship program. We started with two students and added two more each year until we grew to forty to fifty students a year. Among our graduates are lawyers, computer

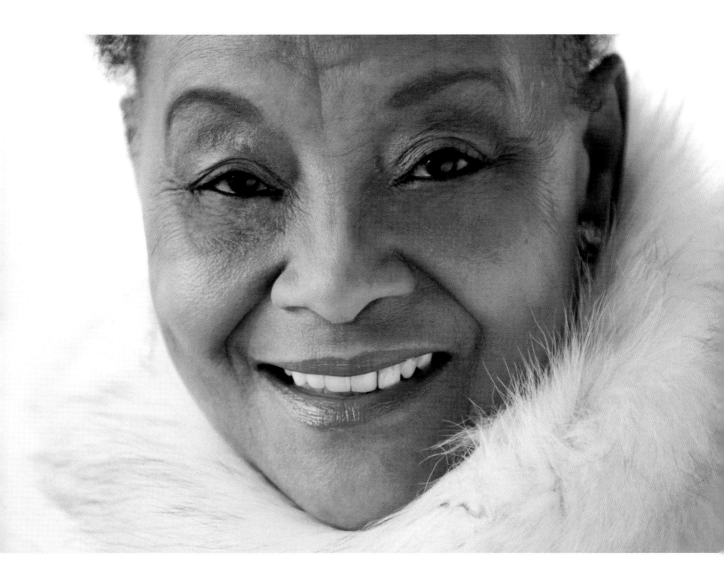

experts, educators, engineers, communication specialists, social workers, medical doctors, architects, and businesswomen. Many go on to graduate studies.

During this time I worked as a consultant for the U.S. Department of Health and Human Services, and I monitored and managed grants to colleges and universities for the department. I also taught at Georgetown University and Catholic University, where I earned a PhD in guidance counseling and educational psychology.

But my drive to help others get an education really comes from my early childhood. My sister and I never knew much about our mother. My father took care of us alone during the early years. Our first grade schoolteacher, a woman named Osaleta Allen Coachman, had adopted four girls and four boys who were also her students, and she would always ask my father if my sister and I could live with her. She would tell my father that he couldn't take care of us right because we were girls, and that girls had to be raised a certain way. They needed a woman in their lives.

But my father loved us dearly and didn't want to give us up. He had a lot of respect for Mrs. Coachman and her husband, and he allowed us to stay with them on weekends. Eventually he let us move in with them, and he would visit every weekend.

The Coachmans were wonderful parents, and they were good to every one of us. Mrs. Coachman—we called her Sister—would say, "I picked each of you because you are all special." Mr. Coachman was a Baptist minister and Mrs. Coachman was the first lady of the church, and so many people came to our house on Sundays. The tables would be lined up outside, and there was plenty of food for everyone. Together with my father, the Coachmans taught me good values, especially the value of an education and that you always have to help others. What I'm doing now with BISA is an extension of what I learned from them.

We all felt very fortunate to have the Coachmans in our lives. We may not have had a lot in the material sense, but the family overflowed with love, generosity, and kindness. The first time I ever felt poor was when I was in college and a professor was talking about sociological classes. He described "underprivileged" people and said that African Americans were in that group. That got on my nerves, and I stood up and told him about my family. I told him that we aren't all dumb and poor, and that all of the Coachmans were well educated and had an abundance of the things that mattered.

I attended undergraduate school at Bethune-Cookman College in Daytona Beach, Florida. Mary McLeod Bethune started the college with a dollar and a half, five little girls, and her young son. She rented a cabin near a dump pile and called it the Daytona Normal Industrial Institute. By the time I was there, it had grown to more than nine hundred students. Dr. Bethune lived in a house on the college campus, and many of us would stand around and wait for her to come out. She would put her hands on our heads and say: "Remember, you kids, enter to learn and leave to serve. I'm proud of my little black boys and girls." She was a great educator. She is my role model. I want to be just like her.

I believe we should do whatever we can to lift up those who are less fortunate, particularly our youth. That comes easy for me because a lot of people helped and encouraged me. I tell my BISA students, "Together, we can make a difference. You, our scholars, are our future leaders."

I believe we should do whatever we can to lift up those who are less fortunate, particularly our youth. That comes easy for me because a lot of people helped and encouraged me.

MANAGER AND FORMER OWNER, WAAA RADIO STATION,
WINSTON-SALEM, NORTH CAROLINA

When I purchased WAAA radio station, I was the second black woman ever to buy a radio station in the United States. Dorothy Brunson in Baltimore was the first by two days. And as I was only twenty-six, I was also the youngest black person ever to buy a broadcast property.

Initially I wanted to be in television, but in 1971, when I began college, there were no national female newscasters or anchors. Not even Barbara Walters. So my ultimate goal was to become the female Walter Cronkite. I majored in speech communications and theater arts at Wake Forest University in Winston-Salem, North Carolina, and I worked at WFDD-FM, the campus radio station. I did everything I could to prepare myself both in theory and practical applications to be a good broadcaster. The primary difference between radio and television is the visual aspect. If you can be an effective radio broadcaster, television becomes easier. The goal is to become good at the craft.

In the summer of 1974, just before my senior year at Wake Forest, I worked at WAAA radio in news and public affairs, and I continued there part-time through the fall semester. That was when I began to realize that there were good opportunities for broadcasting in radio, but I still wanted to be in television, so in January and February 1975 I did an internship at WGHP-TV in High Point, North Carolina. I interviewed people on-camera and wrote and voiced the lead-in and conclusion, and when I got back on campus, students would come up to me and say, "Didn't I see you on TV last night?" That was my awakening. In the cafeteria and library, my face was being recognized. Wow! I realized that being on television would invade my private space. I had not thought about the ramifications of being a face by which people thought they knew you, and I started to rethink my goals.

Meanwhile Eugene Bohi, the general manager of the television station, was so impressed with my work that he told the news director, Fred Blackmon, to hire me immediately at the end

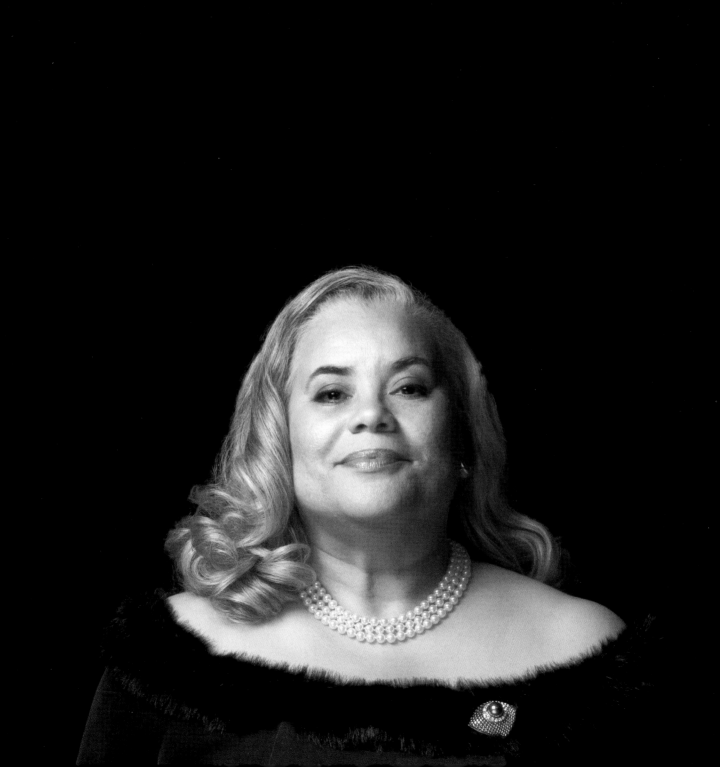

of my internship. That would have meant commuting back and forth from Winston-Salem to High Point daily, and I still had a full course load to take during my last semester at school as well as other commitments. I had to make a quick decision, and the primary thing I weighed was the reaction I had gotten being recognized on television. I turned down the TV offer and decided to go with radio, because that would allow me to come and go as I wanted without being recognized, or so I thought.

My focus is on making a difference in others' lives, being good at the job, giving the story life, and changing things by how I cover events. You can do that on either medium. People often say to me, "Mütter, you ought to be in TV," and I smile, because I had the opportunity to do that and, to a degree, I've been there, done that.

So after I graduated college in May of 1975 I went back to WAAA radio, and it was everything I wanted it to be. I was offered the position of news and public affairs director. I was also offered opportunities to do some sales and advertising work, and I accepted. In general, whenever something else came up and I was asked to go here or do that to represent the station, I willingly accepted. I wanted to learn as much as I could about the station and the community.

I was a hard worker, always have been. I grew up on a small farm that belonged to my maternal grandmother. Both of my parents were college-educated teachers, and we had a good work ethic. Daddy taught at the high school level and helped many of his students go to college. My grandmother went back to school when she was in her sixties to work toward her high school diploma. I learned that the world is a school where you can learn from everybody everywhere.

In 1978 I was offered a promotion to general manager and executive vice president of the radio station. I had just turned twenty-five, and this awesome challenge and responsibility

was being offered to me. I recognized the enormity of it and I hesitated. The owner, Robert B. Brown, was surprised and threw in a bonus. If I accepted the offer and he ever decided to sell the station, I would have first right of refusal. It didn't register at first. I mean, I heard it, but I had no reason to think that he would sell the station anytime soon. Bob was a brilliant man but also extremely daunting. He owned other stations in Florida and South Carolina. I had worked very closely with him, but I had also stood up to him and challenged him. I think he respected that.

I told him that I needed time to think about it, and he gave me the weekend. I accepted, and just months later Bob came to me and said, "Mütter, I've decided to sell the station." I said to him, "You can't do this now, 'cause I'm not ready." He said something to me that I'll never forget. He said, "Mütter, opportunity doesn't always knock when you want it to. You have to seize it or it passes you by."

I knew exactly what he meant, but I was in the position of not knowing anybody else who had done this before, and I had no one to turn to for advice. This was the only man I had worked with, the person I normally turned to for professional advice. But you can't completely trust someone you're going to buy something from. I was in a Catch-22.

As I explored the opportunity, it became obvious that the greatest challenge was going to be coming up with the funds. When I went to bankers, they would say, "Thanks, but no thanks," without even bothering to look at my business plan. I was black, female, young, and single, and I realized more than ever the impact that racism, sexism, and all the other -isms were having in society. I was very angry, because I'm thinking, You don't know me. You haven't even looked at my proposal. I don't want to hear about what someone else has done. I'm Mütter Evans, and I should be judged on my own merits and track record.

Finally I was able to borrow some funds from Greensboro National Bank, a black-owned bank, for the down payment. A Small Business Administration–guaranteed loan from another bank and owner financing from Bob enabled me to seal the deal. My greatest champions throughout my life, my parents, also helped. They are both deceased now, but they are still my greatest champions. They believed enough in me that they put up the home my daddy built, the home my brother and I grew up in, and the home that they still lived in, as collateral. Without my parents' faith and belief in me, it would have never happened. Even though the land their house was on was worth more than the remaining financing initially needed for the down payment, the traditional, conservative banks wouldn't accept it. The second part of the loan, which I got from a traditional bank, had so many stipulations that it had a negative impact on my ability to run the station.

The deal was finally completed in 1979, and the Federal Communications Commission (FCC) approved the transfer of ownership on October 31st. The station's format was primarily gospel and R&B, and we had news and public affairs programming. We interviewed entertainers, local elected officials, and people in the community. We didn't just say you need to register and vote, we registered people at the radio station. I also used the station to start a citywide observance of Dr. Martin Luther King Jr.'s birthday five years before the holiday was enacted, and it continues as the oldest and largest local commemoration. I thought, Why are we waiting for a group of white men in Congress to say we can celebrate this man who did so much for us and was directly responsible for the growth in opportunities that we sometimes take for granted?

I was able to hire people and teach and train on the job. I was able to inspire people who worked with me to do the best job they were capable of and to see them go on and do bigger and better things. Even today some of my former employees come to me and say, "You taught me this." That's been one of the most rewarding parts of it.

Unfortunately I faced many obstacles over the years, the last one being a dispute with the landlord that ultimately became very complicated. When my mother became ill, my attention was divided for about a year, and the problems with the landlord escalated. Then on July 9, 2001, just as my mother appeared to be on the mend and I thought I could put my focus back on the station, my landlord's attorney and a locksmith showed up with documentation and changed the locks on the building. After more than fifty-one years on the air, WAAA radio went silent for almost a year.

I was making plans to rebuild the station elsewhere when my mother passed away unexpectedly that September. An aunt died about a month later, and a close friend whom I had known since college died of a heart attack at age forty-eight about a month after that. It was a very difficult time, but I'm glad that I chose to focus on my mother that last year or so of her life. I know that if I had put the business before her, I would never have been able to live with myself, for she embodied all the qualities that made me a woman with integrity. After my father's death in 1986, she was my staunchest supporter.

Once I had healed and was energized enough to move forward, I realized that I no longer wanted to put in the effort needed to rebuild the station. So I sold it, and the buyer asked me to stay on as manager.

In hindsight, I would have done a couple of things differently if I had known then what I know now. I had always envisioned having a professional and family life, but ended up devoting most of my time toward growing and maintaining the station. I took only two real vacations during my twenty-five-plus years with WAAA. I never married and never had children. I realize now that no matter how much you give, it is never enough, so you *can* give less and still give your best. I've been a very selfless person, but I plan to be a more selfish person going forward. I plan to devote more time to family, friends, and myself.

G irl, you must be crazy!" That's what I said to myself when I sat up in my bed at 2 a.m. in January 2000. I was living in Denver, Colorado, where I had been for the past thirty years, and I was approaching seventy. I had burned out from bookselling, had finally sold Hue-Man Experience Bookstore after running it for fifteen years and retired. Now I was planning to move to New York City, a place most people would not even consider for retirement, preferring instead someplace warm like Florida. But my two daughters and my grandchildren were living in New York, and I was involved with others in planning to open a large bookstore in Harlem. When I woke up early that morning, I was questioning my plan and wondering if I really wanted to start over at this point in my life.

I was not one of those people who always dreamed of opening a bookstore. It was my boyfriend's idea to get us into the bookselling business. He did all the up-front planning and execution, and he was going to operate the store. I was working at a bank and put up the money along with a partner, but I had no intention of being directly involved. But I left the bank shortly before we opened and ended up finding my passion in bookselling.

My specialty was event planning and marketing. I learned that my most loyal customers were the working-class and blue-collar residents. Middle-class customers were more likely to go to the chain stores and often were not as culturally connected. My challenge was to create value for those customers.

My daughters taught me that we had to make our business newsworthy and that once we attracted attention, media would feed upon itself. So I decided that when the media called I would say that Hue-Man was the largest black-owned bookstore in the country. Even though that wasn't exactly true at the time, the media started to repeat it.

I became more visible and vocal by joining the American Booksellers Association, and I was eventually placed on their board of directors and became an expert for information about African American bookstores and authors. I also established relationships with book publishers.

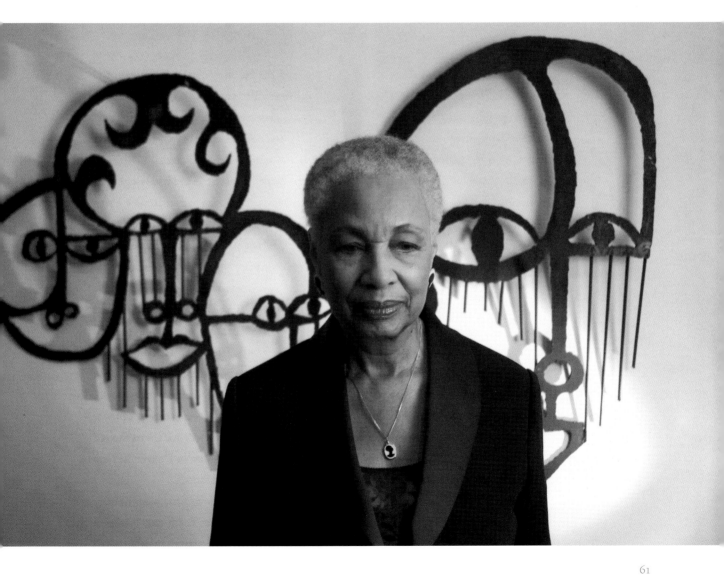

I decided that when the media called I would say that Hue-Man was the largest black-owned bookstore in the country. Even though that wasn't exactly true at the time, the media started to repeat it. . . . We eventually expanded the store and purchased the building and really became the largest black-owned bookstore.

We eventually expanded the store and purchased the building and really became the largest black-owned bookstore. As our reputation grew, authors wanted to come to Hue-Man for book signings. Some of the early authors were James Baldwin, Alice Walker, Paule Marshall, Terry McMillan, and Maya Angelou. Later we had Bebe Moore Campbell, Tina McElroy Ansa, Connie Briscoe, E. Lynn Harris, Walter Mosley, and Colin Powell.

The business became a success, but I was doing it alone by that time, as I had bought out my partner and the relationship with my boyfriend had ended. Although I had employees, it was still hard work. It was a constant hustle with no end in sight, and I burned out. Retiring to New York would allow me to take time for myself and spend time with my family. I could participate in projects where I could give back to the community, do some traveling, and write a book.

That was the original plan, but that's not exactly how it worked out.

Before I even left Denver, the developer of Harlem USA contacted me and asked if I would be interested in opening another bookstore in New York. His company was developing a retail center in Harlem that would include Old Navy, Modell's Sports, Disney, Chase Bank, Magic Johnson Theaters, and an HMV record store, and they wanted a bookstore. Barnes & Noble, Borders, and some local African American bookstores had already turned them down. Apparently they believed that black people in Harlem don't buy books because most of them are working-class. Large book retailers don't see these people in their stores and they assumed that they don't read. But I knew better from my days running Hue-Man in Denver. In New York they were buying books from the street vendors in their neighborhoods.

Several months later, when I attended the Ruby Dee and Ossie Davis fiftieth anniversary party in New York, the developers took me to see the site. It was at 125th and Frederick Douglass Boulevard, and it was just a hole in the ground. But something struck me as I looked

around. All these black people were walking up and down the street and going in and out of the shops, whereas in Denver there are so few of us and we're so spread out. I was intrigued. I thought, This is Harlem. A black bookstore should work here if it works anywhere.

I've always had a lot of confidence and determination, and I get that from my mother. She was my role model. She was a country girl from Mississippi who moved to Chicago in the 1920s during the great migration and worked in private family houses cleaning and cooking. But she wanted more out of life, so she tried millinery and sewing. She had a beauty salon for years, but she got to a point where she couldn't handle the fumes from the chemicals and decided to go into real estate. She got her broker's license at age fifty. She was very determined and adaptable, and she obviously didn't let age stop her from trying new things.

I decided to do it. When I got back to Denver, I wrote a business plan, and with the help of Terrie Williams I found two business partners—Rita Ewing, who had been married to basketball player Patrick Ewing, and Celeste Johnson, wife of basketball player Larry Johnson. They both wanted to learn the bookstore business, and since I wasn't really interested in running the store, we decided that I would train them and eventually concentrate on the marketing.

The hole in the ground eventually became the Harlem USA Retail Center, and after three long years a four-thousand-square-foot space within the center became Hue-Man Bookstore in 2002. Maya Angelou read on opening day, and others who attended included Ossie Davis, Ruby Dee, Stevie Wonder, and Ashford and Simpson. Walter Mosley did our first book signing. When President Clinton's memoir came out in 2004, we were the second bookstore he visited. More than two thousand people showed up. Hue-Man in Harlem is now the largest black-owned bookstore in the country.

I had reached my peak and decided to retire for good. In retrospect, I don't know how I did it. Not many people would decide to start a business at age seventy. But I didn't think about that. It was something I wanted to do and I just did it.

I faced many challenges and obstacles along the way, but I couldn't tell you if they were because I'm black or because I'm female. Sometimes people even reacted negatively to me because I was trained as a social worker and they thought I didn't know anything about business. I just shrugged them off and kept going. The only person I have to prove anything to is *me*.

My husband, Wesley, died of a heart attack in 1970 at age thirty-three. It was quite difficult, because he was so young. His death wasn't anything we could have predicted at that time, but I became interested in health issues and have been ever since. What I learned is that it doesn't matter how educated you are if you don't know how to take care of yourself.

This was a time when white women were getting into feminism and starting to learn about their bodies. The popular book *Our Bodies, Ourselves* was first published, and abortion was becoming available for women all over the country. I was working in a hospital affiliated with the University of Florida, and it was a fertile ground. It was a place to explore progressive thought, and I was encouraged to think forward. We became involved when a white woman came to us asking how to get an abortion in Florida and we didn't know. We eventually found a place in New York—at that time everybody went to New York for abortions—where we could send women, and we set up a hotline. Women would call that number and we would tell them where to go and how to get there. Well, that worked fine if you had the money to get to New York and pay for the abortion, but when a black woman came to us and didn't have the money, it didn't work.

So in the mid 1970s we opened the Gainesville Women's Health Center and provided preventive services and abortions locally at a lower cost. We set it up so that Medicaid paid for abortions for poor women. In 1978 we opened a center for natural childbirth. It was a big turn-of-the-century house, with brass four-poster beds and a playground, and you could bring children. We had lots of exclusive services, but it was cheaper than staying in a hospital. It was called Birthplace, and it's still there today, although they changed the name to Birth Center of Gainesville.

By this time I realized that health care, or the lack of it, was a huge problem for poor black women, and I wanted to do more. I got the idea for the National Black Women's Health Project

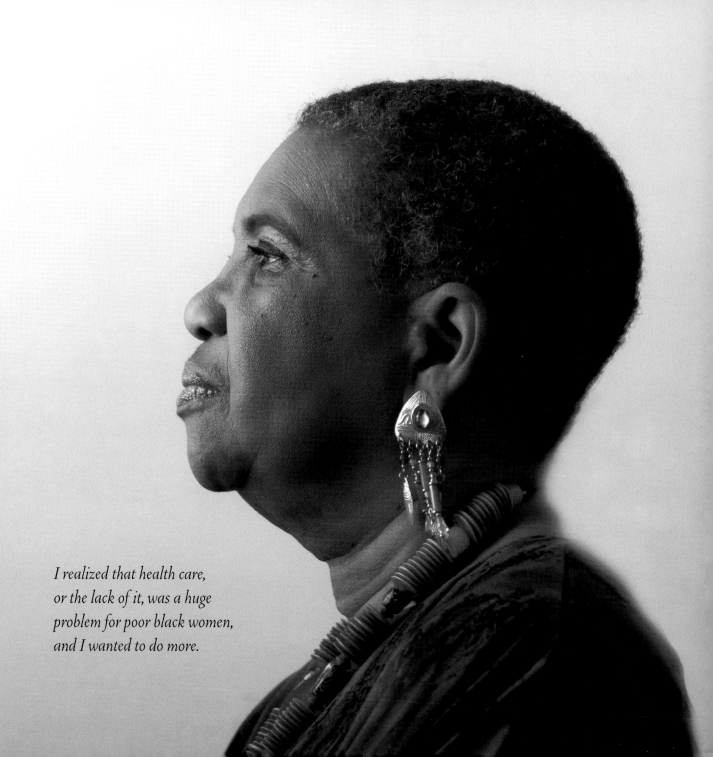

*I realized that health care,
or the lack of it, was a huge
problem for poor black women,
and I wanted to do more.*

in the late 1970s, and I tried to get it started while living in Gainesville, Florida, but I had a hard time getting black women interested. I had a meeting and only one person came. That's an indication of the size of the problem we were facing.

I knew I needed to be someplace where there were a lot of black women, and I decided to hold a series of meetings at Spelman College, in Atlanta. I met women on the faculty there, and we pulled together a group of about forty women from around the country to form a planning committee. We met for two years at Spelman College and built a network of black women interested in health. It became quite magical.

I was going back and forth to Spelman while living in Gainesville, and in 1981 I moved to Atlanta. When we decided to hold the first national conference on black women's health, some of the public health people told us that black people weren't interested in their health. They thought we didn't know what we were talking about. But we had worked hard to build up awareness and thought the time for a conference had come.

The conference was held June 24–25, 1983, and we thought that maybe we would have two to three hundred people. We got more than two to three *thousand.* They came by car, plane, and bus to Spelman's campus. They brought their children with them, because their husbands said that was the only way they could come. So many women were there, we didn't have room for all of them. They sat in the windows and aisles. We laughed and cried together. We talked about the things happening in our lives. It was about black women claiming their power, and everybody wanted to be there. It was a pretty extraordinary affair.

After such a successful meeting, we had to decide how we were going to move forward. So we set up a retreat and met in the mountains of northern Georgia every three months with a group of women who would then go back to their homes and hold their own meetings. We would talk about the reality of our lives, what it was like growing up with sexual abuse or being victims of domestic violence. Most of us were shocked to learn how widespread these problems are in our communities. When you sit in a room of two hundred women and seventy-five have been sexually abused, your eyes are opened.

We realized that our health priorities are different from white women's. The biggest issue is violence. Many black women are in abusive situations. They're being abused by their husbands and boyfriends. They are oppressed and don't know how to free themselves. Girls would ask their mothers what to do, and the mothers would tell them to deal with it. We called this initiative the Black Women's Health Project, and I ran it for about fifteen years. It's still operating, although the focus has changed to physical health issues and it's now called the Black Women's Health Imperative.

I left there and started another health organization to look at the biggest problem black women face now—the health care delivery system. It's really very bad. We have a lot of high-quality medical devices and diagnostic tools, but what good does it do to have the best if we can't reach all the people who need it? Millions of people don't have access to medical care, or they have social issues that don't allow them to focus on their health. Black women's access to quality care is hampered by a lot of things, like transportation and insurance that doesn't cover procedures like a colonoscopy. My daughter-in-law's insurance company doesn't cover colonoscopies, and she works in a hospital!

We have to change the system of delivery. We have to make sure we have a full range of reproductive health care available and massive education. We measure our health success by how sophisticated our tools and devices are. Well, we can use the same capabilities to figure out how to get health care to everyone. Until we address that issue, we will have a lot of people not getting quality health care.

The highlight of my work was when I got a call from the MacArthur Foundation in 1989 and was awarded a fellowship. I got the Essence Award for health, science, and technology the same year. Oh my God, I was so elated! I couldn't believe it. Those rewards filled me with hope and encouragement and even more determination. When I look forward and see the daunting challenges ahead, I sometimes feel overwhelmed, but when I look back and see how much we've accomplished, I feel emboldened. We're a lot better off than we used to be, but we still have much to do, and I will not rest until every black woman in America has access to quality health care.

I was crossing the street in New York City in 1986 and a man and woman—a couple—were crossing toward me. It was pouring rain and we were under umbrellas. As we got closer, they asked me, "Are you Seret Scott?"

At that time I was acting in a show running off-Broadway, and often people will stop you if they've seen your show. The couple said they were small independent producers of a new play and were looking for a black woman to direct it. That was my first venture as a director, and I thoroughly enjoyed it, although the cast and I were barely paid.

About a year and a half later, a playwright friend had a play accepted for the coming season at a major regional theater. She offered my name to the producers as director, and they asked me to come in for an interview. I wasn't nervous when I went in, because with so little experience I thought I had no chance of getting the job. When they made me an offer at the end of the interview, I was stunned.

The play was performed at a major regional theater in Connecticut, and it was my first big break. The reviews in the New York City papers were pretty positive, and a theater in New Mexico called and made me an offer to direct another show. By the time I finished that show, I had several other offers.

Theater has always been the only passion for me. My parents, John and Della, were theatergoers. They took my sister and me to see plays at an early age, and I was hooked by the time I was four. As a young girl, I loved to make up stories, write, direct, and star in my own short plays. Often, after dinner, I would put on skits in our dining room in Washington, DC, and my family would sit and watch me perform. We had a back porch, and I also used that as a stage. I would gather my two best friends, and we'd make crepe paper costumes and then perform my plays on the porch. We sometimes charged the neighbors seven cents to see them.

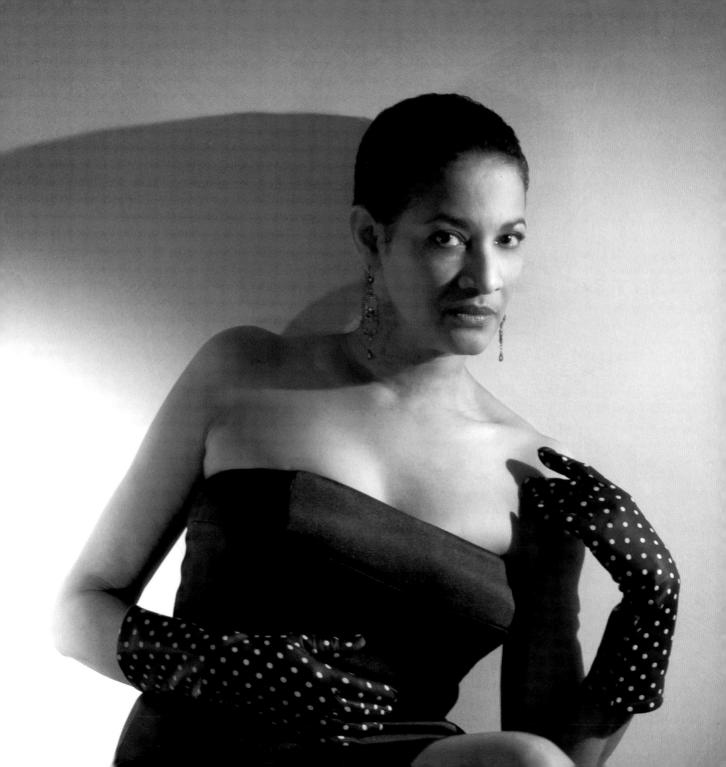

My parents were progressive in their thinking, considering that back then blacks were seldom represented onstage. They always encouraged my interest in theater. Just about every weekend my mother would say, "If you're doing something creative, you don't have to do housework." Consequently I never learned how to do housework well. I'm not sure why my parents were so passionate about the theater, given that this was during segregation, and in Washington black people had to sit in balconies in theaters.

During my senior year in high school, I had to write an essay about theater, and I found a magazine called the *Tulane Drama Review*. In it was an article about an organization in Mississippi called the Free Southern Theater, which did plays and skits based on civil rights. I wrote my essay about that organization. Then in 1966, when I was a student at New York University School of the Arts, I met a man there named Gilbert Moses who had been one of the founders of the Free Southern Theater. To me, Gilbert represented the black theater movement.

The Free Southern Theater had stopped operating by that time because of a dispute about the future direction of the organization. It had started as an integrated organization, but Gilbert and some others thought it would be more effective as an all-black theater. A lot of the members became frustrated about the changes, and people eventually went different ways.

When Dr. King was killed in 1968, Gilbert and a group of others decided to go back to the South and reestablish the theater in New Orleans. I auditioned and joined them. The civil rights movement was very important to me, and in 1969 I left a scholarship at NYU and went to Louisiana. That was the single most important and influential time of my life.

In the South I worked with people who had nothing. They worked in the cotton fields, and many of them had no plumbing, electricity, or running water. Often they had poor communication skills but were very savvy. Our plays communicated messages to them about their

Theater has always been the only passion for me. My parents were theatergoers. They took my sister and me to see plays at an early age, and I was hooked by the time I was four.

lives and their rights, things like voter registration, boycotts, and integration. The plays were designed to empower people as well as to entertain. I felt I made a difference in the South, and that feeling never left me.

One of the plays we performed during that time was Amiri Baraka's *Slave Ship*. It got noticed, and an off-Broadway theater decided to produce it. When it closed in New York City, we toured in Italy, France, and Switzerland. Then in 1973 I landed the lead role in *My Sister, My Sister*, a play that eventually came to Broadway. I won an award for the performance, and enough of the establishment saw it to enable me to work as an actress in many theaters.

When I first started directing and was asked questions like "How did you get where you are?" I told myself that I couldn't make mistakes. Then on one occasion, a black TV director-producer told me that being a director meant answering two hundred questions a day. He said, "If you don't know the answer, say 'Let me think about it and get back to you.' Make considered choices." That was very liberating. I realized that I was being too tough on myself and began to relax. I was there because people trusted my vision.

Some might say that meeting that man and woman in the pouring rain on the streets of New York City was a lucky break. But luck is 95 percent preparation. I had been preparing for that moment all my life.

My mother died when I was just eleven years old. She was a strong influence in my life, but I was fortunate to still have my grandmother and father, who stepped up to guide me, and I knew I would be all right.

I had a hearing loss as a child, but my parents and my grandmother still expected me to do well in school and in life. So I learned to sit up front in class and to read lips and concentrate on people when they talk. People always tell me that I'm a good listener, but honestly, I'm just trying to hear them.

I learned early in life that bad things will happen but there are always options and alternatives. Whatever happens, something good will eventually come of it. I've been accused of being hopelessly optimistic, but I really believe that. God gives and God takes away, and you have to have a strong sense of faith that things will turn out all right. You have to see the blessings in life, even in things that seem like disadvantages.

I remember taking the train from New York City to Baltimore recently and getting off at the wrong stop. I was visiting my cousin, and she told me to get off at Baltimore Washington International (BWI) Airport. On the train, I heard them announce that we were approaching Baltimore, so I gathered all my luggage and got off.

Almost as soon as I hit the platform, I knew that I was not at the airport. Since I have a hearing loss I thought that I must have misunderstood the announcement on the train. It had been a long day, with meetings in New York and a three-hour train ride, and I was two thousand miles away from my home in Seattle. I was tired and frustrated. But I told myself, "You have to keep going."

So I went to the information booth and asked where I was and how to get to BWI airport. The attendant told me that I was at the Baltimore City station and that if I hurried I might be able to get back on the train to BWI. I gathered all my luggage and rushed back to the platform, but I missed the train. I thought, Oh, my goodness. What am I going to do now?

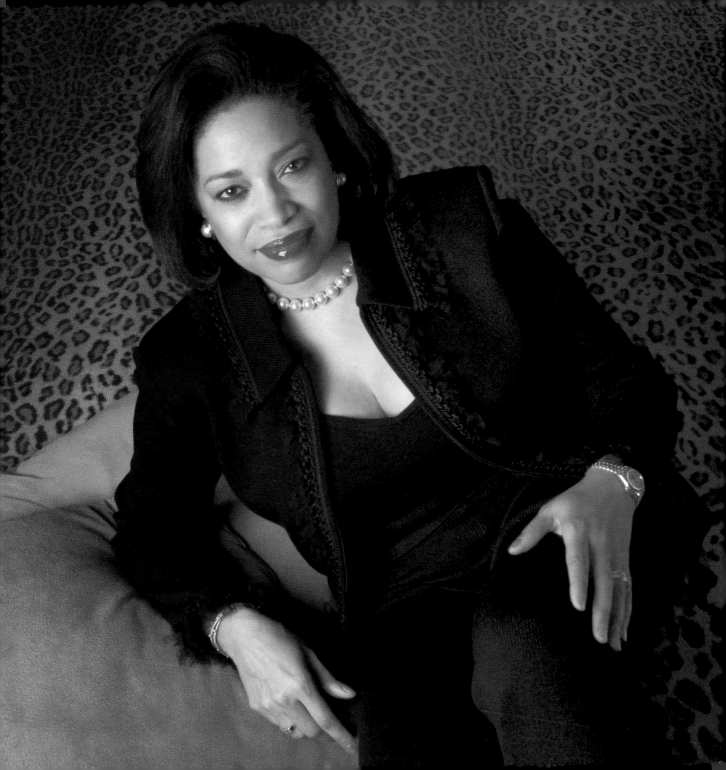

I had a hearing loss as a child, but my parents and my grandmother still
expected me to do well in school and in life. So I learned to sit up front
in class and to read lips and concentrate on people when they talk.

I returned to the station and sat down for a moment to catch my breath. Then I went to the information desk and learned that the airport was one station away and that I could get on the next train. I called my cousin's home number and reached her husband, then I settled in and waited for the train to BWI.

I think a lot of hearing-impaired people would have panicked about getting off a train at the wrong stop thousands of miles away from home. But I just adapted to the situation and plowed forward. I did what I had to do to get where I needed to be. When I finally met up with my cousin later that night, we had a good laugh at my little misadventure.

That resourcefulness and sense of calm in moments of stress is something that's guided me all my life. I remember my mother telling me, "You may not be able to count on others, but you can always count on yourself." I believe that there is nothing I can't overcome. If you miss the first train, just get on the next one.

I've had a great career for the most part, but about five years ago I had a very negative experience working for a mobile entertainment and online directory service. This was after successful careers at Pacific Northwest Bell and United Way of King County, Washington, where I served as president and CEO. I took that branch of United Way from number fourteen in size to number one, and from $54 million in revenue to $94 million. I'm very proud of that. When I worked for Pacific Northwest Bell, I started an educational relations program called the Registry that helped hundreds of children and won a citation from President Ronald Reagan.

But at the mobile entertainment and online directory service, there was a lot of adversity and meanness among the people I worked with. It was a very draining experience emotionally, and I wouldn't have walked into an environment like that intentionally. But I stuck it out, learned a lot, and became a stronger person. I was able to take the experience gained from that

job and then move on to a position as a general manager at Microsoft, and my team is respected and valued across the company.

I missed the train with that previous job, but I got on the next one, and I'm exactly where I should be now.

As I've gotten older my hearing has declined even more, and I've had to make some changes. I wear hearing aids, which was a big adjustment for me, and I've had to learn to read lips better. In meetings I've had to learn to listen and interpret, then summarize. I'll sit in the middle of the conference table rather than at the head so that I can hear everyone better. On a positive note, my hearing loss has made me more sensitive to many things I might not have been as aware of otherwise. We can't always tell whether someone has a disability or a problem. And there are many children in the world who can't afford hearing aids.

We all face challenges as we age. I choose to focus instead on the blessings in my life. I see how fortunate I am to live in the United States, where I can take advantage of the technology that is available to address hearing loss. A woman like me living in another society would be at a huge disadvantage. My husband and children are healthy and happy, and they are a very important and cherished part of my life.

I wish I could still hear all the things I once could, such as birds singing and people speaking softly, but I've adjusted and learned to be happy without them. It's still a very beautiful world. My job is to accept the blessings in my life gracefully and to pass my awareness of them on to my children, just as my parents and grandmother passed them to me.

Alpha Kappa Alpha is a sisterhood of women who have like interests and who care about each other. When we were established at Howard University in 1908, we became the first Greek letter organization founded by black college women in America. We've since grown to include more than 200,000 women from around the world, but from wherever you join the sorority, your sisters are there for you, in good times and bad. Much more than that, we are a service organization; and one of the things I've found is that through sisterly relationships you are able to give in ways you might not otherwise be able to. For the most part, we serve people who are less fortunate, although we focus on black Americans.

We are active in five areas: education, the black family, health, economics, and the arts. When I became president, I felt that we could be more effective if we concentrated on three of the five areas. So while we're still active in economics and the arts, we're more active in education, the black family, and health. Too many children still cannot read and write, and we're very actively trying to change that. We have several programs for children who don't have basic reading skills. They come from low-income areas and often don't have the skills you think are automatic upon entering school, such as phonetics. Our reading program is a part of our Ivy Reading AKAdemy. The U.S. Department of Education gave us a $1.5 million grant to operate nine after-school reading demonstration sites across the United States. Evaluations conducted thus far show significant improvements in basic reading skills. We've also built and dedicated schools in South Africa.

Our major focus in health has been SIDS (sudden infant death syndrome). The incidence of SIDS is highest in the black community, and in partnership with the National Institutes of Health (NIH) and other organizations, we conducted a conference on SIDS in 2003 and had more than five hundred people in attendance. Our partnership with NIH has expanded to address other health disparities among minorities.

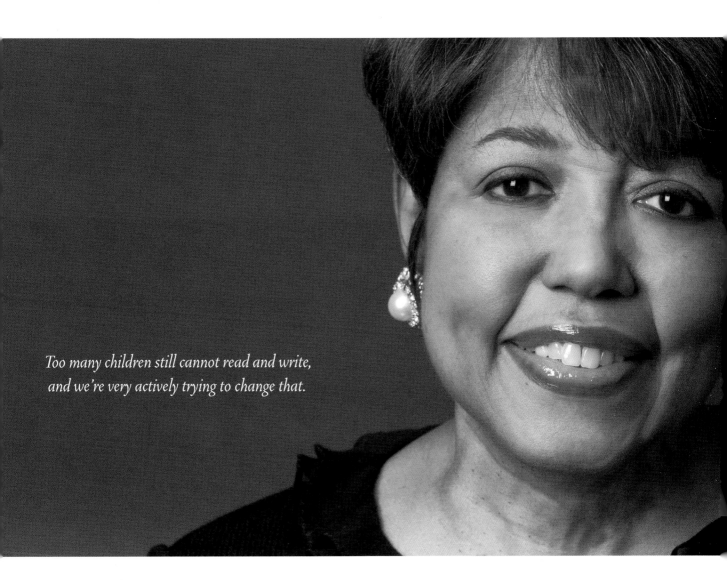

*Too many children still cannot read and write,
and we're very actively trying to change that.*

One of the programs that has been the most rewarding is the Young Authors Program for children in grades two through six. This program has turned out to be much more than we initially expected because of its wide acceptance by parents, teachers, and the children involved. It has a national review by adult authors, who select the finalists, and the essays are compiled into an anthology titled *The Spirit Within: Voices of Young Authors.* At the 2004 AKA convention in Nashville, the young finalists presented their essays, and Laura Bush came to speak to them. The stories were beautiful and very imaginative. One girl's story was about a pencil. Another girl wrote a magic book, and when you read it something magical happens at the end—the book turns into braille so that a blind child is able to read it. As a result of the anthology, the Mississippi School for the Blind had the book published in braille. Children are very creative. Some of their stories bring tears to your eyes.

I remember one Hispanic girl in particular who came to the convention. Her mother, father, sisters, and brothers were just in awe of her. The siblings were so quiet, and the parents were so proud. All of the children's parents were proud. They were meeting the president's wife and they were thrilled. We had eighteen children, and each one met Laura Bush privately before the program onstage. They were so cute. That was certainly one of the proudest moments for me and for us as an organization. The second volume of *The Spirit Within: Voices of Young Authors* will be presented at the 2006 convention in Detroit.

My mother and father were very important in my life in terms of helping to shape my values. They stressed respect, helping other people, being kind. They were not college educated themselves but wanted the best for their children, and they emphasized education and religion. I've always been involved with the church.

I learned from people in different walks of life. At fifteen I got my first job, at a currency exchange. The manager was a neighbor, and she was a stickler for being accurate. One day I was off by two cents, and she made me stay there until those books were balanced. I was almost in tears but I stayed. What I learned from that is that whatever job you have, take it seriously.

I always speak to people, but after I was elected homecoming queen, my boss in the campus post office told me, "You don't speak to everybody." I didn't feel like I had changed, but what I learned from that is that when you're elected to a position, people are watching you all the time and may have expectations that they didn't have before. You have to be conscious of the people around you.

After I leave office, I would like to become much more active in my church, St. Mark United Methodist. I'm also a member of The Links, Incorporated, and I would like to be active in other organizations. I sit on the board of the United Negro College Fund, and I plan to be active at the local level in that organization. Education is so important, and historically black institutions have played a vital role in providing opportunities for higher education for black students. I believe that education is key to improving the quality of life for our people and others in need, and I want to do what I can to help.

Nona Hendryx ◆ 60

For me, music has always been about the message and connecting with people. I want my songs to have meaning, to make people think. I want them to be more than just something to shake your booty to. My years as part of Labelle were special because we broke the traditional mold for black girl groups. We paved the way for women to sing about social and political issues rather than just about heartbreak and romance. We set a new platform.

I was a teenager living in Trenton, New Jersey, when someone asked me if I wanted to sing with a local group. I said yes, not because I had visions of being a singer—I was actually thinking of becoming a teacher at the time—but singing was something else to do, like roller skating or archery. When you're fifteen going on sixteen, it's about having fun.

In the beginning we spent a lot of time rehearsing in our manager's basement—Patti LaBelle, Sarah Dash, Cindy Birdsong, and myself. We rehearsed all the time. We started performing as the Bluebells, and morphed into Patti LaBelle and the Bluebelles very quickly, first traveling locally and then nationally. We played the Uptown Theater in Philly, the Apollo in New York, the Howard in Washington, DC. We performed in the ten-day-long Christmas shows at the Brooklyn Fox Theater and on local television. I realized we were a hit when we were on Dick Clark's *American Bandstand.* That was one of the most popular teenage music shows on television at the time, a pretty big thing.

By this time I was seventeen and still not serious about making my living as an entertainer. Naturally my parents were concerned because I was so young. My father sang in church, and my brother Shelby was in a local doo-wop group. But that was typical of African American families, and it wasn't a big deal. We weren't expected to make a career out of music. We were expected to go to college and have a white-collar career. Still, those early years and musical sounds had a big influence on me. My English teacher, Mrs. Dinkins, also had a very strong impact on my life and my music, especially on my songwriting. I like to write poetry, and she took a great interest in my writing. I kept in touch with her until she died.

Most African Americans assume you should do R&B, and most whites assume you don't do rock. I have no choice but to write and sing what I feel, to follow my musical heart, my musical voice.

So we were traveling and seeing places and meeting all these people, and it was very exciting. There were wonderful times and times that were very difficult to get through. Times when we didn't know what our next move would be. What we did have was each other and a magical blend of our voices with Patti's amazing voice up front. We had a few hits, the biggest being "I Sold My Heart to the Junkman," "Down the Aisle," and "You'll Never Walk Alone." Then we had a few years of little radio success and fewer record sales, and by this time Cindy had left.

So in 1970 Patti, Sarah, and I changed our name to Labelle. That was when we developed a whole new style and sound. Instead of the glam-princess look typical of black girl groups at the time, with beaded gowns, gloves, wigs, and tiaras, we adopted an edgy, postsixties, glamrock look, leading to an outrageous "spacelike" period of silver and feathers. More important than that, we changed what girl groups could sing. I had always written poetry, and I discovered a talent for putting words to music. I began to write songs for the group that were a mix of rock and soul and had lyrics about social unrest, politics, sexism, and racism. We looked and performed much more like a band—more like Sly and the Family Stone—than a typical girl group, and we were the only ones doing that. We were way ahead of the times. We broke new ground.

When Labelle split, I continued to write songs and went to the Mannes School of Music and studied music theory, composition, and piano—classical at first, then private jazz piano. But I soon found that I was more interested in creating my own music than playing someone else's. The writing and preproduction of the music had pretty much been my role in the group, and it was something I took to very easily.

When I went solo, I began to explore more and to work with other musicians and artists. I began to find my own voice, and that allowed me to find myself. I love connecting to people

through music, and I love all kinds of music—soul, funk, rock, rhythm and blues, Arabic, African, Indian, classical, opera. I don't fit into any of the traditional genres, and the biggest challenge for me all these years has been that people assume that you should do a particular kind of music if you're black. Most African Americans assume you should do R&B, and most whites assume you don't do rock. I have no choice but to write and sing what I feel, to follow my musical heart, my musical voice. I do what *I* want to do, and I enjoy finding new ways of doing it.

I had the opportunity to write twelve new songs for *Blue,* a theatrical "play with music" starring Phylicia Rashad and written by Charles Randolph-Wright, which began at the Arena stage in Washington, DC, and played the Roundabout Theatre in New York for several months. *Blue* was also performed at the Pasadena Playhouse in California, starring Diahann Carroll and Clifton Davis. I scored and wrote music for the film *Preaching to the Choir,* and Charles and I wrote a play based on my *SkinDiver* album, which we are workshopping and expect to have in a theater next year.

Almost everything I do is musical, but I also love playing tennis, and I've played since childhood. I enjoy working out at the gym, going to see other artists perform, and shaking my booty on a dance floor. My other passion is reading. I especially like autobiographies, and I read a lot of books on metaphysics and science fiction. I really have no regrets. I wouldn't be where I am today if I hadn't taken every step—the good, the bad, the ugly.

Cheryl Woodruff ♦ 55

President, Cheryl Woodruff Communications, LLC; Founding Editor and Former Vice President and Associate Publisher, One World/Ballantine Books, Random House, Inc.

One World was the first multicultural imprint established at a mainstream publishing house. Those of us who created One World had to take a lot of heat, from snide "black people don't buy books" clichés to threatened sabotage. But the One World launch party held at B. Smith's in New York in 1991 was the largest gathering of African Americans connected to literature, culture, and mainstream book publishing ever mounted. And in 1992 One World received the Literary Market Place Corporate Award for excellence in adult trade publishing, taking its place alongside Beacon Press, Princeton University Press, Harvard University Press, and the Brookings Institution. When I was promoted to vice president and associate publisher in 1994, I became one of the highest-ranking African Americans in publishing.

As a young girl growing up in Detroit, I loved to read. My most significant childhood memory was the day I could finally get my library card. My mother always said that once I got my library card there were always more library books on my bed than there were bedcovers.

I came of age during the 1967 riots in Detroit, and from those ashes rose one of the cornerstones of the black arts movement—Broadside Press. The founder, Dudley Randall, was the first to publish Sonia Sanchez, Nikki Giovanni, Haki Madhubuti (aka Don L. Lee), Etheridge Knight, and many others. Lee's poetry book *Think Black* sold more than 100,000 copies, a phenomenal feat for a book of poems, especially then. As a teenager, I remember being completely beside myself whenever a new Broadside Press book was being published. Growing up in that atmosphere made me always regard writing as a kind of political activism. Broadside gave me a context for the power of black writers to impact society, because those books changed our reality and helped us define ourselves.

During my first ten years at Ballantine Books, I was a consummate workaholic, and I acquired two titles that each went on to sell over a million copies: *You Just Don't Understand:*

If we are committed to preserving the best of our culture, we're going to have to take on the responsibility of discovering and cultivating the best mediums for our messages. It's our cultural responsibility.

Women and Men in Conversation, by Deborah Tannen, which spent 152 weeks on the *New York Times* bestsellers list, and *It'll Never Happen to Me: Adult Children of Alcoholics,* by Claudia Black. I acquired many other books that sold over 100,000 copies.

So I was working, working, working, and in 1991, I acquired the rights to Bebe Moore Campbell's book *Sweet Summer.* I remember getting really upset when I saw the jacket for the book. This was a coming-of-age story that takes place in Philadelphia and rural North Carolina. It was a brilliant book, and on the cover the art director had put a photograph of an African girl in a head wrap walking across the desert. I lost it. I shot off a really hot memo basically saying, "What in the heck?" I would handle something like that quite differently now, but back then, when publishing a book by a black author was a rare experience for me, I was undone. No one responded to my memo, but in fact all was in Divine order. Some months later Ballantine's president, Susan Petersen Kennedy, called me into her office. By then I had also acquired Marita Golden's early books, and Susan said that she had read my memo. She acknowledged that the cover for Bebe's book was all wrong and asked if I would be interested in doing something with Ballantine's African American–interest titles.

At that time we had five black professional women at Ballantine—senior publicity manager Beverly Robinson, sales rep Brenda Brown, designer Kristine Mills-Noble, educational sales rep Tamu Alajuwani, and me. Susan issued us a publishing challenge, which we enthusiastically accepted. That group of women, under my supervision, became One World. I always conceived One World as a multicultural list, for all people of color. The promo line for the imprint was "Many Cultures, One World."

I marvel at how many African American editors today work exclusively on African American titles. During those early years at One World, we all had to maintain our regular full-time jobs and our titles on the general list, while working on our new list. We were allowed to use existing resources at Ballantine, but that meant I had to enlist the cooperation of all the other Ballantine departments to work on what some begrudgingly perceived to be a "black girl thing." We dealt with a lot of political jealousy and hostility.

What worked in our favor was that we had Susan's backing and a sense of mission that came from my admiration for what Dudley Randall had done with Broadside Press. We weren't

doing this for ourselves. We were doing this for black people. I also had a secret weapon, my friendship with a former Broadside poet, Brooklyn activist Mae Jackson. Mae became my One World prayer partner, and we prayed every single day for God's guidance and strength. I resolved that no matter how exhausted and frustrated I was, the naysayers would never see me cry. They didn't know who they were messing with. The quickest way to get me to do something is to tell me that I can't. I was eventually promoted to executive editor then to vice president and executive editor and finally to associate publisher.

At One World, I published many award-winning and bestselling titles. By far the most difficult book I published was Johnnie Cochran's autobiography, *Journey to Justice.* That book was published in a cultural maelstrom that divided America. Black people saw Cochran as the ultimate hero and white people saw him as the devil. White coworkers confronted me in my office with heated arguments and challenged my judgment. It reminded me of the provocative climate in which the *Autobiography of Malcolm X* was published. I knew that *Journey to Justice* wasn't about me, it was about the mission. Witnessing the enormous pride that black people took in themselves by being able to count this brilliant lawyer as one of their own was worth every blow along the way.

Today people are lamenting the commercialization of black books and the difficulty of producing and selling quality writing. They are frustrated by what they perceive to be a narrowing of the marketplace. The coveted readers who created the black book boom in the 1990s have now entered a new cycle of life, with countless new mediums fighting for their attention. Indeed, there is no turning back the clock. In the twenty-first century, books will no longer be the only way to reach an audience with important information or powerful stories. Technology has created phenomenal new opportunities and exciting new ways of taking the writer to the reader.

If we are committed to preserving the best of our culture, we're going to have to take on the responsibility of discovering and cultivating the best mediums for our messages. It's our cultural responsibility. We can't relegate the duty to the hands of mainstream commercial publishers. It's naive to expect them to be Broadside Press. It's our duty to harness the extraordinary new tools available so we can give black readers the very best that black writers have to offer. It's up to us.

I went to law school by default. At the University of Michigan, I majored in journalism, and in my senior year, in 1972, the head of the department offered to help me get a job at Johnson Publishing Company in Chicago, the world's largest African American owned and operated publishing company. But Detroit is my home, and I didn't want to leave Michigan. I decided instead to try to get a job at a local newspaper. I went on an interview, and I'll never forget what the editor told me. He said that I had a very strong background but that he had just hired a black reporter. I was floored. A quota of one! This was obviously discrimination, but he was unaware of that as he proudly announced his recent hiring decision. I was absolutely devastated.

I was dating someone at the time who was in his first year of law school. He drove me to that interview, and when he saw how upset I was, he said, "You should go to law school. This is exactly the kind of injustice you should fight." It was at that moment that I decided to become a lawyer.

I enrolled at Northeastern University School of Law in Boston. Given my background, law school was a huge hurdle for me to overcome. My siblings and I were the first generation in our family to graduate high school, let alone attend college. My mother went to the ninth grade, Dad to the tenth. Even though my parents didn't finish high school, they understood the value of an education. My mother did domestic work. My father worked in a factory for thirty-five years, and he would come home so tired. He always said, "Get a good education. You don't want to do this." They may not have had the skills to guide us through the college application process, but they said we *had* to go to college. And they instilled a strong work ethic.

Many of my classmates at Northeastern University had parents who were lawyers. They grew up speaking the language of the law. I didn't, and I felt very intimidated in this setting. I had a lot of self-doubt. Being black and a woman certainly contributed to these feelings. But failure was not an option, and I devoted myself to getting out of there. I had dreams, and I had

to do whatever was necessary to accomplish my dreams. Other black students were at Northeastern with backgrounds similar to mine, and we banded together.

I graduated in 1976 and practiced law for twenty-two years, in private practice, corporate, and the U.S. Attorney's Office for the Eastern District of Michigan. I also served as president of the State Bar of Michigan. To this day I'm the only black woman ever to hold that position in the history of the Michigan bar.

Becoming a judge was something tucked away in the back of my mind, but to become a state court judge in Michigan you have to campaign and raise money. I knew I did not have the stomach for that. Federal judges are appointed by the president of the United States, and it's a lifetime appointment. That was not even in my dreams. When I was in law school and applied to be a law clerk to a federal judge, I found that they mainly hired clerks from the top ten law schools or from Ivy League colleges. I thought that if I couldn't even get a job as a law clerk to a federal judge, how was I going to become one of them? Even today, African Americans are underrepresented as law clerks to federal judges. For the most part, we become clerks to black judges, and there were very few black judges when I applied thirty years ago.

In 1996 there were three vacancies on Michigan's federal bench, but I wasn't paying close attention. By then I was the president of the state bar and managing partner of my law firm. Also, my daughter was a senior in high school. I was incredibly busy. But the chief federal judge, Julian Cook, a black man who was a friend and mentor, called that fall and asked if I had thought about applying for one of the judgeships. I said no, and he said, "Well, you should. The time is right. You're getting a lot of attention as president of the state bar. You've had a great career." Still, I didn't apply. I really didn't think I had a chance.

He called back a week before the December 31st deadline and asked if I had applied, and again I said no. In the interim, another one of our federal judges called and urged me to apply

I come from humble origins, but I have always had very high expectations for myself. I believe strongly in the power of potential.

as well. On December 31st I said to myself, "Roberts, what have you got to lose? You've worked hard. Maybe you *do* have a chance." So my secretary and I spent New Year's Eve completing the application. I delivered it at 5 p.m. on December 31, 1996.

Bill Clinton was president, and Carl Levin was the senior Democratic senator from Michigan and the person who would make the recommendations to the president. Levin's screening committee interviewed over eighty applicants and recommended ten to him. I was on that list. Then Levin culled that list to three after interviewing us and made his recommendations to the president. I was one of the three.

I was excited, but it wasn't time to celebrate just yet. My hearing was held up for more than a year for political reasons. When I headed the Wolverine Bar Association, a black bar association, ten years earlier, we came out against the Bork nomination to the Supreme Court. Michigan Republican senator Spencer Abraham believed that Republican senators would remember that I had opposed the Bork nomination, and he used that as a reason to delay my hearing. In the interim my law firm broke up, and I was reluctant to take on another job in anticipation of the appointment. So I practiced on my own.

I had good relationships with supportive Republican and Democrat lawyers in Michigan. Finally, with the intervention of an influential white Republican lawyer who raised much money for his party, I got my hearing before the Senate Judiciary Committee. I was voted out of committee and received the unanimous advice and consent of the Senate.

Senator Levin called and gave me the news, and I was overcome with joy. President Clinton signed my commission on June 29, 1998, and I took the oath of office on August 11, 1998. I met President Clinton when we had "baby judges" school in Washington, DC, and he invited us to the White House.

My family was thrilled. They had many questions about the whole concept of a lifetime judicial appointment. "Well, who's your boss?" "Who gives you permission to take vacations?" It is the ultimate in job security. To have the kind of security, independence, and authority that federal judges enjoy is an awesome blessing.

It's been wonderful, but it can be a lonely pursuit. Sometimes I have to limit contact with lawyers I consider friends if they have cases before me. Judges also must be careful about voicing opinions in public on matters that can end up in litigation, because of the risk of disqualification.

The law profession has changed dramatically from when I started practicing thirty years ago. Sometimes I would go on a deposition and be mistaken for the court reporter or the witness. That doesn't happen as frequently now to black female lawyers. Although, as a judge, I have been mistaken for one of my staff members by out-of-town lawyers who don't know me.

I come from humble origins, but I have always had very high expectations for myself. I believe strongly in the power of potential, in figuring out potential and exploiting it.

My twenty-year-old son has Down syndrome. When he was born in 1986, I thought my life as I knew it and wanted it to be was over. I was depressed for a number of months. I had an aunt named Shirley who had Down syndrome, and I had watched her mother—my grandmother—take care of her. Shirley was profoundly retarded and never formally educated. She lived with my grandmother until she died at fifty-five years old. That was a long life for someone born in the 1920s with Down syndrome. She probably lived that long because of the good care she got from my grandmother. Every day of Shirley's life, my grandmother devoted herself to taking care of her. My grandmother's only wish was that Shirley die before her.

When my son Jonathan was born, I thought I would have to give up my law practice to take care of him. What got me out of my depression was when my sister-in-law called and told me to turn on the *Today* show. I was still in bed—where I was spending too much time—and

flipped to the channel. A young man with Down syndrome was being featured. He was working as a White House page delivering packages and messages, and he was quite articulate as he talked about his work and how important it was to him. I got a completely different view of how Jonathan's life could unfold despite his handicap. I began to come out of my depression and started thinking of what my son's potential could be, just as I had always done for my brilliant daughter, Rachel. My son may not achieve what Rachel has, but his potential is great as well.

My son is doing marvelously well. He was recently showcased at a black-tie affair. He works in the mail room for a company in downtown Detroit two days a week and is in school three days a week. He is the happiest person I know, and so peaceful. Every moment of his life is thrilling for him, and he has taught me so much. I learned patience through him and how to enjoy the simple things in life. He helps me to stay in the moment.

I hope at some point to find the time to do more volunteer work. Two years ago I developed strabismus; my eyes started crossing. I was seeing double and triple. We often take our senses for granted, but it was then that I realized how much during the course of even one day I depend on my sight. I was unable to read for work or pleasure, and I was terrified. Last fall I had surgery, and it was 90 percent corrected. The entire experience caused me to focus on people who are illiterate and want to read but can't. I have since trained as a proliteracy volunteer to teach adults to read. I hope to be able to devote more attention to this in the future. It goes back to the power of potential. None of us is greater or lesser if that potential is discovered and exploited.

Despite many hurdles, I have been blessed. Having an abiding faith and hope has sustained me. I have lived the life that I imagined, and I have allowed that imagination to expand the world of possibilities for my children.

My life is proof that you never know what you have inside you until it's called upon. I know I didn't.

When my husband passed away in 1966, I was thirty-two years old, I had four small children, and I had never worked. Jimmy was my first love, my life. We had been married for twelve years when he died suddenly, and I didn't think I would make it without him.

Jimmy and I grew up in the same neighborhood in Detroit, and when I was sixteen years old we went on a double date with my brother. My dad was very strict and controlling, and Jimmy and I had to do a lot of sneaking around. Dad thought he was a general, and he ran his household like it was the military. We had to do things his way. Dad was a functioning alcoholic, and he abused my mother when he was drinking, but he was still very refined. He appreciated beautiful things and taught us to appreciate beauty. I felt loved by my father, but he was harsh, and I resolved never to marry a man who treated his family the way he treated us. I wanted someone who was kind and gentle, and I found that in Jimmy. I thought he was so handsome. Sometimes I would just sit and look at him, and my whole world felt right.

When I was nineteen Jimmy and I decided to get married. I knew my father wouldn't approve, so we eloped. My dad didn't speak to me for six months, but I was expecting that. After we were married, Jimmy returned to school to become an electronic engineer, and I dropped out of college and became a wife and mother. I was Mrs. James Banks, and that was all I wanted to be. I didn't work or pay bills, and I couldn't pursue my interest in art because I was consumed as a wife and mother. I was happy because that was the way I thought it should be.

The week before Jimmy died, he hadn't been feeling well. He went out to play basketball with his friends from work, and normally when he did that he was home by 10 p.m. But that night he wasn't. At about midnight, I started calling hospitals. When I still hadn't heard anything by the next morning, I called my parents. Although we lived in Detroit, Jimmy worked

My life is proof that you never know what you have inside you until it's called upon. I know I didn't.

in the suburbs, in an all-white area, and I was worried that he had been stopped by the police and taken to Jail. My mom came over and got the kids off to school. I was too worried to do it.

They found Jimmy later that morning in his car in the Sears parking lot. I think he was trying to get back to be with us even though he felt ill. It's still hard for me to talk about it, even to this day. Friends and family tried to console me, but I was in so much pain and inconsolable. I put up a wall and closed myself off from everyone except my mom and my brother. I regret doing that now. But at the time, there was nothing anyone could say or do to make me feel better.

Several days after the funeral, I was still very depressed, and my oldest daughter came to me and asked, "Who's going to take care of us now?" I said, "I am." She looked at me doubtfully and said, "But you don't know how." That shook me. I quickly snapped out of my fog, squared my shoulders, and said, "Oh, yes, I do."

From that moment on, I was on a mission to rebuild our lives. Even though my husband was gone, no one could raise my children better than me. I sold our house and the car Jimmy died in. They brought too many memories of unfilled wishes that I had shared with Jimmy and of the life we would have lived together. I went from being Mrs. James Banks to being Miss Mom. The children gave my life meaning and purpose.

I eventually went to work because our income was running out. I drifted for a while, working in a fabric store and at other odd jobs. That was not fulfilling, but it was all I thought I was qualified to do. Then my daughter got financial aid for college, and a lightbulb went off in my head. I thought, Why not me, too? I was forty years old by the time I enrolled in Mercy College in Detroit to study art. I didn't know what I would do with it. I just knew that I loved art, always had.

My professors were very encouraging. They told me that I was very talented. I was blown away by that. In my second year, I was encouraged to apply for a grant that was open to minority students to work at a hospital as a medical illustrator over the summer. I got the grant, and

when summer was over the hospital asked me to work full-time. I created illustrations for medical journals, educational and promotional pamphlets, and brochures. Eventually the hospital formed a medical illustration department and made me the senior medical illustrator. I felt so fortunate to get that job and to be able to take care of the kids doing something I loved.

Years later, when I was about fifty-eight, I was looking out over the city from my high-rise apartment and thinking: Everyone's okay. My children are able to take care of themselves and contribute to society. Now it's time for me.

Around this time, I met Leroy, the nicest man, and we had a whirlwind romance. We met in October, and he asked me to marry him in November. We got engaged and got married in May.

This was a very different kind of love from my love for Jim. Leroy was a Jewish man ten years my junior and extremely intelligent. Intelligent men are sexy. I used to call him my young stud. But my kids thought I had lost my mind. They wanted to hire an investigator to check Leroy out. To calm everyone down, we drove to Washington, DC, where three of my children were living, so they could see why I loved him.

Six months after we got married, Leroy had a massive heart attack. He went into a coma, and when he woke up he was brain damaged. He didn't know me. He couldn't stand up. He was not the same man. We moved him to a nursing home, and I was there every day for the next year and a half, until he died.

So here I was, once again a widow and wondering what to do with my life, how to go on. By this time I was sixty. I thought, I need to get away from Michigan and all the memories. Although I had a wonderful career as a medical illustrator, I decided to start over—again. I retired early and moved to Washington, to be near my kids.

I have since built a wonderful life here as an artist. I set up a studio in my home overlooking the Potomac River, and I handcraft one-of-a-kind pieces of jewelry, redesign old jewelry, and draw portraits on commission. I love what I do. Best of all, I'm near my children and grandchildren.

I've learned that you should never stop growing and learning. No matter how trying the circumstances of your life, you have to keep your mind and heart open so that you can accept all the beauty that life sends your way. Who knows what tomorrow will bring for me?

Ruby Dee ◆ Early 80s ACTOR, AUTHOR, ACTIVIST

I don't know what it is to live in an environment that is not tense. When I was six I had epilepsy and I was afraid. I outgrew that, but as I got older there were lynchings and picket lines and marches and funerals and sometimes so much violence you couldn't go to work. I remember fighting to get into Hunter College High School. I remember being arrested for protesting. I didn't *become* an activist. I just was one.

We struggled so much when I was growing up, but we had lots of fun, too. I learned to shoot a bow and arrow and went to target practice. We took music lessons and played the piano at church. Mother sewed, and I used to make dolls. A neighbor taught me how to knit. We made Christmas baskets and had parties at the armories. Mother rented rooms in our home, and she would sublet them sometimes to entertainers when they visited New York, since black people couldn't stay in hotels.

I had a temper. I was always fighting other girls. We fought in the street, on Seventh Avenue near where we lived and went to school. I was no bigger than a mosquito, and I remember beating up people bigger than me. Many of my fights took place after school, to help my baby sister.

It was the only kind of life I knew.

When Ossie [husband Ossie Davis] died, I was in New Zealand working on a film called *No. 2.* He was in Florida working on a film called *Retirement.* We had been married for more than fifty-six years, and I didn't know what I would do. Fortunately they held the film up for me. Now I'm involved with getting this book out of my husband's speeches and writings. We have also come out with an audio of our joint autobiography, *With Ossie & Ruby: In This Life Together.* We wrote the autobiography together and a few years later read it together for the audio, which came out in 2006.

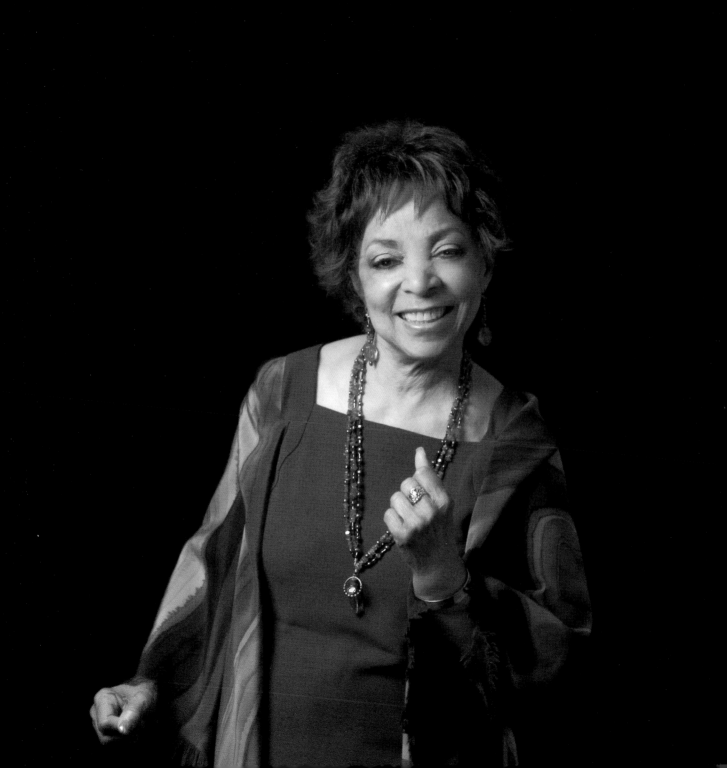

I've been writing since I was nine years old. I won prizes for my poetry. My mother read to us and helped me to appreciate poetry. She would send my poems to magazines and newspapers like the *Amsterdam News*. But I never thought of myself as a writer, until one day Ossie told me to acknowledge that I'm a writer. I've written screenplays, weekly news columns for the *Amsterdam News,* and *My One Good Nerve,* a collection of poems and short stories.

I've always been into a variety of projects. I'm learning that it would be easier to try to finish one thing before I move on to something else. But often "something else" is ready before I'm ready to move on. That's exciting, but I'm trying to relax and let things come as they may.

My sense of humor gets me through all of this. The other day my daughter said, "Ma, you're so funny." My children are what I'm most proud of, the respect that they have for other human beings. They grew up in the traditional struggle. We took them to picket lines and marches. My son, Guy Davis, plays blues guitar and travels all over the world—England, Canada, Australia. Hasna is an educator and a writer, and my eldest daughter, Nora, runs our company, Emmalyn II Productions.

Things are much better for black actors now. The NAACP and Urban League, the Thurgood Marshalls and other legal minds, challenged racism, and things began to change. Ossie and I did whatever we could to help them. We did the groundwork for young people. We widened the escape hatches, and there are more kinds of roles for black actors these days, with fewer stereotypes. We're doing films now that are more acceptable to ourselves. We've had black films and books for many years, but they were not part of the mainstream offering. Now actors are getting Oscars and working for the big companies. One of my proudest moments was when Ossie and I were awarded the National Medal of the Arts in 1995 from President Bill Clinton. We joked about how we almost didn't go to the ceremony at the White

House because we thought somebody must have made a mistake and forgot to look at our dossiers. But it's nice to be recognized for your work.

If I hadn't become an actor I think I would have been an antiques dealer. I love antiques. Or I might have run a watch shop or been an artist. I used to paint, and I have a few things hanging around the house.

It's still a contradictory world, despite all our technological advantages. We're finding more and more technical ways to do less and less. We're selling ourselves too cheaply. And the things happening to young people today, with all the violence, drugs, and sex on the screen and in music. We parents and elders have let too many negative forces come into our homes and snatch the minds and hearts of our children, dictating what to look at, what to think, what to eat, how to dress, and where to place our allegiances. We thought we had won something now that the doors have been opened, but they stole our children.

We need to take our children back and replace the negative forces around them with compassion for some of life's most urgent agendas, such as education and world peace.

I've always been into a variety of projects. I'm learning that it would be easier to try to finish one thing before I move on to something else. But often "something else" is ready before I'm ready to move on. That's exciting, but I'm trying to relax and let things come as they may.

Toni Fay ◆ 59

RETIRED VICE PRESIDENT, CORPORATE AFFAIRS, TIME WARNER INC.

At Time Warner I thought of myself as an activist working from inside the corporation. I felt blessed to have achieved a notable level of influence, and I was determined to use my position and power to advance African American businesses, communities, and people. I had an opportunity—and an obligation—to build bridges of cultural understanding across lines of race and ethnicity through the innovative use of media and the resources of a large company. Taking risks was essential, but I felt I was doing the right thing and that I possessed the skills and abilities to accomplish my objectives.

At Time Inc., before the merger with Warner Communications, I developed a reputation for getting things done. I had launched the company's community relations and minority business development programs and published the first social responsibility report. When the company announced its merger with Warner Communications, I seized the opportunity—in an environment then characterized by backbiting and jockeying for position—to introduce programs that would make the agenda of the new company more culturally inclusive.

My first major project in this changing environment was *Songs of My People,* a photography project about the contributions of African Americans to American culture. The project was conceived by New African Visions, a not-for-profit organization committed to the encouragement and promotion of visual and literary projects created by African Americans. *Songs of My People* included a coffee-table book, an international exhibition, music, and video. In the midst of a well-publicized and contentious merger, I persuaded the book division then owned by Time, Little, Brown and Company, to publish the book. In 1990 more than fifty of the nation's premiere African American photojournalists were assigned to cross the nation and capture the diversity of the black experience on film and to come back with a balanced and accurate look at a people much maligned and often misunderstood. The project was a first for our book division and a first for many of the photographers, some of whom had never been published.

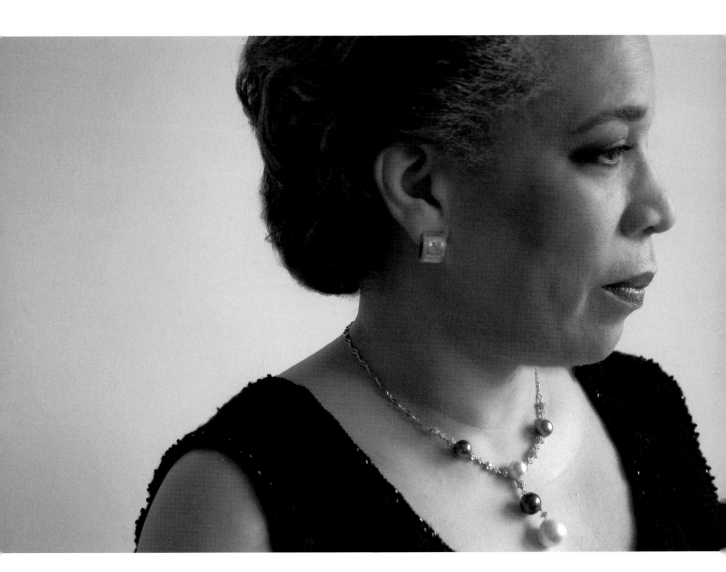

I found additional resources, with the help of Jerry Levin (then a vice chairman of Time Warner), to fund the exhibition, and we partnered with the Smithsonian Institution and the U.S. Information Agency to tour the exhibition to more than 110 U.S. cities and 150 posts in Asia, Africa, Europe, Latin America, and the Caribbean. The project traveled throughout the world for six years and opened the door for more photo books by black people.

In 1995 I pushed the envelope further by developing a photographic exhibition titled "It's US: A Celebration of Who We Are in America Today." "It's US" posed four questions: What does it mean to be—and to become—an American? What traditions and dreams do we share? What challenges prevent us from living in harmony? And how can we meet those challenges? The exhibition was supplemented with a strong educational component, including guides for teachers and a poster on U.S. immigration. In partnership with the American Library Association, "It's US" traveled in both photograph and paper format to 130 cities, 5,000 schools, libraries, and community centers. It sparked a nationwide dialogue about the challenges, realities, and dreams that all Americans share.

In 1997 the actor Edward James Olmos, who had heard of the success of *Songs of My People,* approached me to "sell" to our operating companies a project called *Americanos: Latino Life in the United States.* The project consisted of a book, exhibition, and HBO documentary and was a celebration of Latino culture through photography, film, music, and the printed word. I had to persuade the various divisions of Time Warner to commit their resources to the project, which they considered high risk and "not a popular idea." We did it in Spanish and English, and it too was a breakthrough project.

I was always aware that I had to prove myself and defend my work. I was a change agent—the conscience of the company. I was expected to understand the majority culture and to translate the minority culture to white colleagues.

I was particularly proud of helping to realize *Half Past Autumn,* featuring the art of photographer Gordon Parks, prior to the acquisition of Time Warner by AOL. This was another nail-biting project, given the dynamics of this ill-fated merger.

All of these projects were considered to be outside my corporate portfolio by my bosses, and they were a test for me and the company. I was rewarded for thinking outside the box and executing successfully, and in 1993 I became the first African American vice president and officer at Time Warner.

In addition to taking on projects to advance cultural understanding both internally and externally, I still had to deliver on what my bosses considered my portfolio. In the education arena, I developed a groundbreaking literacy initiative called Time to Read. In three hundred locations across the country, Time Warner staff was trained to teach students and adults to read in schools, libraries, prisons, churches, homeless shelters, and community centers. We used our print, music, and video products, supplemented by a bulletproof educational curriculum. I received an award for the program from President Ronald Reagan. Today it's the largest corporate-sponsored literacy initiative in the country.

As the "go-to senior black person at the company," I also fulfilled an informal role. I mentored and coached many black executives and referred hundreds for jobs in the company. I maintained an informal network of employees through meetings and social gatherings. One outcome of those informal sessions was a strategy to encourage each company division to adopt an equity stake in a black business. At one point in Time Warner's history, the company had positions in the cable network BET, in *Emerge* and *Vibe* magazines, and in Amistad

Books. To the company's credit, I was given a lot of autonomy, but I also put in long hours and had little free time and a limited social life.

I know that my drive and work ethic came from my parents. Both of them were college graduates who believed that my brother and I had two responsibilities while growing up: to do well in school and to achieve more than they did. My parents' motto was to advance the race, be a role model, and excel. I grew up in the segregated Northeast, and although I'm a native New Yorker, my parents moved to the newly redlined community of Teaneck, New Jersey, and I attended junior high and high schools that were 99 percent white. I attended white colleges. I learned quickly how to negotiate for a level playing field.

I held senior positions both in government and in the not-for-profit sectors, but I believe that my most rewarding position prior to joining Time Inc. was with the National Council of Negro Women. I reported directly to Dorothy Height, and from her, I learned how to execute programs, work globally, and write convincingly. Most important, I gained a respect for the power and influence of organized constituencies and the black club movement, a phrase coined in the early 1900s for the black sororities, fraternities, and other associations formed due to segregation.

Although I experienced success at Time Warner, I was always aware that I had to prove myself and defend my work. I was a change agent—the conscience of the company. I was expected to understand the majority culture and to translate the minority culture to white colleagues. Many people in corporations had not worked with, or been supervised by, a person of color. It was a balancing act.

I have little patience with black people who are in a position to positively affect the lives of other black people and choose not to do so. They adopt the attitude of "you get yours" and work overtime trying to fit in to make sure they keep their jobs. Risk taking is a part of leadership—embrace it, even to the point of being willing to quit your job. You can always get another. I was rewarded for expressing diverse and constructive views. It demonstrates integrity. I enjoyed a reputation of being tough but fair, willing to solve problems, ready to access opportunities for others, and open to sharing what I knew to advance an idea, person, or cause. Once you've earned power, be comfortable and confident enough to exercise it.

Louise Rice ◆ 64

NATIONAL PRESIDENT, DELTA SIGMA THETA SORORITY, INC.;

RETIRED COLLEGE PROFESSOR

Benjamin Mays, president of Morehouse College, is credited with saying that "the tragedy of life does not lie in not reaching your goal. The tragedy of life lies in having no goal to reach." I've used that quote for inspiration over the years. I always felt that I was limited only by the boundaries I set for myself. If it could be done, I could do it.

My father and mother separated when I was two, but my mother always pushed me to excel. Although she was a cook with only a sixth grade education, she set high standards for me and taught me that I had no limitations. When I told her I wanted to go to Tuskegee Institute, she said, "I'm willing to send you where you want to go, if you're willing to do the work."

Education is important to me. I feel that people who have knowledge and skills are in a better position to improve their lives. I got my PhD because I thought that was the next step after a master's, and I always wanted to be the best. I also knew my mother had a hard time because she had no degree or diploma. She was a smart woman, but she was a cook all of her life. She would tell me, "You don't have to be a cook. I want you to have a profession." In high school, my senior English instructor always said, "Reach for the skies." I wanted to be a teacher because I thought that by being a teacher I could help others be all they wanted to be. You can reach a lot of people in the classroom.

My ninth grade high school homeroom teacher was one of my biggest inspirations, and we are in contact even today. I remember her teaching us what we should and should not do. The boys would hold our hands as they walked us to and from school, and Miss Johnson would look out the window of her classroom and point her finger at us.

I joined Delta Sigma Theta in 1961, when I was a student at Tuskegee, and I have been an active member ever since. When I went to Tuskegee, I didn't know a lot about sororities. Someone told me the Deltas had the highest grade point averages and received the most

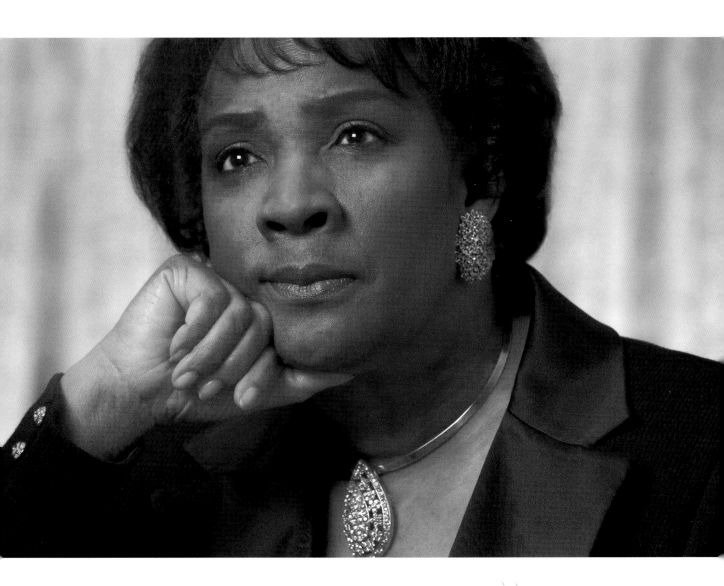

awards. I liked the way they carried themselves and saw in them an extension of myself. So I decided to pledge.

I climbed slowly through the ranks, serving in several offices in my alumnae chapter in Augusta and as a regional director before going on to win national office. I believe I won because members looked for the Delta experience—a proven track record for dedicated service and past achievements. And I always did what I said I was going to do when campaigning.

The biggest challenge as national president is dealing with a lot of personalities, especially during membership intake. Parents are trying to get their daughters into the sorority, and on some campuses the administration has capped the number of new members. They may have three hundred qualified women but only fifty slots for new members. It's very competitive. Parents often don't understand why their daughters don't make it, and I take the time to listen and explain the process. I tell them not to take it personally and to try again in the future.

Although I didn't know what sororities did when I went off to college, I think that now more than ever before students are very aware of what sororities and fraternities are all about, even before going to college. We're very active in their communities, and they begin to iden-

Many organizations do not reach out to the black community the way black sororities and fraternities do. So it's not surprising that when these young people get to college, they want to be a part of our experience.

tify with us very early on. Many organizations do not reach out to the black community the way black sororities and fraternities do. So it's not surprising that when these young people get to college, they want to be a part of our experience. That's encouraging.

My family is also important to me. My two sons and three grandchildren keep me young and give me something to look forward to. My three-and-a-half-year-old granddaughter wants to travel with me. She calls me at times and her parents don't even know it. It's a blessing to have family and friends there for you.

Besides family, God and prayer are what get me through the difficult times. I always ask for direction each day to help me make decisions. I depend on my faith. Little bothers me, because I always feel the answer is with a higher power.

When my youngest brother, Phillip, committed suicide at age twenty-two, I was a young, single mom. My daughter Nikko was two, and we came in from the babysitter and received a phone call from my mother. She was on the line, yelling, "He did it! He did it!" I asked, "What are you talking about?" She said, "He hung himself." It didn't register at first. I thought, This is not true. I thought, Okay Lord, I have to get myself together.

I went to my parents' house, and by the time I arrived, the coroner's people were there, so I never saw him hanging. My parents had come in from work and saw him, and my mom was hysterical. My dad was trying to be the strong black man, but you could see the strain in his face.

What I found out later was that they had kept so much from me about my brother. Apparently Phillip started talking about suicide when he was nineteen, and my mother took him to a psychiatrist. My older brother, Cornelius, had already left home, and when I left to go to Hampton University, Phillip felt a sense of abandonment. My parents never told me, and I never knew my going away to school affected him.

The secrecy got to me, but I couldn't be upset with my parents, because that generation is different. I knew they had done what they thought was best at the time. My whole focus was to be strong and help them get through this. I had lost a brother, but my mother was going through so much pain that I didn't have time to think about myself. She was depressed and couldn't understand it. She probably blamed herself to a point. Like most black men, my father kept his feelings bottled. He probably had his private moments.

Almost a year and one month later to the date, Cornelius choked to death. He was thirty years old. I was leaving day care with Nikko, who was three by this time, and she said, "Your brother's dead." I said, "You mean Uncle Phillip is dead?" She said, "No, your brother is dead." Then when I got home, I received a phone call from a friend who said, "Sorry to hear about

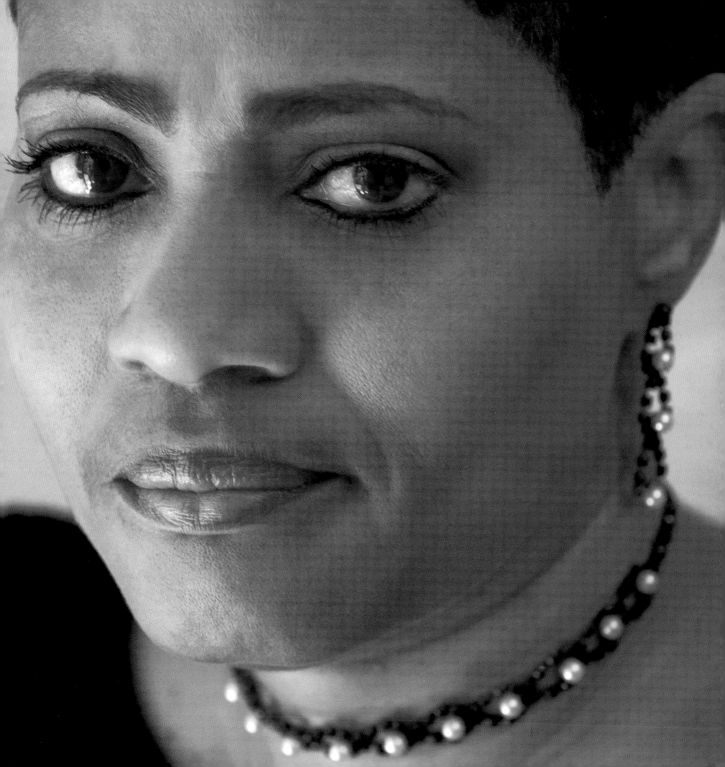

My brothers let peer pressure and society dictate
their behavior rather than family. In contrast,
I chose to be in control of my destiny.

your brother. I hear he passed away today." I said, "No, that can't be." When I called my mother, she knew nothing about it.

Nikko must have had a premonition, because my parents came over before long and told me that it was true. My brother was dead. My father said he had to go to Prince George's County Hospital to identify the body. I didn't want him to go alone, so I told him I would go with him while my mom stayed with my daughter. You say, This is not true, this is not happening. The whole time I'm driving to the hospital, I was praying that it wasn't him. My father went in before me, and when he came out, I knew. My brother had had a lot of problems with substance abuse when he was growing up, although by that time he had two young sons and we figured he was doing okay. But he and Phillip were inseparable. They were not only brothers but had become best friends just before Phillip died. I think that Cornelius was still mourning for Phillip and didn't have the will to come back. It's like when a husband and wife are together a long time and one dies right after the other.

I will say that both of my brothers had low self-esteem. They did not realize that they had a wonderful role model in our dad. He worked two jobs to make sure we had everything we needed and more. He was there to give us love and discipline. But growing up as a black man in America can be a challenge, and somewhere along the line there was a disconnect. My brothers let peer pressure and society dictate their behavior rather than family.

In contrast, I chose to be in control of my destiny. Both of my brothers were needy, and they pulled so much from my parents. That made me want to be independent and stronger. I pushed myself to get through college and made a lot of sacrifices to please my parents.

After my brothers died, my parents and I became legal guardians to Cornelius's sons, Anthony and Neal. Anthony was three, Neal was two. My mom saw this as a second chance from God. They lived with my parents for a few years and then they moved in with me. I had been married once, before my brothers died, and after their deaths I married twice more and was involved in two serious relationships. My friends used to call me the terminator, because I would get rid of guys in a flash. But my relationships suffered because the men could not handle the responsibility it took to raise my nephews and two daughters. Raising children is hard. You have to be committed to making sure you are there for them. I sacrificed a lot to keep my nephews, but I have no regrets. It had to be done.

When I see siblings who don't get along, it brothers me, because I don't have my brothers. It's such a waste for siblings to fight. My father took sick recently, and I didn't have siblings to help me. It literally wore me out. A lot of times I sat in my car alone and cried. That's why when I see sisters and brothers who don't get along, it makes me mad.

I thank God for seeing my family through these two great tragedies. My dad is recovering, and my mom has slowly come out of depression as her faith in the Lord grew stronger. Jesus is the rock that I stand on. If he had not been by my side throughout all the trials and tribulations, I too might have given up on life. Instead I have become a stronger woman through the tests I survived, and I finally found a God-fearing man who gives me and my children unconditional love and understanding.

The man I married was every girl's dream. We were together for twenty years, had one child, and it was a good marriage during most of that time. Larry was a dentist and I was a teacher. He was a devoted husband and father, and we took nice family vacations.

But it was difficult raising a child with both of us working full-time, and after thirteen years the marriage went south. He would say the problem was me; I'd say it was him. Marriage is never easy. You both have to work on it when it slacks, and you have to work on it together. There were times when he wanted to facelift the marriage but I didn't, and times when I wanted to work on it but he didn't.

We also tried a marriage counselor, but I didn't like him, and after we dropped the counseling, Larry said, "Why stay married if you don't want to see the counselor?" I still didn't want a divorce. Marriage is for the children, and everyone was telling Larry not to leave for the sake of our son. But Larry had changed a lot by then. I think he stopped loving me and fell in love with someone else.

He eventually left, and we separated. That period was emotionally devastating for me, and I lost about twenty pounds. It was especially difficult for our son. Ezra was about fifteen years old at the time, and he missed his father terribly. He didn't understand what was going on.

I didn't understand either, really. After thirteen to fourteen years of marriage, I had to start all over again? I was confused, angry, depressed, and filled with questions. Was it a real marriage or were we just going through the motions? Why was it so easy for him to walk away after so many years together? When the chips are down nowadays, people say "I'm out of here" much too easily.

I sat around the house and cried all the time. My mother called them "pity parties." Divorce is such a long process of mediation, going to court, and seeing the lawyers, and I just couldn't shake it.

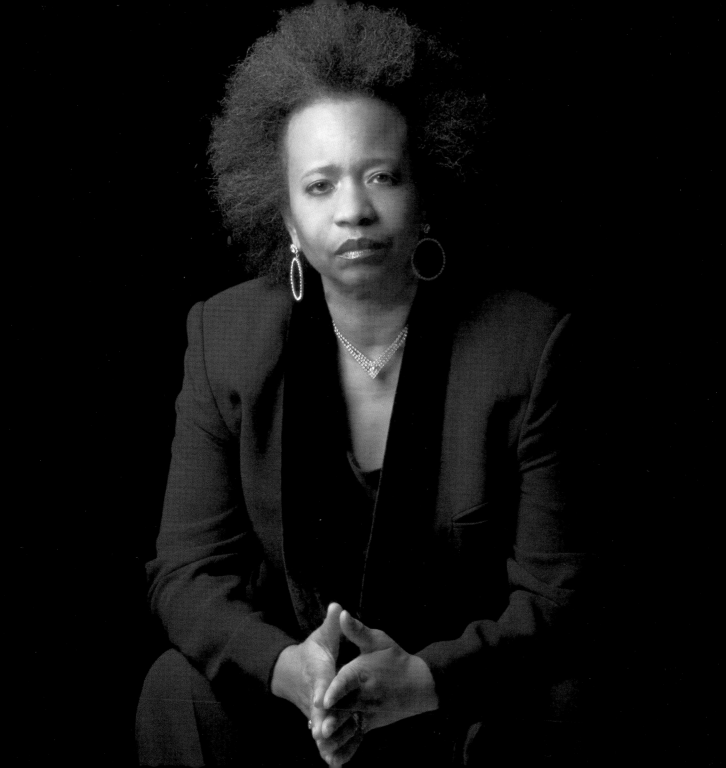

We finally signed the divorce papers last spring, and the judge said, "Congratulations." It was like something hit me. I realized that the marriage was *really* over, that Larry was not coming back. And that's when my life began to open up again.

Something about signing the divorce papers allowed me to accept that there was nothing more I could do to save the marriage and that I needed support. Fortunately I did have the support of my family and friends, and eventually I began to see the light at the end of a long, dark tunnel. I began to realize that I could now be the person I truly wanted to be.

It took me a while to get back into the dating scene. I never had trouble meeting men before I got married, but after the separation I doubted my attractiveness to men. I thought, How am I going to get back out there and start dating again at my age? I would lie around on the couch in the sitting room off the bedroom and watch television all day long. My mother would come over and tell me, "Carolyn, you need to get up off that couch and go get yourself a man."

I finally took her advice. The first man I dated after Larry had moved on was someone I had known for years. In fact he had been my father's best friend until my father passed away several years ago. This friend was much younger than my father, about my age, and my father brought him home when I was very young and introduced him to me, trying to fix us up.

But we never got together until after the separation, and he took care of me financially and emotionally during that difficult time. My self-esteem was very low, and this man would tell me that there was nothing wrong with me. He told me that I always had a personal style that attracted men and that I hadn't lost it. I think it is very important when you come out of a marriage to have someone around who is interested in your well-being.

I later met another man, and we've been together going on three years now. He's been good for me. In the beginning, he took me out to dinner and dancing. We aren't as active now, but we've grown very close. Another man, an older man, also likes me. And a younger man in his

One of the reasons that I think I attract men is because I have a lot of tolerance.
I don't set my standards impossibly high.... I also think men find my hair attractive.
It's natural and free.... I'm comfortable with who I am, and men can sense this.

thirties calls a lot. We met at a club. But I'm not interested in them. I don't have the energy for more than one man now that I'm older and, besides, I don't want to do that to the man I'm dating.

One of the reasons that I think I attract men is because I have a lot of tolerance. I don't set my standards impossibly high. I've dated bus drivers, gardeners, doctors, and PhDs. I look for attraction, personality, good conversation, and common interests. There's no formula for meeting men. You just have to know yourself and what you like. I also think men find my hair attractive. It's natural and free. I don't change my style a lot. I may update it, but I'm comfortable with who I am, and men can sense this.

Divorce attacks your self-esteem, but I'm back to being my old self now, maybe even better. In fact, at one point when I was talking to my ex as we left court, he looked at me and suddenly said, "You're back, aren't you, Carolyn? And stronger than you were before." He could see it because of the way I was dressed and my attitude. I said, "I had to become stronger after what I went through with you."

Living like a single woman again makes me feel younger. My son is grown now, and I'm only responsible for myself. Children want you to stay in that previous role, and when Ezra comes home from college, he gets a little annoyed because I'm not running around the house cooking and doing things for him like I used to. Sometimes I'll go into the kitchen and pretend to be busy fixing something just to make him happy.

I look at dating differently now than I did when I was younger. Back then, the ultimate goal was to marry well and live happily ever after. I no longer look for the knight in shining armor or the storybook romance. I look for dependable men who can give me companionship, understanding, and tolerance. Also, the men I'm seeing now are divorced, and it's tastier to get a seasoned man who has been through marriage. They treat women better because they have more knowledge about us. They've "been there, done that." They know exactly what they want in a mate. And now so do I.

My intense interest in art began on my first day in kindergarten. I was frightened and did not want to leave my mother, and I cried. Fortunately I had a wonderful teacher who gave me some crayons and paper and encouraged me to draw. Little did I know at the time that art would become my vehicle for self-expression.

My parents were very supportive of my interest in art and encouraged me. My high school instructor was really instrumental in encouraging me to seek a career in art and to enroll at Carnegie Mellon University in Pittsburgh. After college I married a man who is also an artist, and we decided to move to New York City to pursue our careers in art.

It was during the civil rights movement that I became serious about painting. I had a lot to say about the racial climate of this country, and I chose to express it through my art. As I continued my studies in painting and drawing, I made a concerted effort to seek out a black instructor, because I had never had a black teacher while living in Pittsburgh. Norman Lewis was a well-established black artist at the Art Students League in New York, and he encouraged me to strengthen my composition skills so that I could build my work on a firm foundation. Later, at the suggestion of a friend, I became interested in printmaking and studied at the Bob Blackburn Printmaking Studio in New York. Printmaking enhanced my painting and gave me a way to create more affordable art. It took a while for things to evolve to a point where I eventually began exhibiting at the Acts of Art Gallery in Greenwich Village. There I met Judge Bruce Wright, who became one of my biggest collectors.

My work is figurative, and I use social commentary as a means of expression. Travel had given me a broader perspective of the world and of the black man and his culture. Each time I traveled to a different country, I would return home to do forty paintings from photos and

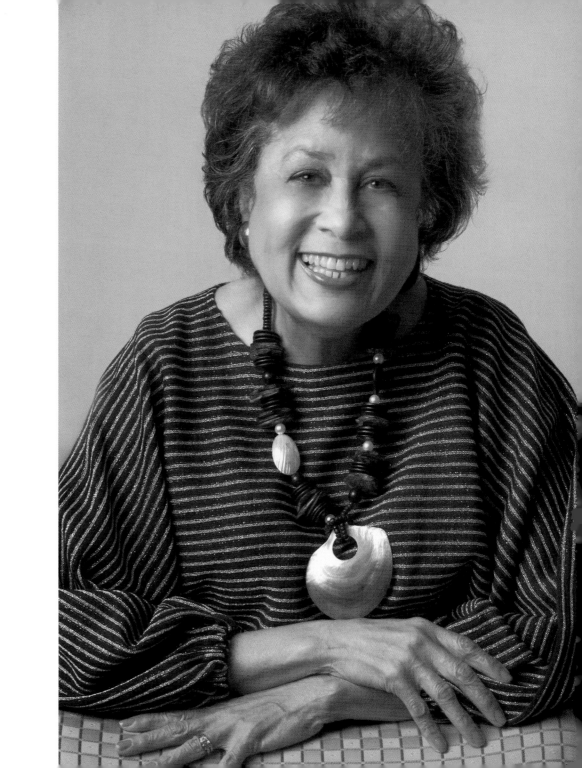

sketches I had created while away. Some of the places I have traveled to are West Africa, Brazil, Mexico, Portugal, Venezuela, and many Caribbean islands. Traveling to countries close to the equator changed my color palette. I began to use bright, intense colors as opposed to the gray, somber tones that I had been accustomed to using.

Another source of inspiration for me is books. One of my favorite authors is Zora Neale Hurston. I was introduced to her in 1988 when the book *Their Eyes Were Watching God* mysteriously appeared on my doorstep. I began reading the book immediately and was completely enthralled with her work. After reading all of her books, I managed to complete over 265 monoprint interpretations, which were the beginning of my "Images of Zora" traveling exhibit. There is sort of a correlation between the two of us. We were both young when we first came to New York to continue our education and pursue our interest in African American folklore. Recently I completed the artwork for the adaptation of one of Hurston's children's stories titled *The Six Fools.* This was my first children's book, and it was a very challenging but rewarding experience.

Hopefully as you grow older and develop more of a reputation, it becomes a bit easier. One of the highlights of my career was being invited by the Virginia Commonwealth University in Doha, Qatar, to exhibit and teach printmaking there. The eighteen-hour trip from New York to Qatar was grueling but exciting. I was the first visiting African American

woman to exhibit at the university, and a young friend who teaches there was responsible for bringing me over. What a memorable experience! The trip occurred during the war in Iraq, and naturally my family was concerned for my safety. I am glad that I took advantage of the opportunity, and when I returned home my family was very happy and relieved to see me back on American soil.

I am a cancer survivor, and that experience has made me more aware of my mortality. I do not see myself stepping back to relax. After a life-altering experience such as that, a new perspective occurs, and you are so thankful for every day that presents an opportunity to work. I realize how blessed I am.

It was during the civil rights movement that I became serious about painting. I had a lot to say about the racial climate of this country, and I chose to express it through my art.

Marilyn Gaston, MD ◆ 66 FORMER ASSISTANT SURGEON GENERAL; FORMER DIRECTOR OF THE BUREAU OF PRIMARY HEALTH CARE, U.S. HEALTH RESOURCES AND SERVICES ADMINISTRATION; REAR ADMIRAL, U.S. PUBLIC HEALTH SERVICE

The Little Engine That Could is a classic children's book that's still popular today, and one of the refrains in the story—"I think I can, I think I can"—plays in my head over and over whenever I face challenges. I think to myself, "I have a voice. I can do it."

As director of the Bureau of Primary Health Care, I was responsible for improving the health care of 12 million poor, underserved, and disadvantaged people in the United States and its territories. It was always a challenge to defend the bureau's budget to Congress, given all the competing priorities. And I—a black woman from the projects—had the responsibility of going up to Capitol Hill, the seat of power, and doing just that. When I first became the director, the bureau's budget was $1 billion. By the time I left it was $5 billion.

The women in my family were fierce women, and I think my perseverance comes from them—my godmother, grandmother, aunts, and especially my mother, who always said to my brother and me, "Don't give up, don't give out, and don't give in." We lived in Cincinnati, Ohio, in the projects, but I was surrounded by love, encouragement, and wonderful role models.

My mother was the first in our family to graduate college. She was also the first black medical assistant/secretary in the Department of Pathology at the Cincinnati College of Medicine. She worked for George Washington Carver as a medical secretary.

My grandmother ran a pie business. She had ten trucks, and she supplied the hotels in southern Ohio with her pies during the Depression. The train tracks ran in back of her house, and she would feed the hobos that hung around the tracks from her kitchen.

My godmother established the first home for black elderly in Cincinnati. She also helped integrate the public pool in our neighborhood, alongside civic groups such as the NAACP. My godmother would take about six of us black kids to the pool every Saturday, and all the whites would jump out and run to call the police. But my godmother kept doing this until finally they gave up and allowed us to stay, even before the pool was officially integrated.

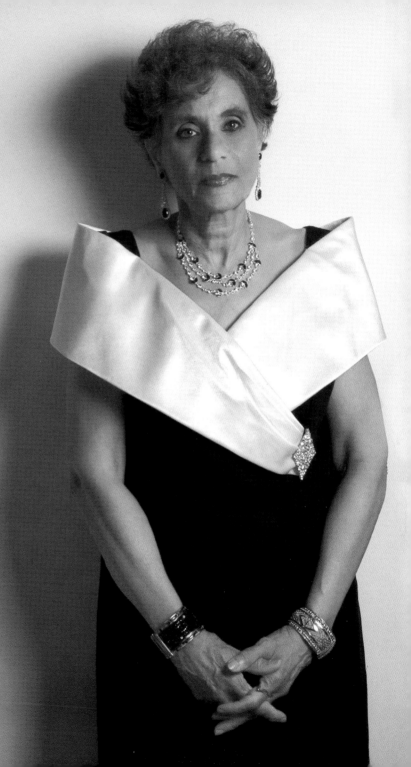

As I got a little older, I learned more and more about the lack of good medical care in poor black communities, and by the time I graduated medical school my desire to help my mother had become a desire to help my people.

Many black women have stories like this. We work hard to lift ourselves up, then we reach back into our communities to help others still left behind. Black women have done this for centuries. I sometimes think of us as modern-day Harriet Tubmans. You know, the woman who escaped slavery and went back to the South again and again to help others escape. Instead of rescuing our people from slavery, now we're rescuing them from things like lingering racism, poverty, disease, and poor medical care. I always remind women that, as Becky Bertha states in her poem, "Harriet freed three hundred people but first had to free herself."

My mother, grandmother, and godmother were all dead from preventable diseases by age sixty. When I was about twelve or thirteen years old, my mother fainted in the living room. It scared me to death. We later found out that she had cancer of the cervix and was bleeding so badly that not enough oxygen was being carried to her brain. Since we were poor and had no health insurance, my mother had put off seeking medical care. I decided then and there that I would become a doctor to help my mother.

My teachers at the time thought I was being foolish when I told them about my dreams of becoming a doctor. I had three strikes against me—I was black, female, and poor. I had no business thinking like that. But my mother always encouraged me. She thought it was great that I wanted to become a doctor.

As I got a little older, I learned more and more about the lack of good medical care in poor black communities, and by the time I graduated medical school my desire to help my mother had become a desire to help my people. I've been on that journey ever since. Early in my career I helped establish a community health center for low-income African Americans and served as its medical director. I did groundbreaking research at the National Institutes of Health on sickle-cell disease. I've never had a private practice. I've mainly worked in publicly funded health centers to help poor people. I've had a lot of support over the years from both inside and outside the halls of power, and I'm very thankful for that. I firmly believe that it takes team-work to make the dream work.

In 1998, while I was working as assistant surgeon general, I learned that I had breast can-cer. I survived with the support and love of my family and friends, but I'm a different person

after going through that. My belief in God increased, and in a strange way I feel almost blessed. My idealism was reinforced, and I've reached a new point in my journey to improve health care for women, minorities, and the poor.

Since retirement, or when I reordered my priorities, I've been setting up support groups for women around the country called Prime Time Sister Circles along with Dr. Gayle Porter, a clinical psychologist. She and I coauthored the book *Prime Time: The African American Woman's Complete Guide to Midlife Health and Wellness.* When I was healing from cancer, a support group of black women called Rise Sister Rise was key to my survival. So I am personally very committed to creating support groups to help women change and live healthier and happier lives.

The Prime Time Sister Circles teach women how to live better lives and decrease the risk of illness through diet, exercise, stress management, and quality medical care. We have set up programs in the Washington, DC, area, Chicago, and Florida and have plans to spread out nationally. We were recently honored by Civic Ventures as a national finalist for the Purpose Prize, which recognizes people in the second half of their lives for doing innovative things that are a change from their careers and are making a difference.

It's clearer than ever to me that this is why I'm here, and this is what I plan to do from now on.

People often say, "Marilyn, you're too optimistic." But what you believe is a choice. Henry Ford said there are two kinds of people: one kind believes they can do it, the other believes they can't. Both are right.

I faced a lot of obstacles in my journey—poverty, racism, sexism, disease. But I've come to believe that when you confront obstacles, you become stronger and better able to face the next one. I was blessed to be surrounded by people who believed in me—family, friends, colleagues, mentors. I had strong role models who taught me the power of believing in myself and that all things are possible. Once they found the way to empowerment, they reached back to guide me, and now it's my time to guide others.

Veretta Garrison ♦ 66

INTERCULTURAL COMMUNICATION AND MARKETING
CONSULTANT; SENIOR OLYMPIAN AND SPOKESPERSON FOR
OS-CAL; FORMER MANUFACTURER, DESIGNER, AND RETAILER
OF WOMEN'S CLOTHING

W omen are programmed to be kind, helpful, supportive, and giving. I suggest that those words be left out of girls' vocabularies. Those are things you can't be in business if you want to succeed. They don't work in the corporate world.

I had a retail store in Rochester, New York, for twenty years, and my clientele was the predominantly white country club set. People often wonder why I chose that location. I tell them, because that's where the money is. There's a saying that a bank robber, when asked why he robbed banks, said, " 'Cause that's where the money is." You can have lunch and go to church with your black girlfriends. But let's face it, that's not generally where the money is.

I was blessed to be raised by wonderful parents and grandparents who were very entrepreneurial. We lived in Cleveland, Ohio, and I was encouraged to explore and do things that were not typical at that time. My father was a successful businessman and politician and very progressive in thinking that women should not be put in a box. My mother was way ahead of her time in exposing me to things. The entrepreneurial spirit was encouraged and made my parents proud.

We had a piano in our home, and lots of other kids did not. I was bossy, especially with boys, and I would offer to give the kids in our neighborhood piano lessons. I charged them, and they would bring me their pennies. I even made a keyboard out of cardboard and gave it to them to take home and practice on. My mother today has the pennies and nickels I earned as a child in her scrapbook. I think that's why I see opportunities and why I'm willing to take risks. I always say, "Nothing beats a failure but a try."

I also believe that it's important to understand other cultures and how they differ from your own. I can remember my first intercultural experience. It was in 1943, when I was four years old and I went to a mixed-race nursery school. My parents always had friends from other

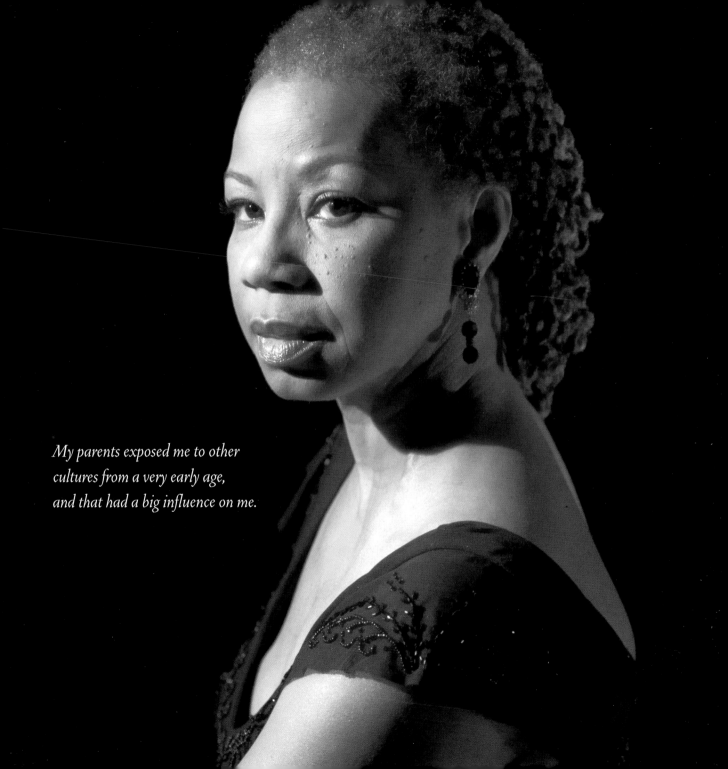

*My parents exposed me to other
cultures from a very early age,
and that had a big influence on me.*

races and cultures. At five I took French lessons. I also studied German and Yiddish, and in 1960 I went to Germany and studied at the University of Heidelberg. There were about ten thousand students there, and I was the only black female. My parents exposed me to other cultures from a very early age, and that had a big influence on me.

I got the idea to go into diversity consulting from my father in the early 1990s, when my parents came to visit me after a trip to Senegal. I had moved my clothing manufacturing and design business to New York City by then, and in my studio I had people working for me from Bulgaria, Swaziland, Colombia, Puerto Rico, and Morocco. I shipped to Neiman Marcus catalog, Nordstrom, Bloomingdale's, and other fine stores across the country, and I was running around in my studio when my daddy made a comment that I'll never forget.

He had been in the insurance business for years and was one of the first African American underwriters for life insurance. He was director of the Ohio State Lottery Commission by then, and he said, "It's not about working hard but about working smart. You shouldn't be working so hard." I said, "Daddy, what do you mean?" He said, "When I come back into this world, I'm going to be a consultant. I sign checks to so many consultants. I pay them to tell me what I already know." Daddy suggested that I consult on diversity, since I had always been around it. Now I was always rebellious and debating things with him, but I was in my early fifties by then, and this time I listened. He gave me a contact, and I called her and began getting consulting work almost immediately.

In the consulting business you're always looking for new clients, and one day when I visited my banker he asked what I was up to. I told him I was consulting on diversity and intercultural communication, and he suggested that I talk to the vice president of the bank about consulting for them and gave me the contact information. When I got back to my office, I thought, How can I get this man, the corporate vice president of a multinational bank, to listen to me? I decided to imagine that I was a European-American male. I put my feet up on the desk, dialed the number, and when I got his gatekeeper, I said, "Hi. This is Veretta. Put Joe on the phone." And she put me right through. I eventually got the contract, one of my biggest. I

could have called and used my African American female tone and manners— "Hello, may I speak to so-and-so, please?" But I don't think I would have gotten through. I can often get others to do what I want because I speak their language.

By far my best accomplishment has been to raise my three sons to be positive forces in the universe. One is a doctor, one an environmental project manager in Alameda County, California, and the other is in computer networking. In September 1995 I was visiting one of my sons, who was doing his medical residency in Connecticut, when I had a massive stroke. I had lain down because I didn't feel right and two weeks later woke up out of a coma. I was fifty-six years old and I was paralyzed on one side of my body. I couldn't walk or talk. I couldn't do anything. The only reason I'm here today is because my son knew which doctor to ask for at Yale Hospital.

I've always viewed challenges as opportunities, and this was no exception. When my son came to visit me in the hospital one day, I said, "Now, how am I going to make money in this?" There's an opportunity in everything. I went on to become a senior Olympian and spokesperson for Os-Cal.

How could I not plan to be in a better place if I'm going to be a responsible parent and role model to my kids and grandkids? I had a duty to my family to get better. But more than that, I owed it to *me* to do this. Also, my vanity wouldn't allow me to lie around not looking good. I had met my current husband in 1993, and we were just beginning to date when I had the stroke. I was not a pretty sight at all, but he stuck with me.

After several months of speech and occupational and physical therapy, I left the hospital walking, but I had to learn how to do everything else all over again. My recovery took years, and there were times when I was scared. I stayed in Connecticut for nine years to be close to my son and my doctors. Then when I realized that I wasn't going to die, I moved to Louisiana. I wanted to be someplace warm and in an area central to my three sons and grandson. I just decided that I wasn't going to be scared anymore, that I was going to make the most of things and continue to take advantage of opportunities, just as I always had.

When you're on television for as long as I've been, people assume that you're the character you play, and the one thing people are surprised to find when they meet me is that I have a much better sense of humor than Van Buren does.

I started college as a dance major and didn't get into acting until my second year. A friend needed an elective and asked me to take an acting class with her. I enjoyed it so much I took another class, then another and another, until I realized that I had changed my major to drama. Acting was not foreign to me, though, because music and theater were very much a part of my family when I was growing up in Detroit. My oldest sister, Linda, attended a performing arts school, and I remember going to see her perform. I was mesmerized by what I saw. Linda is six years older than I am, and more than anyone she planted the seed.

I had also done a lot of theater in high school, so I think I always felt more comfortable in that arena than in dance. I love the way you can get lost in a role. I also sing, and when I first moved to New York I found myself doing a lot of musicals. Back then the government subsidized the arts, and there were all these little theaters around the city, so I was able to get a lot of experience.

As people got to know my work as an actor, I was able to go from musicals to working as an understudy in plays. Little by little, I started getting the lead roles. My breakthrough role onstage was in a play called *Lady Day at Emerson's Bar and Grill*, a one-woman show about Billie Holiday. I started as an understudy, and when the actress left I took over the role. Meg Simon, a casting agent, came to see the show, and she liked my work so much that she recommended me for the production of *The Piano Lesson*. Meg's recommendation single-handedly changed the path of my career. I worked with August Wilson and Lloyd Richards—a highlight of my career—and we had a great cast. The play eventually landed on Broadway, and I was nominated for a Tony Award for best actress for my portrayal of Berniece.

I had done some television, and that plus my work in *The Piano Lesson* led to a guest spot on *Law and Order*. NBC had threatened to cancel the show unless Dick Wolf brought on more women. He liked my work from when I did the guest spot and hired me to play Lieutenant Van Buren in the fourth season. The show is now in its sixteenth season, and I'm the longest-running cast member. Landing that role was perfect for me, because it allowed me to stay in New York, where I have opportunities to perform in the theater.

What's interesting about television is that when you play a character for so long, your real character begins to merge into the character you play, as the writers get to know you. Over time, more of my traits have been incorporated into Van Buren—her nurturing and sense of right and wrong are traits that we share. One of the aspects I love about the show is that we have script meetings. They allow the actors' voices to become a part of the texture of the show. The woman I've been playing all these years has a way of doing things. People expect her to act in a certain way, and I have to protect who she is. The script meetings allow me to do just that.

To be on such a highly rated show is an actor's dream. But I'm always cautious about saying things have changed for black actors. In some ways, the situation has improved tremendously since I started twenty-five years ago. When I was growing up it was rare to see a black actor on TV. But now it's great to see all of the young actors coming along, and there should be more. To date, I'm the longest-running black actor on a television drama, so it hasn't changed enough. One of the biggest differences I've seen is that we're starting to produce our own films, and there are more black writers and producers working in television.

The biggest challenge for me probably comes from within—just being able to accept that I'm the product. I also have to remember to keep my head above rejection and to remind myself that rejection has nothing to do with my ability as an actor. There is simply a lack of roles for black women, and as you get older it gets more and more difficult, because there are fewer and

Whenever I have a chance to talk to young actors, I tell them to read as many books as they can. There is nothing like losing yourself in a good book, and it really plays into our ability to create characters on stage and screen.

fewer roles for women in general. The challenge is to define other ways to make your life interesting and fulfilling.

One of the things I enjoy outside of acting is reading. So many wonderful novels are being written by and about African Americans. When I was a young girl, there were so few published African American writers. It's great to read the classics and authors like James Baldwin and Ralph Ellison. But I wanted to read stories about our communities. There was a time when I was on the road and I would see a black bookstore and buy all the books by black authors, and by the time I reached the next destination I'd have read them and would buy more. Now it's nearly impossible to buy them all, and that's great. My projected goal is to find a way to produce some of the incredible stories that I've read over the years.

Whenever I have a chance to talk to young actors, I tell them to read as many books as they can. There is nothing like losing yourself in a good book, and it really plays into our ability to create characters on stage and screen. We're in the computer age now, and you can find anything and everything on the Internet. But a good story encourages you to think and imagine beyond what is on the page. Reading can change your life.

My acting career has allowed me to do wonderful things that I would not have been able to do otherwise. Since I've been in New York, I've worked outside of the acting profession for only two months. I remember telling myself that I wanted to be on Broadway before I turned forty, and I did that at thirty-eight with *The Piano Lesson.* Being recognized with an Emmy, a Golden Globe, a Screen Actors Guild Award, and an Image Award for my role in *Lackawanna Blues* was definitely another highlight of my career. I love the consistency that *Law and Order* provides me. I've been really lucky in the business, and luck is being in the right place at the right time with the right stuff.

Marie Dutton Brown ◆ 65 FOUNDER, MARIE BROWN LITERARY AGENCY; PUBLISHING CONSULTANT

I got into the publishing business during the heart of the civil rights era. Harlem's congressman, Adam Clayton Powell, was the chairperson of the House Education Committee, and he held a hearing on diversity in book publishing. Publishers were called to testify about their efforts to produce multicultural books and to promote employment diversity. There were a lot of discussions, and many articles appeared about the fact that very few books reflecting the history of African Americans were being published.

I had been a schoolteacher and education coordinator in Philadelphia when an editor from Doubleday, Loretta Barrett, made a presentation at one of our in-service training seminars in 1967 and suggested that we meet again whenever I would be in New York. I had heard about Loretta because she had previously taught in the English department with my mother at Simon Gratz High School in Philadelphia. When I worked for the Office of Intergroup Education, I introduced multicultural curriculum and resource materials to administrators, teachers, parents, and students in Philadelphia.

Loretta and I did eventually meet in New York, and she arranged for me to speak with people at Doubleday to discuss my work in the school district. Following those meetings, I was offered a position as a general publishing trainee in August 1967, and by the time I left in 1981 I was a senior editor. Doubleday had been a family-owned business up until that time, and it was being sold to a corporation. The culture of the company was shifting, and many of my editorial colleagues also left around this time. They went to other publishing houses, but no editorial jobs were offered to me despite numerous interviews. Eventually I accepted an offer to be editor in chief of *Élan*, a new magazine targeted toward African American women. Unfortunately, only three issues of *Élan* were published, and when it folded I was without a job for the first time in my life.

That was a new experience for me, and it was traumatic. I applied for unemployment and I spent four months job hunting with no luck, even though as an editor at Doubleday I had

Forty years after Adam Clayton Powell held the congressional hearings, getting our stories told is still a challenge simply because many of the people who ultimately make the decisions about which books get published don't have a clue about African American culture.

successfully published award-winning books and both black and white authors. I had published many pop-culture titles, including some of the first books on reggae as well as books on black history, culture, and social issues, such as aging and self-improvement. But in job interviews, publishers were asking me to develop strategic marketing plans. One had me travel several hundred miles out of state to their headquarters and be interviewed there and in New York on five separate occasions, yet never even got back to me at the end of all that with an offer or rejection. My white editorial colleagues were being hired based on a single interview.

I spent a lot of my time in bookstores during this period. One of them was Endicott Booksellers, an independent bookstore on Manhattan's Upper West Side. I visited the store frequently and finally approached the owner and asked her for a job there. On the very last day that I was on unemployment, she called to ask if I could work at the store for the Christmas holidays. That was when I began to turn my life around.

My two years at Endicott Booksellers were a great learning experience, with actual on-the-job exposure to how books are sold and what motivates customers to buy books. I loved the store, and I know that being there helped keep me balanced during this transitional time in my life. I often met with my friends and colleagues in publishing, and they always asked me what was new, which books were selling, and who was buying them. I gained intimate knowledge of a side of the business that many had little or no direct experience with—hand-selling books—and they knew and appreciated that.

Also at this time, the publishing business began to undergo a change that would have a huge impact on my career. When I started in publishing, most authors submitted their books directly to editors. But increasingly, publishers began to prefer that authors be represented by

agents, partly because they were being overwhelmed with submissions. Advances in technology, with electric typewriters, word processors, computers, and copiers enabled authors to write faster and to make multiple submissions of queries, manuscripts, and proposals to publishers. A few editors began to refer authors to me for representation. I had really wanted to return to the editorial side of publishing and had not considered becoming an agent, but in 1984 I launched my literary agency. At first I remained at Endicott, but gradually I reduced my hours at the bookstore until I was a full-time agent.

I am very grateful to have been able to get back into this business that I love so much, but there is still a cultural divide. Forty years after Adam Clayton Powell held the congressional hearings, getting our stories told is still a challenge simply because many of the people who ultimately make the decisions about which books get published don't have a clue about African American culture. They only know what they see and read in media reports, and that is so often one-sided or distorted.

I know that I have been able to grow and continue in the business by figuring out how to negotiate and cross the divide, and even though it is definitely not a level playing field, I always play the game assuming that I am going to win. In order to participate effectively, we must play to win.

Working as an editor would not be the right fit for me now, because the publishing industry has changed so much. I would love to launch a small publishing venture. So many gifted and deserving authors are not being published, and the work of those who are published is not reaching their potential readers. I don't want to radically change the industry, but I do want to get more stories told and sold that represent a balanced portrayal of who we are and what our history has been.

Dianne Caesar ◆ 60

Having to raise two young children, six years and eighteen months old, without their father is something you never imagine happening to you. I was forty years old when my husband, Adolph Caesar, died suddenly while working on a film in 1986. I had thought we would grow old together. But you have to go on. I had to survive for these two young people, and I just kept getting up every morning and putting one foot in front of the other.

I met Adolph when I was working for the Washington, DC, bicentennial, on a big program at the Kennedy Center. I did behind-the-scenes work, and Robert Hooks, the producer and director of the program, brought an actor with him whom I knew but hadn't seen since college. That man introduced me to Adolph.

Adolph had a stellar career as an actor, starring in movies like *A Soldier's Story,* for which he received an Oscar nomination, and *The Color Purple.* But what people remember him most for was his magnificent voice; his was the voice you heard in the ads for the United Negro College Fund saying, "A mind is a terrible thing to waste." That was him right up until he died. He was one of the first prominent voice-over actors, and his joy was acting.

We moved to New York City and married in 1977. I was not an actress, and I kind of figured out that I needed to look for friends of my own. When you're around actors, you can't compete. You have to establish your own personality. I had attended Spelman College and had been active in the civil rights movement, including being jailed in Atlanta while trying to buy a hamburger at one of those little hamburger joints where blacks weren't allowed. So in New York I got involved with Spelman alumnae. I had also been "discovered" when I was at Atlanta University working on my master's degree and sitting in a restaurant. A woman asked me if I had ever modeled. I said no, and she asked if I wanted to audition to be a commercial model. I said, "Sure," and went on to do some modeling.

*Wisdom comes with age, and it's important to form groups of
people whom you can inspire and who can inspire you.*

So in New York I worked on fashion shows and sat on various boards. I had children and was very involved with motherhood. Adolph had a daughter from a previous marriage, and being a stepmother was difficult for me at first, but my relationship with my stepdaughter changed when I had a child of my own. When you have children you give up a lot of your life freely. You have to. Their needs are more important than yours. I didn't understand that until I had my own children.

I didn't leave New York right after Adolph died, because by then I thought of New York as home. The children were in school and their friends were there. They had just lost their father, and I didn't want to take anything else from them. Fortunately everyone came together to hold me up, and I learned how important it is to have good friends. A good friend in Harlem was rehabbing her house and garden, and I helped. I couldn't wait to get to that garden every morning. To be able to get out and "dig deep" was very therapeutic for me.

Six years after he passed, my mother developed Alzheimer's, and I decided to move back to North Carolina. Adolph had provided for me well, and I had never worked during our marriage or after. But living in New York was expensive, and I had made some bad investments, so I decided to sell everything and move back to North Carolina.

A few years after coming back to Winston-Salem, I began to work again. In New York I had organized charity and fashion shows, and I became director of a big arts and crafts fair that featured pottery and furniture. That was a huge challenge, and for a while they were worried that I wouldn't be able to pull it off. But I did, and that introduced me to a wider group of people in the arts.

I realized that I'm good at getting people connected. I'm good at smoothing things. Someone described me as an "iron hand with a velvet glove." That probably comes from my

mother and the other women in my family, who had to deal with challenging situations and did so firmly but gracefully. Black girls are taught subtle ways of maneuvering around difficult situations. My mother would take us downtown, and there were two water fountains, one labeled for whites and one for coloreds. She would always lift me to the white fountain and say, "We don't drink colored water." Some of the theaters were segregated, and blacks had to sit in the balconies. So we just didn't go to those theaters. That was my mother's way of protesting.

I now work for an organization started by African American women called the Delta Arts Center. We offer art classes and exhibit the works of artists such as Romare Bearden, Elizabeth Catlett, Nanette Carter, and Philemona Williamson. When I started here in 2001, I was fifty-five years old, and it was my first real job-job in years. It's been the highlight of my life. They were on the right track, but I was able to facilitate moving the gallery into a new building. I was appointed to the governor's arts commission and was recently recognized as an outstanding businessperson here in Winston-Salem.

Wisdom comes with age, and it's important to form groups of people whom you can inspire and who can inspire you. My father used to say that I was about as helpless as a Mack truck. After Adolph died, I faltered for a while, but with the help of others I learned to navigate and make it on my own.

Many of us spend a long time chasing that which will make us whole. You know, we think we will be whole if we have a husband or if we can buy this or that. But what makes us whole is within ourselves. Remember what old folks tell you, learn from your experiences, accept what is given, pray for strength, and become wise. Be grateful for each new day.

Linda Chastang ◆ 52

EXECUTIVE VICE PRESIDENT AND GENERAL COUNSEL, NATIONAL ASSOCIATION FOR EQUAL OPPORTUNITY IN HIGHER EDUCATION

I believe you can do anything if you stick your neck out there and take risks. A lot of people are afraid to take risks. They're stuck, or content. Sometimes they don't have the means to provide a cushion so they can safely take risks or to allow their children to take risks, and that's unfortunate. Sometimes they do have the means; they just lack the courage or the vision to take risks, for one reason or another, and that's doubly unfortunate.

I've always had jobs that came with no road map. They came with just a general description and an objective. I have had to make my own road map and set my own goals. That's more risky, but I thrive in situations like that.

I'm fortunate to have a husband who pays to keep the lights on, and he encourages me to do whatever I want. But even if I hadn't married Mark, my attitude would have been the same. I had confidence that I could handle jobs like that. Most people end up settling for more structured jobs or jobs with limited possibilities.

It helped that I knew I could always go back home to my parents. That's comforting and empowering. So that even if I were, say, "annoyed" with Mark, I knew I could go home. A lot of people don't have a home to go back to, so they can't take risks or it's harder for them to take risks. They feel that they have to settle for work or a lifestyle that's more secure but may not be rewarding.

I'm counseling a young black woman now who is thirty-one years old. She quit her job two years ago and started freelancing, something she'd always wanted to do. I told her that she needs to set up a retirement plan and other things. I asked her what her parents thought about her quitting her job and going freelance. She said she hadn't told them. It's been two years since she left her job, and she hasn't told her parents! She obviously doesn't feel she has a support system, and that's so unfortunate.

I think it's important for my son and daughter to know that they have a cushion under them so that they will be willing to get out there and take risks. I just told my son the other day that he can *always* come home.

Education is also important in our family, not necessarily for the degree, but for the learning. My father received both his undergraduate and graduate degrees while raising a family. My mother got her doctoral degree when she was fifty years old and working full-time. Both of my parents are lifelong learners.

I was teaching law school, had young children, and was pursuing a master's of law in taxation at the same time that my mother was pursuing her doctorate. It was not easy or convenient, and I wanted to give up, but I thought that if my mother could do it, I could do it. I also thought about the example I would set for my children if I gave up, even though they were toddlers at the time. I think it's important for parents to set examples, and I wanted to show them that persistence pays off. With my children I always think about setting an example. They may not listen to you, but they watch what you're doing.

I believe you can do anything if you put your mind to it and don't give up. When I worked on Capitol Hill as chief of staff for Congressman John Lewis, his district in Georgia decided they wanted to build a big federal building in downtown Atlanta. Everyone was telling us, "No, you can't do that." Many in the community came out against it—members of Congress, state and local officials, the media. But my boss believed it was the right thing to do, and I was determined to get it done. I spent three years exploring all the options, and at the groundbreaking

*It used to bother me when people called me persistent. I didn't
think the term described a lady favorably. I know differently now.
It just means that I keep at something until it gets done.*

ceremony, Congressman Lewis acknowledged my persistence. It used to bother me when people called me persistent. I didn't think the term described a lady favorably. I know differently now. It just means that I keep at something until it gets done. And I think that is a good thing.

I have a friend whose husband died recently. He had been a pilot in the navy and had always said that when he died he wanted a flyover at his funeral. But he didn't have the credentials. He was seventy-two years old when he passed away, and he was in the military back when blacks didn't have the opportunities to achieve the credentials needed for a flyover. So I got on the phone and made the case to the navy, to sympathetic members of Congress, and to others that this was a civil rights issue. My friend's husband got the flyover.

I always encourage my kids to take risks, to venture outside the box, to think creatively, and to be persistent, just as my parents encouraged me. Life is so much more rewarding when you do.

Pat Briscoe DeJarnett ◆ 51 DIRECTOR, SCHOOL-BASED HEALTH CARE, CINCINNATI CHILDREN'S HOSPITAL MEDICAL CENTER/NEIGHBORHOOD HEALTH CARE, INC.

As a child I could never answer the question "What do you want to be when you grow up?" but I knew I wanted to make a difference. At age thirty-two I was vice president of a not-for-profit corporation that operated a network of community health centers serving medically underserved people in southern Ohio, and I could make a difference in a big way. My personal life was going well, too. I was happily engaged, and I had a near picture-perfect life. That's when a slight hearing loss that had not really impacted my life up to that point started on a downslide.

I remember sitting around a table at a work social playing Trivial Pursuit and being the only black person at the table. Someone read a question to me, and I didn't hear it. I asked him to repeat it, but I still didn't hear it. I was embarrassed. What was going on with my hearing? Rather than ask him to repeat the question again, I just said I didn't know the answer. I didn't want to be bothersome.

One of the white guys at the table quite smugly gave the answer—Arthur Ashe—while looking directly at me and then gave a short black history lecture. That was when I realized that the question was "Who was the first black male tennis player to win the U.S. Open?" Of course I knew the answer was Arthur Ashe, but I was sure my coworkers were thinking, Hey, she doesn't even know about her own people. How embarrassing. That was the last straw. I decided right then and there that I was going to get a hearing aid, and I made an appointment with an audiologist the very next day.

Being young and pretty vain at the time, I was happy that my hairstyle covered the aid. I didn't want to be bombarded with a lot of questions about it. Initially I did well with just one small hearing aid. Then I needed two small hearing aids, then two larger ones, and finally two power aids. As my hearing got worse, the aids did less and less to help. One day I would be able to hear the beeping of the microwave or my pager going off and the next day I couldn't. It was scary.

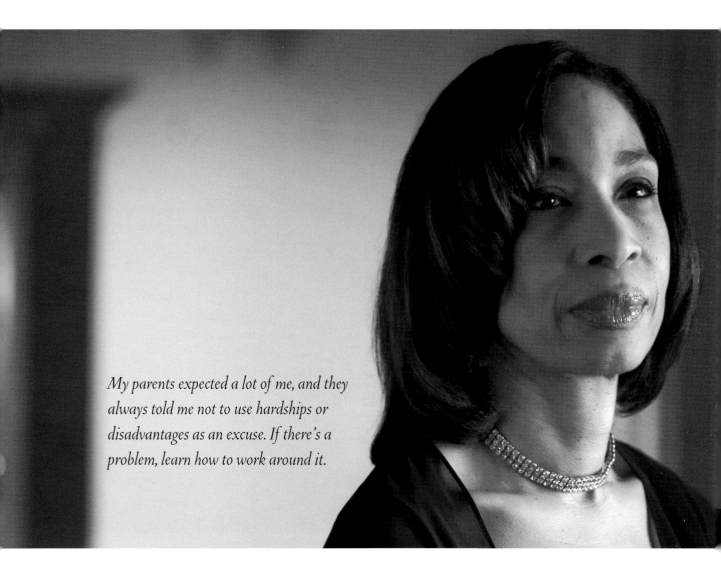

My parents expected a lot of me, and they always told me not to use hardships or disadvantages as an excuse. If there's a problem, learn how to work around it.

I could still hear on the phone, and I became a master lip-reader to compensate during face-to-face conversations. People complimented me for having great eye contact and paying such close attention to what they were saying. Actually that was my survival strategy. I had to do that to hear what was going on. But at the end of the day I was drained and stressed out from having to pay such close attention and from the constant fear of not being able to hear enough to get whatever was going on.

When I was in my midforties, I was on a management team where we each took turns taking minutes at weekly meetings. Whenever it was my turn, it was stressful for me because I had to look at people when they talked to be sure not to miss anything, and when you take notes you have to look down. So I learned to remember what people said, jot it down briefly, and fill things in later. I would not have dreamed of asking to be excused from this note-taking task because of my hearing loss. I didn't want exceptions. That would feel like giving in.

One day at the office I heard a clicking sound and wondered what it could be. Someone came to my office and said, "You better get out!" That was when I realized that the clicking sound was a fire drill. The alarm was blaring and all I heard was clicks. When I got outside someone said, "If that had been real, you would have burned up by now." I was shocked that I couldn't hear something that was so loud.

At forty-nine I was selected to serve as interim president and CEO of Neighborhood Health Care, Inc., a corporation that operates federally qualified health centers in Cincinnati. Although my hearing was much compromised by that time, I was able to very competently run board meetings, present externally, keep lines of communication open with staff, and do whatever else was necessary to run the company. I think that black women learn throughout life that we have to work harder than others to succeed. You know the old saying, "When the going gets tough, the tough get going." Sure, it was a hurdle, but not one I couldn't overcome.

Like my sister Connie, I inherited my hearing loss from my father's side of the family, but I never expected that it would proceed so drastically. At age fifty I decided to get a cochlear implant. This is a surgical procedure where an incision is made behind the ear and a transmitting coil is then inserted into the inner ear. A device that resembles a hearing aid, called a processor, is worn externally to pick up sounds and send them to the inner ear through the transmitting coil. After the surgery, I started noticing steady improvements in my hearing, and it was wonderful that my hearing was now going up instead of down. After about three months, I could hear pretty well, and now, a year later, my hearing is remarkably improved and still getting better. It's amazing. I enjoy music more now and listen to the radio all the time.

Is my life picture-perfect? No, but I'm pleased with how things have turned out. It's still important to me to make a difference, and as director of school-based health care in Cincinnati I am able to make a difference in people's lives in a big way. I love my current job, and I know there are not a lot of people who can say that.

I have a good family life. I have been married for nineteen years and have a wonderful blended family, with two adult children and two teenage daughters. Luckily, neither of my daughters inherited my hearing loss, although being teenagers they sometimes tune me out if I'm telling them something they don't want to hear. All in all, they are great kids, and I'm extremely proud of them.

My parents expected a lot of me, and they always told me not to use hardships or disadvantages as an excuse. If there's a problem, learn how to work around it. The lessons I learned while growing up about being strong, independent, and resourceful are valuable ones, and I have worked hard to make sure they are passed on to my children.

Loretta Argrett ◆ 68

FORMER ASSISTANT ATTORNEY GENERAL, TAX DIVISION,
U.S. DEPARTMENT OF JUSTICE; FORMER PROFESSOR OF LAW,
HOWARD UNIVERSITY

I think I've been successful because I've always been passionate about the things that matter to me. I grew up believing, as so many blacks of my generation did, that you had to be twice as good as whites to have a chance at success.

My family lived in a small town, Greenwood, in the Mississippi Delta, not far from where Emmett Till was lynched. I remember that if you wanted to go to the movies you had to sit in the balcony, and that we couldn't use the gas station restrooms when we traveled simply because of the color of our skin. Fortunately my father operated a business in a building that he owned, and my parents did everything they could to shelter us from the harshness of racism. Of course there was no way they could be completely successful at that.

I come from a long line of civil rights activists, and perhaps that's why I'm so passionate about fairness and justice for all. My maternal grandfather was a cofounder of the NAACP in his county in southern Mississippi. The village where he owned his farm has been named after him. Several of my father's relatives in the county were leaders in an economic boycott of the white merchants who had discriminated against blacks. That boycott led to litigation in 1969 that was ultimately decided in their favor thirteen years later by the U.S. Supreme Court. My father was one of the first blacks to register to vote in our community and was a cofounder of the Greenwood Voters League. After my father went to the polls, he was threatened by whites, so he took me, my sister, and my mother to a friend's house to stay overnight. Then he and my uncle went back to our house, loaded their weapons, and barricaded themselves inside. My father was well known throughout the area as an expert marksman, and I think that's why no one harmed them.

When Martin Luther King Jr. came through Greenwood during the 1960s, he and some members of his entourage spent the night at our home. Although I had left home by then, my

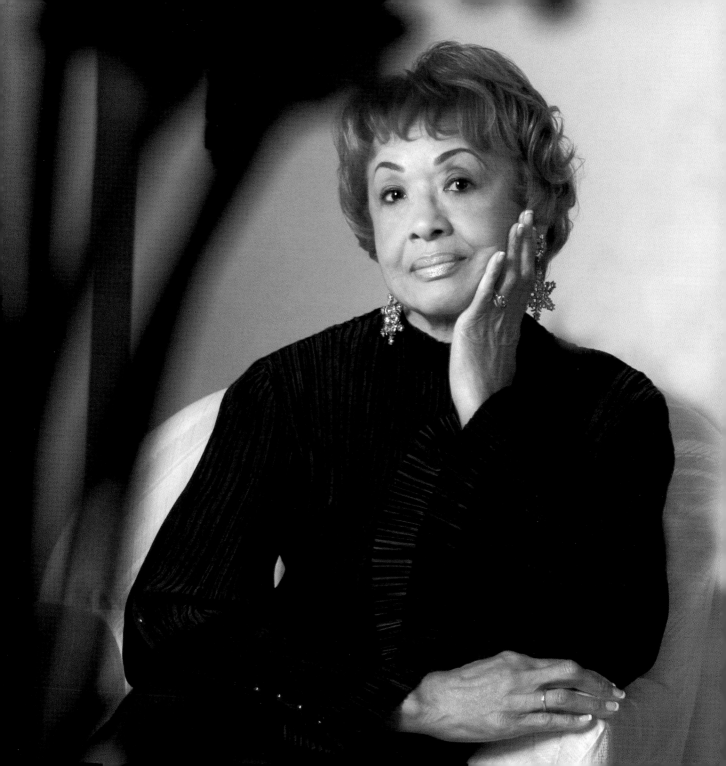

younger brother described sitting in our living room and listening to Dr. King and our father debate the limits of pacifism. My father believed that one should "turn the other cheek," but he was prepared to defend his family if necessary.

With these life experiences, it's probably not surprising that I have tried to make a difference in the lives of people with whom I have come in contact. I have always believed that service is the price one has to pay to live in a civilized society. My first venture into community activism took place in the early sixties when my husband and I decided to move to Montgomery County, Maryland, to take advantage of the good schools here for our children. We quickly realized that some real estate agents were not showing us houses in certain areas. Although we ultimately bought a house in a predominantly white area, I was really disturbed by our experience, and I volunteered to become a "tester" for the local fair housing organization. Black testers would pose as buyers or renters and visit a Realtor (or home), closely followed by white testers. If the black testers were told that the property had been rented or sold but the white testers were not, then the organization had grounds to take action.

As time went on, I became involved in other activities. Not far from my immediate neighborhood was a poor black community that had been there for years and years. The county decided to promote urban renewal in that area, and I got involved to help ensure that those residents didn't get pushed out. I wanted to be certain that it didn't turn into "urban removal" instead of urban renewal. The community was improved, without removal. Our community continues to this day to be racially mixed.

During this time I was a research chemist, and I loved my work. It was intellectually challenging and fun, but my community activities were becoming more satisfying than research.

While working at the Walter Reed Army Institute of Research, I became a volunteer Equal Employment Opportunity (EEO) counselor in addition to my regular duties after an activist friend and coworker said she needed my help. I counseled other blacks who believed they had been discriminated against. Most of them had low-paying and menial jobs. But over time I realized that, while I was a professional and had a valued position, I had problems of my own. I filed an EEO complaint that ultimately was resolved to my satisfaction.

I considered whether it was time to redirect my life. After reflection, I concluded that blacks would not achieve parity until we had reached economic parity, and that we could not reach economic parity until we had lawyers, accountants, and other advisers to help us build our own viable businesses and communities.

With the support of my husband, I entered Harvard Law School. It was a big challenge going back to school, as I was thirty-five years old and had two young children, who had to adjust to new schools when we moved to the Boston area. After I graduated we returned to our home and I worked for major law firms in Washington, DC, ultimately becoming the first and only black woman partner at one of them. In my practice I was able to achieve my goal of representing black entrepreneurs, professionals, and nonprofits devoted to achieving economic parity for disadvantaged communities. Earlier in my career, I spent two years working for a

I come from a long line of civil rights activists, and perhaps that's why I'm so passionate about fairness and justice for all.

prestigious congressional committee, the Joint Committee on Taxation, becoming its first black staff person.

Over the years, I have taught law at Georgetown, American, and Howard University schools of law. I enjoyed teaching and viewed it as a way to give back to the community and inspire others—particularly minorities and women—to consider tax and business law as a specialty.

After President Clinton was inaugurated in 1993, I was nominated to be assistant attorney general of the Tax Division at the U.S. Department of Justice. Upon my Senate confirmation, I became the highest-ranking African American woman in the department's history, and the first African American woman to head the Tax Division. I oversaw criminal and civil tax litigation on behalf of the federal government throughout the United States.

I'm as proud of the management changes I made in the division as I am of the high quality of the work that we accomplished during my tenure. The Tax Division had been known as a white male bastion. I had even heard it referred to as a plantation. After I arrived I quickly learned that there were few women managers and no black managers, and that most of the low-level jobs were held by African American women in "dead-end" positions. After evaluation and study, I led a reorganization of work flow and jobs, revised job descriptions, created career ladders to permit job advancement, and held training programs to equip employees to meet the requirements of the new jobs. I met some resistance to the changes I was implementing, but I believed in them passionately, and Janet Reno, who was the attorney general, supported my efforts. During my tenure I also made sure that blacks and women were among those who held senior positions. I proved that you can have an integrated staff and be very successful.

My second husband and soul mate, Vantile Whitfield, died last year after a lengthy strug-gle with Alzheimer's disease. That was a long and painful journey for both of us—more for me than for him, I suspect—but I know that I am a better person because of that experience. My life has been and continues to be full, and I continue to be involved in activities where I believe I can make a difference. In 2005 I received the Margaret Brent Award, one of the highest awards that the American Bar Association gives to women lawyers, for being a trailblazer in the law and a mentor to others. I am truly blessed, as I have a wonderful family—two children, of whom I am extremely proud, four grandchildren, a brother, and a vibrant and active mother, who is ninety-four years old.

My husband used to say that I have a gift for inspiring people. Others have said that, too. I attribute that in no small part to my faith in God and my passion for people, life, justice, and seeing the glass as half full rather than half empty. We can't all be like Dr. King, who had the ability to move mountains with his passion. But in my own small way, I hope that I have been able to pave the way for others and to make a difference.

Whene I was invited to join an interest group that was to become a chapter of The Links, Incorporated, in 1982, I was reluctant. I thought the organization did not match who I was. My father was a farmer-landowner and a political and community activist. He fought the Ku Klux Klan in Florida and would help black people who were in danger of losing their property. My mother was a teacher and worked in the community. My four siblings and I worked on the farm, and we were very active. There were music lessons, 4-H, church, and after-church activities. I came out of that kind of experience, and my orientation has always been toward giving and doing something.

The Links had a reputation of being a group of party people, but what I didn't know—and what a lot of people don't know—is that they were giving away the thousands of dollars they raised at those parties to scholarships for black youth and to support community activities. The Links, Incorporated, became the first black female organization, and maybe the first black organization, to give $1 million to another black organization—the United Negro College Fund. A second $1 million was given to the NAACP Legal Defense and Education Fund. Links members individually give service to other organizations like the National Urban League, the NAACP, the History Makers, and the United Negro College Fund. What we really had back when I was asked to join was a public relations problem, in that we weren't getting the right messages out. We do a much better job of that now.

So I thought it was mainly a social organization when I was invited to join. But Mrs. Jacqueline Robinson, who was then the chapter establishment officer, told me—in no uncertain terms—that I was mistaken. She insisted that I give it a try, and I did. The women in the interest group, who lived in and around the Washington, DC, beltway, were and are extraordinary. I slowly came around.

That interest group eventually became the Potomac Chapter of The Links, and I served as its first president. Later I was invited to serve on the executive council. It was highly unusual

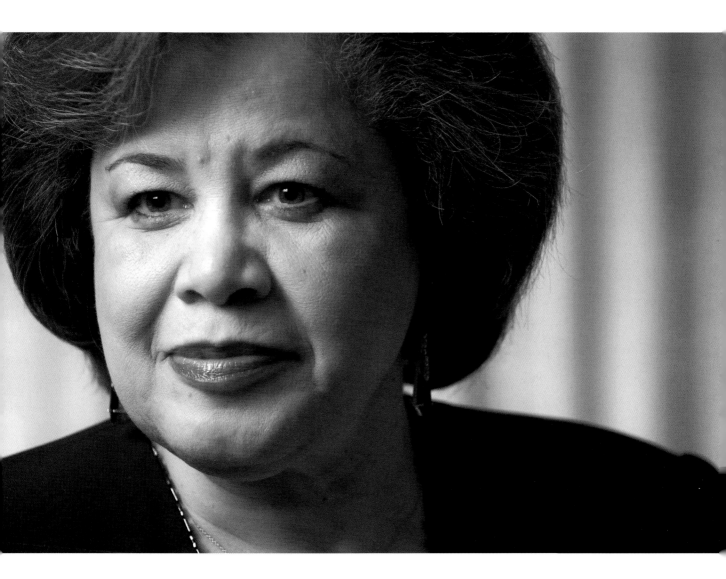

for someone with limited experience within the organization to be invited to join the council. I was asked to handle grant programs, and that may have been because in my professional role I had been very successful in securing grant funds. The Potomac Chapter had developed a program called High Expectations, for young girls in DC, and we obtained a grant from the Junior League and the Washington Post Foundation; I had written the grant. That program became the basis for a larger program that involved chapters across the nation, called Project LEAD: High Expectations. I obtained a grant of $1.2 million from the Department of Health and Human Services to fund the award-winning program.

I was appointed to the council again, and during that tenure I was asked to consider running for national vice president. I had never run for anything before except Miss Florida A&M when I was in college, and I lost. So I said, "No way." But from time to time, I would talk about running to my husband, Joseph, and to people I deeply respected like Jackie Robinson, who had this vision that I would one day be national president, and Althea T. L. Simmons, chief congressional lobbyist of the NAACP. Jackie, Althea, and I were Deltas, and they made me promise that I would one day run for president of a national organization. When Jackie and Althea died, I knew I had to fulfill my promise to them. I cried and cried, but decided to run, and I won.

Joe had been ill, and he died unexpectedly in September 2000 at age fifty-eight. We were sitting in our family room joking and watching television when he suddenly slumped back on the sofa and fell into a coma. He died seven days later in the hospital.

My niece Angela, who was my little Delta sister, had died only months earlier, in May, of a rare form of cancer at age twenty-six. She had just finished medical school, and a graduation ceremony was held for her in the hospital because the physicians did not think she would live to June. An aunt and uncle had also recently passed away.

It was all a bit much for me. I didn't go to work for a month after Joe's death. Friends would come by and take me out to get me out of the house. Women who had lost husbands would

call me and give me suggestions about how to cope. Family members and friends called. None of it did much good. Finally a friend who lives in California, Delores Covington, wrote to me and told me to go ahead and have my pity parties, but for only fifteen minutes a day.

That snapped me out of it. I realized that grief can take you out. Slowly I came up with my own model on how to handle grief. I increased my community service activities. I began to speak out about how we needed to revitalize The Links, and members began to ask me to run for the presidency. In 2002 I became the first person to be elected national president unanimously by voice vote. I was stunned. Being elected by acclamation was a defining experience in my life.

What I enjoy most about being a Link is working with other women who want to give service and help black children. We are kindred spirits. We want to take care of our own. You can't wait for someone else to do it.

Our activism and service played a major part in getting President Clinton to grant clemency to Kemba Smith, who had received a twenty-four-and-a-half-year sentence for a first-time, nonviolent drug offense. Our members wrote thousands of letters to legal and congressional offices about her unjust imprisonment. We've built thirty-one schools in remote areas of South Africa, and we're renovating an additional thirty-one. We've built two schools in Nigeria. We work with the Ministry of Health in Uganda and the World Health Organization to send funds that help promote safe birthing. We've sent tennis shoes, clothing, and books to South Africa and health and medical supplies to Haiti. We have provided forums for many emerging and accomplished performing, visual, and literary artists. We have been active in the fight to reduce health disparities, especially diabetes, heart disease, and cancer. After Hurricane Katrina, we established a permanent commission and fund to deal with disasters in the United States and collected more than $150,000 for the victims. Our third million-dollar grantee will be named in the coming months.

My parents set the bar high. So did my husband, siblings, and others who believed in me. Regardless of what goes on in my personal life, I *have* to be involved in work that makes a difference. I will continue to stay active in The Links when my term expires, as well as in Delta Sigma Theta. I will do other volunteer work. I will always find ways to give meaningful service.

I remember the day my son, Okorie, was kicked out of his elementary school cafeteria for throwing food in a fight like it happened just last week. He was eight years old, and I thought, What in the world am I going to do? I eventually decided to drive from my place of work, which was about ten miles away, to Okorie's school every day at noon for the entire week he was not allowed in the cafeteria. I would pick him up and sit in the car with him for an hour. We would eat, sing songs, and talk about his future and how he would be the next Dr. Martin Luther King.

Now, when I think back, I realize that I could have handled that week in a way that would have been much easier on me. But my husband and I divorced when Okorie was a baby, and all through my son's upbringing I was filled with guilt and fear. When it became clear to me that I would have to raise my son as a single parent, I felt guilty that I was unable to make it work with his father, a mathematician who would have been a good role model for his son. Instead of bringing Okorie up in a stable two-parent household, I was going to be raising him as a single mom in an urban environment. I knew that the odds were stacked against me, and I was scared to death. Hence, my not entirely rational decision to leave work and drive twenty miles round-trip every day to sit with Okorie during his lunch break.

But I was determined that Okorie was still going to have everything a boy should have, even though his father lived in another part of the country. When he was four I decided, Okay, it's time for him to go into sports. So I signed him up for the Wheaton Ice Hockey Team in Montgomery County. Practice started very early on Saturday and Sunday mornings, so we would get up at about 4 a.m. and I would dress him in his ice hockey clothes, lay him back in bed, dress myself, and then carry him to the car and lay him down in the rear seat. By the time we got to ice hockey he would be awake. When he was older, he also played soccer, lacrosse, tennis, football, basketball, and did wrestling.

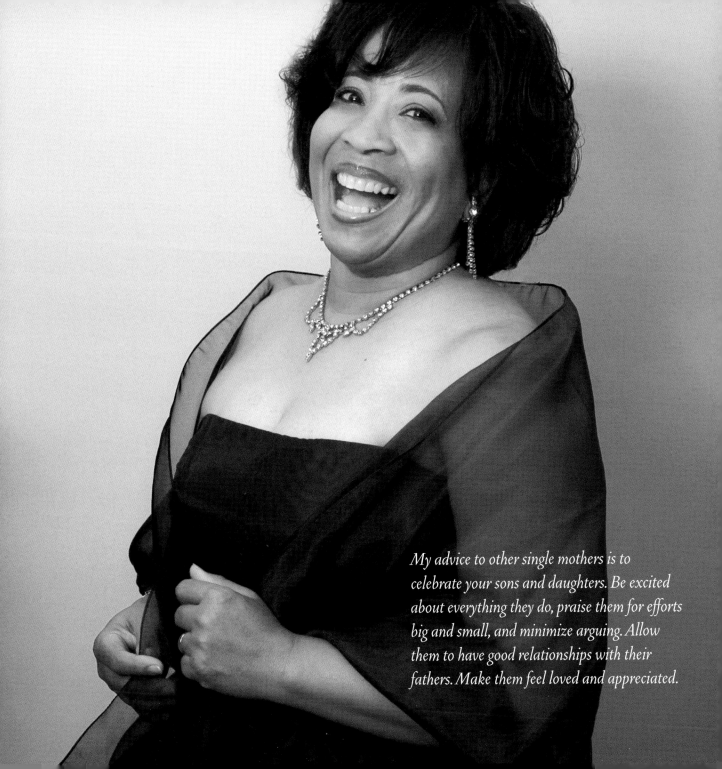

My advice to other single mothers is to celebrate your sons and daughters. Be excited about everything they do, praise them for efforts big and small, and minimize arguing. Allow them to have good relationships with their fathers. Make them feel loved and appreciated.

My next-door neighbor and good friend Phyllis would be so mad at me. She would say, "I'm going to call child protective services, because I see you taking that poor boy out at 5 a.m. in all those ice hockey clothes." The neighbors all thought I was crazy.

When Okorie was six or seven I decided, Okay, it's time to learn music, and he began studying cello and preparing to participate in the DC Youth Orchestra. When he left a hockey game to go to his private cello lessons, he still had on his ice hockey clothes. He would remove the knee pads, but there was no time to change. This went on until he was eleven, when he began studying at the Levine School of Music. At this age he also toured the Orient with the DC Youth Orchestra.

I wasn't happy with his elementary school, for many reasons. It was a negative setting, the test scores were average, and I thought Okorie had more potential. I also thought that Okorie needed more structure. I went around and checked a few schools, and we finally settled on Landon, in Bethesda, Maryland, where the students dress in shirt and tie every day and they expect a high level of achievement. I was so intense during this period. If I'd had to go to a thousand schools to find the right one, I would have. I was on a mission, driven by my fear and guilt.

One day I looked up and Okorie was being recognized under the category of Negro achievement by the National Merit Scholarship program. He also won a scholarship to Morehouse College. He was accepted at Duke and Columbia and wait-listed at Princeton. Harvard asked him to apply there, but Okorie said, "Absolutely not." Landon is an all-male, predominantly white school, and Okorie said he *had* to go to a black college. He wanted to learn to feel comfortable around other black men. So he went to Morehouse. I was slightly disappointed when he turned down the Ivy League schools for Morehouse after all I had put into educating him. But I respect his decision now.

I would like to say that I thought this out in advance and knew what the outcome would be, but I can't. I was a mother in desperation. All I knew was that Okorie was going to have everything he would have had with his father living with him.

I was able to adopt this approach only because my mother and father were extremely supportive during the "Okorie years." At one point in time, we lived in their home, and that gave us the comfort and stability of an established household. It offered sanity in what sometimes

seemed an insane approach to raising a child. My mother forced us to slow down, at least somewhat, and she and my father made it financially possible to seek private education, music lessons, sports, traveling, entertainment, and all the things many parents want for a child.

I never spoke angrily about Okorie's father around him or painted a negative picture of him. I knew that the father image was important in a boy's life, and I always hoped that Okorie and his father would someday have a good relationship. His father reached out to help when Okorie went to college, and today they are the best of friends.

I was so wrapped up in Okorie's life that when he left for college I became very depressed. I cried from September to December. When I went to the grocery store I cried. When I went to church I cried. When I talked to Jack, my husband now, I cried. Jack told me, "He has gone to college, Brenda, not to jail."

I ended up putting on a lot of weight. I was soothing my grief with food. For eighteen years while Okorie was growing up, I didn't think about myself. I always had tuition and other bills for my son, and I didn't know how to shop for myself or pamper myself. Okorie was my constant focus, and when he left, I felt lost even though I had remarried. My husband bought me a dog and that helped, but I still kept putting on the weight.

It took a long time, but I finally began to realize that I was going to be fine without Okorie as a major part of my life and that it was okay to focus on myself. I took up dancing lessons, joined social clubs, and lost the weight. We bought a new house. I went from calling Okorie every day to sometimes forgetting to call him for a week.

Was it all too much? Would I do it that way again? I have no regrets with regard to how I raised Okorie. He turned out just fine. He teaches English at Landon now and gives private cello lessons. He's also working on a doctoral degree. He's a wonderful husband and father. I couldn't be happier with him as a man.

My advice to other single mothers is to celebrate your sons and daughters. Be excited about everything they do, praise them for efforts big and small, and minimize arguing. Allow them to have good relationships with their fathers. Make them feel loved and appreciated. And most important of all, encourage them to dream and to believe that one day they could become the next Dr. Martin Luther King.

When I founded the Children's Defense Fund in 1973, I never dreamed it would be so hard to get this country to take care of its children. Despite teen pregnancy, drugs, poor health care and education, and violence everywhere, it's still hard, but we have made significant progress.

The biggest influences in my crusade to help America's children were my parents, who led by faith and example and did what they could to give us a healthy start in life despite the segregation all around us. Daddy was a Baptist minister and pastor of Shiloh Baptist Church in Bennettsville, South Carolina. Mama was a pillar of the church, head of the Mother's Club and its fund-raiser and choir director as well. Whenever my parents saw a need in the community they tried to fill it. We couldn't play at the neighborhood playground, so Daddy built a playground behind the church for the black children in the neighborhood. Mama was a social entrepreneur, and she used to run the most imaginative contests of all kinds for the community: baby contests and Miss Universe contests. In addition to my sister and three brothers, they took in several foster children, and they had the same expectations for their daughters as for their sons.

We were blessed to have lots of books in the house. Shakespeare was on the mantel as well as works by Langston Hughes and Booker T. Washington. Daddy loved to read, and we read together every day and always had the latest books. My siblings and I figured out early on that reading was important to our father. The only time he wouldn't give us a chore was when we were reading, so we read a lot! My parents also taught us to make sound choices and to use good judgment. I remember being caught reading *True Confessions* at age twelve or thirteen. Daddy said, "Marian, what are you reading?" I answered, and he told me to stand and read it aloud. I never read *True Confessions* or anything like it again.

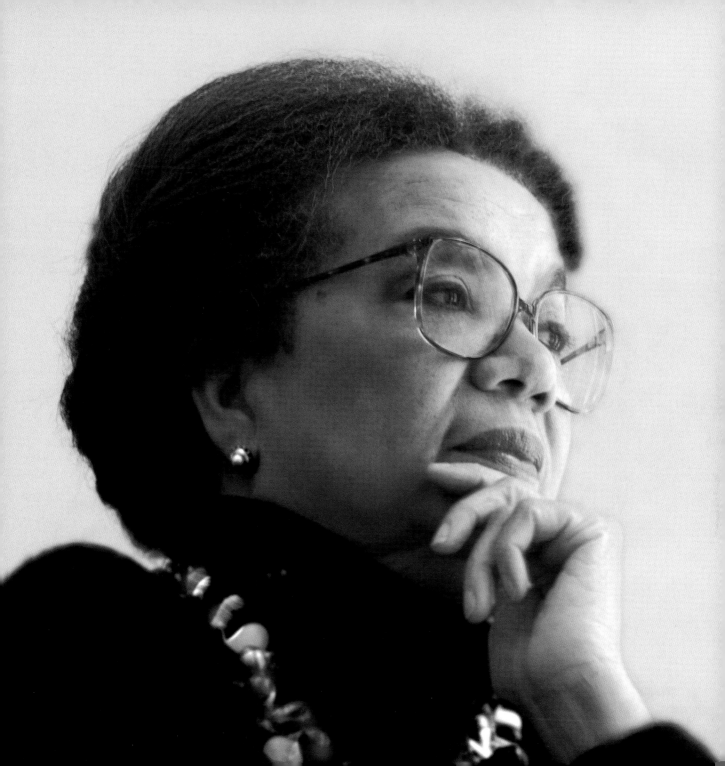

Because of segregation there was a great effort to expose us to all sorts of role models. Daddy would pile us in the car and take us to see any great person within a hundred miles of Bennettsville. Dr. Benjamin Mays, president of Morehouse College, spoke at our church. We met Mary McLeod Bethune when she spoke at a college near us. Langston Hughes read his poems at my high school. We were exposed to extraordinary role models and were taught that the whole world was ours.

Education was stressed, and our parents made it clear that those of us who were educated had an obligation to use that education to help those less fortunate. There was a big debate in the family about where I would go to college, although law school never crossed my mind during those early years. I ended up at Spelman College, and I was going to go into premed until I met the frogs in my biology laboratory. But Spelman was the right place to be at the time. That's where the great speakers came—Dr. King, Dr. Mays, and others in our compulsory chapel. I later became the board chair at Spelman after being one of the biggest opponents of chapel while I was a student, and one of the first things I did as board chair was to reinstate compulsory chapel.

I also thought about studying music, to please my mother, until I got a Merrill fellowship to travel abroad in my junior year. After an enlightening year in Europe and the Soviet Union, where I met Nikita Khrushchev, I knew I could never go back to the South and live willingly under the confines of segregation again. I thought I would enter the foreign service until I volunteered at the local NAACP office in Atlanta during my senior year and realized that poor people could not get legal help when they wanted to challenge discrimination because they couldn't afford it. In Mississippi at that time, there were 900,000 African Americans and only four black lawyers. Some of my college friends in the Student Nonviolent Coordinating

The tragedy of our children is a national tragedy.
We know what ought to be done; the issue is, how
do we build the political will to do it?

Committee (SNCC) went to Mississippi to register blacks to vote, and I asked myself, How can you think of going into the foreign service when the revolution is about to happen right here?

So I decided to apply to law school at Yale and said if I get in, I'll go. I hated all three years of it. I found the classes dull, and I wanted to be in the South with my friends organizing voters. But I thought I needed a law degree to fight racial discrimination.

In 1961, in my first year of law school, I went down to Greenwood, Mississippi, to visit Bob Moses and other SNCC friends, and on the very first night I was there, there was a shooting. The next day Bob Moses marched a scraggly crowd to the courthouse to register them to vote, and the police set the dogs on us. I remember running and people scattering, and for the first time I understood in a deeper way the fear behind segregation. This was dogs, violence, mobs, young people being arrested. I grew up in South Carolina but saw nothing like this. I remember going up the courthouse steps after they arrested SNCC organizers and being stopped by policemen who wouldn't let me in. That was when I knew I would go back to Yale to finish and then return to Mississippi to practice civil rights law.

I finished law school and wrote briefs for the NAACP Legal Defense and Education Fund out of its headquarters in New York for a year before setting up law offices in Jackson, Mississippi, to handle cases for the Freedom Summer of 1964. I was the first black woman to pass the bar and practice law in Mississippi, and I was basically running a factory to defend the civil rights workers who ran the voter registration drive. I had twenty-five to thirty school segregation cases. It was a war zone, a violent era, where you could hear bombs going off and bullets flying by regularly. When I started my car in the morning, I would leave the driver's door open. I had been told that by doing that I would have a better chance of being thrown from the car and surviving if a bomb had been planted.

Eventually I realized that I could win cases but that if we wanted to bring about real structural and lasting change, somebody had to look at policy—at jobs, housing, food, education, safety—and answer the continuing attacks on the Mississippi Head Start program. The bottom line is that I recognized that the poor and blacks didn't have anybody to stand up for them when powerful senators like John Stennis and James Eastland tried to cut off federal support. They didn't have a voice in Washington. You can make as many laws as you want, but unless they are enforced you can't bring about enough change. So I decided to move to Washington, DC, where I took many of the lessons learned in Mississippi and founded the Washington Research Project, the first public-interest law firm to provide a national voice for the poor. It was also the seed of the Children's Defense Fund (CDF).

In the thirty-eight years since then, this has become the most dangerous time we ever faced. The prevailing ideology is to repeal the New Deal. The federal regulatory process is being changed. Technology, which allows us to reach many more people, also makes life much more complicated. Technology and media are controlled by too few, and in many ways it's now harder to get the message across and to frame issues and solutions in our ten-second entertainment-oriented culture.

I find myself going back into the community more, as we did during the days of the Mississippi Freedom Summer. Over the last ten years, CDF has put more money into state and local offices, where the majority of our work now takes place. In communities all across America, we have established summer literacy programs called Freedom Schools, and more

than seven thousand disadvantaged children are being served. This is a model that's been tested, and it's very effective. We have to train a new generation of leaders by empowering children so they can make a difference themselves.

We're also concerned about the children affected by Hurricane Katrina. Many of them were poor and in bad shape to begin with, and they're worse off since the hurricane. We want health care and mental health care for every one of those children. Another big new concern of ours as we go forward is poverty, as the gap between rich and poor becomes wider. There's a crisis in what CDF calls the Cradle to Prison Pipeline®, because a black boy who is five years old today has a one in three chance of going to prison. Poverty, race, and zero-tolerance school discipline policies are criminalizing children at earlier ages. And although we hear much about the crisis among black males, girls are the fastest-growing group being detained. The tragedy of our children is a national tragedy. We know what ought to be done; the issue is, how do we build the political will to do it?

We must get out of our comfort zones and build a movement. We must raise our voices. The mission of the Children's Defense Fund is to Leave No Child Behind® and to ensure that every child has a healthy start, a head start, a fair start, a safe start, and a moral start in life. I will work toward this mission with CDF forever. I think this is why I was put on this earth.

Theater is my passion and always has been. The creative process is very visual for me, and I'm always working on something in my head. When I was a girl, I used to take my jacks and balls and create little scenes in church.

My mother always took us to the theater and to the ballet and the opera. She was working on her PhD at Columbia University, and in the summer when we visited her she would take us to see performers like Marian Anderson, Paul Robeson, Katherine Dunham, and Dorothy Maynor, founder of the Harlem School of the Arts. And whenever the ballet came to Richmond, Virginia, she would take us to see the performances there.

She was a teacher, and she loved clothes. The minute she left the house—I could hear the car door shut—I would run to her bedroom and dress in her shoes, bags, and hats and then perform in front of her three-way mirror. A woman named Mrs. Boatwright from Savannah, Georgia, a wonderful seamstress, made clothes for us. We would show her pictures of clothes we liked, and she could throw a newspaper on the floor and make a pattern.

I began studying ballet in Richmond as a girl and took it up more seriously at The American School in New York City after I attended Hampton Institute. I studied science in college and was thinking of becoming a doctor. I was always passionately interested in theater but thought I had to do something else that was considered more respectable, until one day I got the nerve *not* to do something else. In New York I discovered that I was a wonderful dance technician, and I thought, I can do this. I performed in concerts in the United States and Europe, did some television specials, and one summer was offered a job in a Broadway musical called *On the Town*. That was the turning point for me.

This was in the late 1940s, and as a black woman performer you just really had to be better than anybody else. The director Elia Kazan saw me dance and auditioned me for a play. He did not use me, but he saw something in me and got me a scholarship with Lee Strasberg, whom I worked with for eight years. That was when I made the leap from dancing to acting.

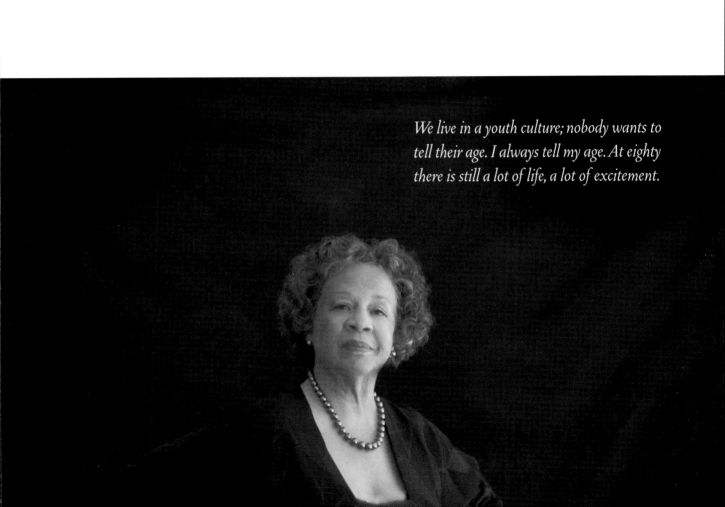

We live in a youth culture; nobody wants to tell their age. I always tell my age. At eighty there is still a lot of life, a lot of excitement.

My first acting job was with Ethel Waters in *Mamba's Daughters*. Some of the highlights of my career are performing in *A Raisin in the Sun* and *Blues for Mr. Charlie* on Broadway, in *Bohikee Creek* with James Earl Jones, and in the films *Winter Kills* and *The Wiz*. I've also done television: the Hallmark Hall of Fame, Kraft Theater, *Law and Order,* and even a few soaps like *As the World Turns.* Vinie Burrows and I were in a soap commercial together. I think I was the first black woman to do this. I think of moving from dancing to acting as a natural progression. Even now in looking back I realize that everything I have done has been a stepping-stone to where I really wanted to go next.

I just directed a play called *Funny House of a Negro.* Forty years ago, Adrienne Kennedy wrote this groundbreaking play that takes place in the subconscious of a young black woman who is having an identity crisis right there on the stage. It's all very surreal. I originated the role, and now I'm directing it at the Classical Theater of Harlem. It's quite a challenge, but I realized that I knew this woman and could get into her subconscious. I've also directed other productions, including *The Brothers* by Kathleen Collins and three or four plays by Philip Hayes Dean.

Of all the things I've done, though, my biggest moments were the births of my two children. I always recognized that as the seminal experience. Raising two children while working was also the biggest challenge, of course.

I've always mentored at least two or three people in the theater at any given time. I wish I'd had a Billie Allen to mentor me when I first went to New York. That's the way I was raised, it's who I am. My parents encouraged us to give back. It's not about you. My mother would always say, "You are no better than your brothers, and whatever is happening to anyone in the world could happen to you." It's fulfilling and exciting when you see other people grow. That vision is part of the cycle of life. And as they say, what goes around comes around. I think that there is so much for everybody, it's not a competition. We all need each other.

Things have opened up for black people, but not nearly as much as they should. Our progress comes in small increments, in waves. We go forward two steps and backward three

steps. I feel black actors now have wonderful programs and can study all over the world. But the opportunities are not given, they are seized. You have to be ready to take big risks, and you have to have confidence that it's going to be fine. You sweat a lot and you sacrifice a lot. The work is hard, tough, and sometimes lonely, and you don't always get approval. But I love the process, and my faith keeps me going.

We need to pay more attention to arts and literature. You can change the way people think through the arts. You can reach them on a very deep subconscious level, and in many instances it really does change our perception of life. Theater is not only entertainment, it's also a way to persuade and inspire. People often say to me, "Oh, you've changed my life forever."

I remember doing *A Raisin in the Sun* on Broadway, and this woman I know had come to see it, a white woman from the Midwest, and afterward she said to me that it had occurred to her that our families are so similar. She said she saw her family up there on the stage. That's what it's all about. How many times have you read a book that changed your perception and thought? The arts can open your eyes. I think that's what we as actors live for.

We live in a youth culture; nobody wants to tell their age. I always tell my age. At eighty there is still a lot of life, a lot of excitement. My sight may have dulled, but my other senses are sharper. As I get older, I feel much more comfortable. I realize that everything doesn't have to be a challenge. Some things can be a joy. When you have done the things you set out to do, you get the chance to feel good about yourself. And I have seen and experienced so much all these years. I saw Marian Anderson perform at the Met! I never thought I would live to see that. Alice Walker's *The Color Purple* is making Broadway take notice. Oprah Winfrey is a producer. She's a powerful woman who commands attention. Linda Twine, who was the musical director for *Jelly's Last Jam,* is conducting the orchestra, and there's an extraordinary cast of talented and well-prepared African American actors. Buses are coming from all over to see this show. It's thrilling. I am here for all these wonderful things, and that's what keeps me going.

Sisterspace and Books was my life. When we were evicted from our building, a part of my mind and spirit was evicted from my body.

Cassandra Burton, my former partner, opened a clothing consignment boutique on U Street in Washington, DC, in 1989, and the store immediately became a special place for African American women. Our customers would come to the store to shop, but they also shared their daily trials and tribulations as though they had been called to the altar to testify. It did not take us long to realize that we had created a safe haven. We saw a need for a space where black women could go to talk freely and not feel intimidated or judged. We established a Saturday morning discussion group and within weeks had twenty-five to thirty women coming to the store at 10 a.m. Our discussions were as varied and intense as the women who attended. The grapevine worked overtime, and a sense of pride about the store quickly helped to spread the word.

The discussions made it clear to me that we needed more information, so I brought a shelf from home and some of my books. Those on self-image, spirituality, music, health issues, financial topics, education and career choices, sexuality, hair, and skin color were the most popular. Cassandra's consignment was the place to be on Saturday mornings.

Then in 1992 three black women writers made the *New York Times* bestseller list—Terry McMillan, Toni Morrison, and Alice Walker—and I wanted to open a bookstore. My passion has always been promoting literacy. I know so many people in Washington who do not have basic literacy skills. When I was a child growing up in Gainesville, Florida, the city bookmobile would come into the neighborhood, and the black children could not choose their own books. Instead the driver would choose any three books and hand them to us through the window. The white children were allowed to enter the bookmobile and choose their own books. I decided that one day I would have all the books I wanted and make sure that others who wanted books would also have access to them.

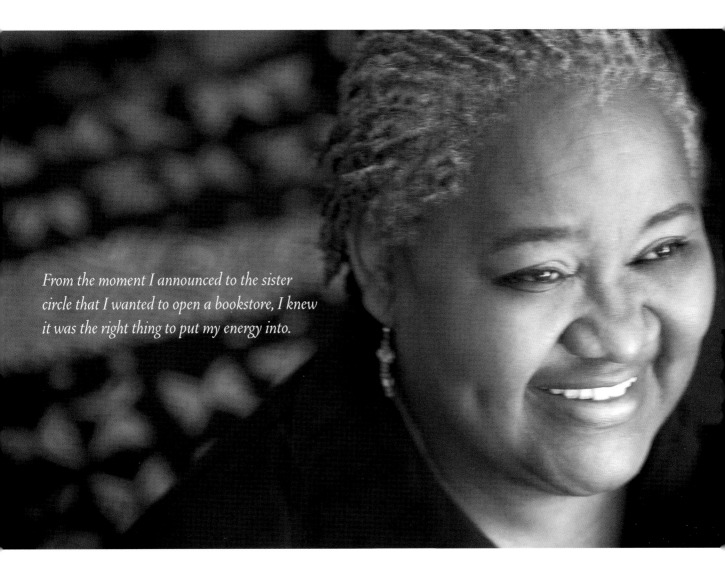

From the moment I announced to the sister circle that I wanted to open a bookstore, I knew it was the right thing to put my energy into.

From the moment I announced to the sister circle that I wanted to open a bookstore, I knew it was the right thing to put my energy into. I had no experience with opening or operating a bookstore, but I had the vision, the will, and a group of women who applauded the idea. That was enough to begin with.

I started making calls to anyone and everyone who I thought would help. A really nice representative at the American Booksellers Association (ABA) told me that I would need at least $50,000 to open a decent bookstore. We didn't have that kind of money, and her comment went in one ear and out the other. I just kept calling 800 numbers to get more advice. Most of the sales reps would listen a little, laugh a lot, and tell me to complete ABA training and get some money and then call back. Some of them told me I was crazy and hung up. I was hurt and disappointed but more determined than ever to find help.

Finally I reached Manie Barron, an African American man who was then a telephone sales rep at Random House. He was the miracle I needed! I called him weekly, sometimes three times a week. Manie traveled around the country and knew that books by black women were selling well in white-owned chain stores and black independents. My weekly question to him was, Why not let us sell them in a store owned by black women? After a few months, I finally convinced him that we had enough women eager to buy books, and he sent me the credit application to open a $10,000 account at Random House. The following week, we had books. I was delirious, the sister circle was ecstatic, and Manie was no longer being stalked!

Before we could even open all the boxes, the sisters were running up the steps to buy the books. Women were coming at ten in the morning and staying all day. We also sold books by Black Classic Press, and that attracted the serious political readers. We were about celebrating ourselves, and other people became a part of it. We only had four hundred square feet of space but lots of energy and joy and hope.

In the beginning several publicists and agents told us that the publishers were not going "to waste their money and send black writers to you" because we were too small and not on the map. I decided to ignore them and to reach out to the authors ourselves. We created a newsletter and did unconventional things to get the word out, like going to the chain stores and asking the authors to come to our store. Nikki Giovanni was the first big-name author to come to our store to read and sign books. We also got a little divine intervention. One day one of the local author escorts—a young, openly gay, white man who was very enthusiastic about black authors—called and asked if we wanted Susan Taylor, editor in chief at *Essence* magazine, to come to the store and sign books. Of course we said yes, and from that moment on, we were on the map.

We had books, clothes, and boxes everywhere and soon outgrew that location. The UPS man would come to deliver boxes of books to our cramped space. He thought we were crazy and often told us so. Every day I would take a walk past a building I really loved, and one day I noticed a For Lease sign in the window. Within three months we were in the building. We didn't have much money, but we knew the history of the U Street corridor and wanted to stay in the area. We had also created strong relationships with people in the community, and they wanted us to stay.

In 1996 we moved two blocks to a larger location. Cassandra had decided to close the consignment store, and we became a full-time bookstore. We also offered GED classes, an after-school program, and numerous workshops and events. We became a community-based institution.

Immediately after we moved into the new location, we started having problems with the building and the trustees—disagreements over maintenance, repairs, trash pickups, and snow removal—that escalated over the years. There would be days when we had no heat or air-conditioning. In the third year of our five-year lease, with little to no progress with the

trustees, we started paying the rent into an escrow fund as a way of protesting and to attempt to force the landlord to respond to our requests. We did not anticipate a four-year legal battle.

In 2004 we were informed by prospective buyers that the trust wanted to sell the building. We wanted to buy it too. We got support from the community and worked with Industrial National Bank and made several offers, the last on July 29 in mediation. We left the courthouse thinking we had an agreement and understanding with the trustee to buy the building. We returned to the store and contacted all the media to announce that we would become owners within weeks. That Saturday, on July 31, we had a celebration and fund-raiser at the Lincoln Theatre. Unbeknownst to us, the trustee had signed the final eviction papers after we left the courthouse.

On Tuesday, August 3, 2004, the day Charles Ogletree was due for a book signing, federal marshals entered the building with an eviction notice, ordered me and my mother to leave, and started placing our possessions on the sidewalk. I was stunned. My mother was in shock. Cassandra and her mother arrived within minutes, and our activism kicked in. We called the media and others in the neighborhood and within twenty minutes had fifty people in front of the store. They lovingly packed and stored our inventory a block away. I had separated the books we needed that night for the Ogletree book signing.

I refused to stop and feel the pain. I was in a state of shock, and over the next several weeks, I soothed myself with food, cried a lot in private, and listened to painful stories from others who were also devastated. I was in a manic state, trying to figure out a way to make a bookstore appear. I was going crazy!

Finally some sisters pulled me aside and told me that I had to go to therapy or I wasn't going to make it. They suggested that I stop, get some help, and reopen the store later. I knew they were right, but I felt that I could not live without the bookstore. I was a workaholic and had lost my personal identity. I was obsessed with Sisterspace and Books and didn't know how to live without it. Months later I had a breakdown, and that was the day my healing began.

After a year in therapy, I've learned a lot about myself and others. I have learned to value myself more than ever before and to love others in a deeper and more meaningful way. I am learning to maintain boundaries and to honor my great need for privacy. We were not trained social workers or counselors, and we should not have been so emotionally involved with our customers and community. My new way of life includes balance, structure, meditation, rest, exercise, healthy foods, and lots of new books and close friends. I now have a glorious vision for a new Sisterspace and Books.

When I reopen a sister space, I will never be behind the counter again. My role will be behind the curtain, which is a healthy place for me. There's a lot of gentrification in this area, and we need a community center, a cultural and educational center, now more than ever. We need workshops for women who ask, "How do I buy a home?" and "How do I get out of debt?" My goal now is to figure out how to transfer all the knowledge gained from running Sisterspace and Books for ten years.

My mother, my greatest hero, went back to school to get her GED while raising seven children. She instilled in me the desire to learn and to pass on knowledge. I also admire Georgia Douglas Johnson. She lived near here in the 1920s and organized the Saturday Nighters, a writers circle that included Alice Dunbar-Nelson, Langston Hughes, Alain Locke, Claude McKay, Mae Miller, and others. Dr. Eleanor Traylor, chair of the department of English at Howard University and my chosen mentor, helped me to see how to merge my love of literature and community activism.

I am blessed to have been able to live a life as a community activist and to have a role in promoting literacy. I believe that I've made valuable contributions to our community and to the whole society. I have also learned the hard way that we as black women need to take care of ourselves first. Then we'll be in a much better place to help others. I cannot love you if I do not love myself.

Romaine Thomas ♦ 77

President, Washington, DC, Chapter of AARP;
Retired Elementary School Principal

I had Christian parents who struggled to provide a warm and nurturing environment as well as a comfortable and happy home as I grew up in Washington, DC. My dad was a mechanic by trade and owned several trucks for his hauling business. He worked long hours to gain a decent income for his family. Mom stayed at home during my elementary school years, and when I was thirteen she went to work at St. Elizabeth's mental hospital in Anacostia. According to the standards for being poor, we were just a few steps above the poverty line. But my spirits were always high, and I never felt the need to seek materialistic trappings or a pretentious lifestyle. My brother and I knew exactly what was expected in terms of behavior. I've always looked at life in terms of service and trying to inspire others to achieve. I got this from my parents. They did not have degrees in higher education, but they had principles and values that were never compromised.

As I focus on my career, it is quite obvious that I had a passionate love, respect, and appreciation for children. At one time I wanted to be a pediatrician. Later I thought of being an architect, because I was always fascinated with beautiful buildings, freestanding structures, and design. But when I came out of high school, my parents didn't have the means to afford Howard University or medical school. It was more affordable to become a teacher, so I went to Miner Teachers College, in our hometown.

After finishing college, I went on to obtain a master's degree at George Washington University and continued my education at Howard University, Vanderbilt University in Tennessee, and other institutions for higher learning. I taught elementary school for approximately thirteen years. Then I was selected to serve as supervising instructor at the Demonstration School, and I had the responsibility of training students in the art of teaching. This proved to be a gratifying experience. It was wonderful to know that I had an impact on the teachers who would fill the classrooms in the DC public schools. After this assignment, I accepted the position of assistant principal at Ketcham Elementary in Anacostia and became the principal in 1971.

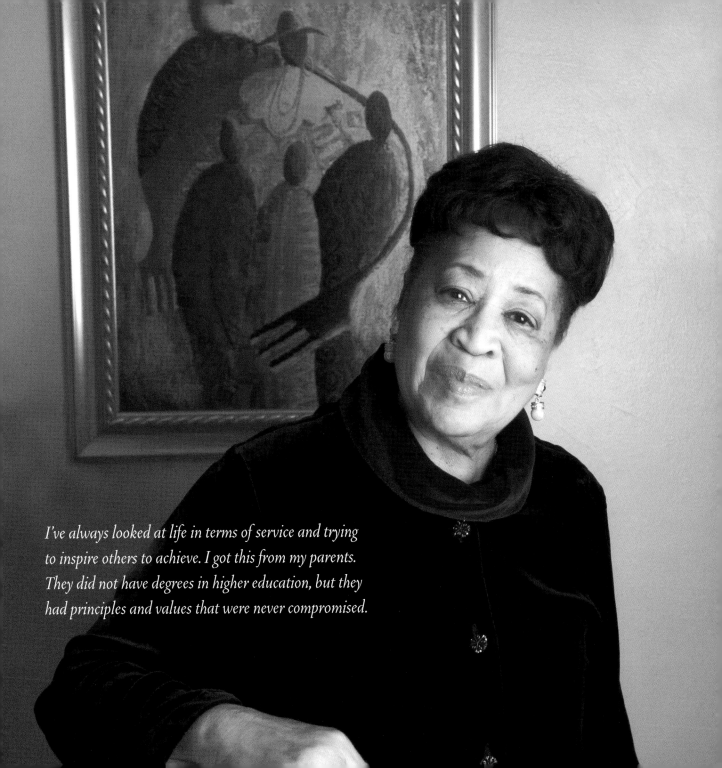

*I've always looked at life in terms of service and trying
to inspire others to achieve. I got this from my parents.
They did not have degrees in higher education, but they
had principles and values that were never compromised.*

Although many of my children were at risk due to social and economic barriers, as well as abuse and neglect, I stayed committed to our mission of providing a quality education for all the children at Ketcham Elementary School. Parents, teachers, support staff, and the community were important in this effort. By working together as a team, with my leadership, the possibilities became realities. We created an exciting and contagious learning environment where children wanted to succeed.

People would often ask why I decided to become a principal in the DC public school system. Yes, it was a tough job, but I had watched my parents struggle through tough times, and perhaps that's why I've always liked challenges.

In 1971 I was one of two African-American principals from forty-six states to receive the National Distinguished Principal Award. The program honors outstanding elementary and middle school administrators who assure that America's children acquire a sound foundation for lifelong learning and achievement. It is jointly sponsored by the U.S. Department of Education and the National Association of Elementary School Principals. I am convinced that my selection was a result of my hard work and dedication.

My husband, Harry Thomas, had a passion for civic duty and politics. When he served as a Washington, DC, council member, we were a team that became very involved in the community, school affairs, and local and national politics. We were strong advocates for children and civil rights. I believe that my interest in education influenced Harry to become involved in children's issues when he served as council member.

One of the most tragic events in my career occurred on September 11, 2001. A teacher and student from my school were killed when the plane that they were traveling on crashed into the Pentagon. It was a heartbreaking loss of life for the DC public schools and the National Geographic Society. This was supposed to be an exciting and enjoyable learning experience at a wildlife sanctuary in Santa Barbara, California. Instead the evil forces of terrorism sent shock waves around the city, our nation, and throughout the world. What had been a normal, crisp, and beautiful fall school morning turned into an atmosphere of disbelief, fear, insecurity, and concern for our safety and survival.

I quickly realized that I had the challenge of leading others through what were probably some of the most difficult days of our lives. This was the ultimate test of my leadership and the spirit of human endurance. My parents, students, families, and staff members were greatly affected, and I had to restore faith and maintain a productive school environment. It was gratifying to realize that I was not alone. The tremendous outreach and compassion of people throughout this city and around the world gave me the strength, courage, and faith to provide strong leadership. The acts of kindness and love gave me the faith and confidence I needed to get through the many days ahead.

Prior to 9/11, I had been contemplating retirement. This persuaded me to finally retire at the end of the school year. It had been emotionally draining, and I felt it was time for a change. I tried to look forward and think about other ways I could contribute. I knew I would still have to be actively involved in the community and service for children. Knowing myself, I just knew I wouldn't be sitting at home.

Someone made me aware of the position of state president of the DC chapter of the AARP and encouraged me to apply. I saw this as another calling for service, and I accepted the challenge. The selection panel was comprised of national and regional officers. It was a competitive, rigid screening process. I was the successful candidate.

AARP volunteers are the heart of the organization, and as the state president of AARP Washington, DC, I serve as the lead volunteer in this area. The organization provides information, advocacy, and service, with a focus on people age fifty and older. The motto of the founder, Dr. Ethel Percy Andrews, provides the foundation and purpose of the organization: "To serve and not to be served." I was happy to join in this spirit and engage in programs that make a difference in the quality of life for people as they age.

My philosophy at this point in my life is to make the most of every day. The opportunity to serve others has unique benefits that have brought fulfillment to my life. The many experiences and people I have encountered over the years have enriched my being and given me a broader perspective and appreciation of the meaning of life.

I became a literary agent after practicing law for ten years. My parents wanted me to be a lawyer, and that's probably why I became one, because I certainly didn't have an interest in law. When I finally decided to do something else, I knew that whatever I did would have to suit my interests, and what I was most interested in was the milieu of books and writing, a world I'd known all my life. My parents were book collectors, and I grew up in a house filled with books. They allowed me to read whatever I wanted, and I read everything. Dad was in government, and Mom was a teacher. I had an intellectually and culturally stimulating upbringing.

I decided to become a literary agent rather than work for a publishing house, because I didn't want to work for a corporation. I knew something about that life from my days practicing law. By this time I was in my early thirties, and I had reached a point where I knew what I wanted.

Quite early in my career as an agent, it was evident to me that so little of the African American experience as I know it was represented in the books being published. There was and continues to be a disproportionate representation of African Americans who are ignorant, dangerous, and poor. One can experience myriad examples of the negative aspects of the African American journey and have few positive reading experiences. What was missing was the solid, culturally rich milieu I had known as a child—a world of going to the theater, ballet, symphony, and museums. Too often that absence continues in what is published today. I consciously set out to acquire authors whose work represented aspects of the African American experience that didn't conform to stereotype. I don't represent African Americans exclusively. I never have. I wanted to represent books that were wonderful in and of themselves. I think I have done that.

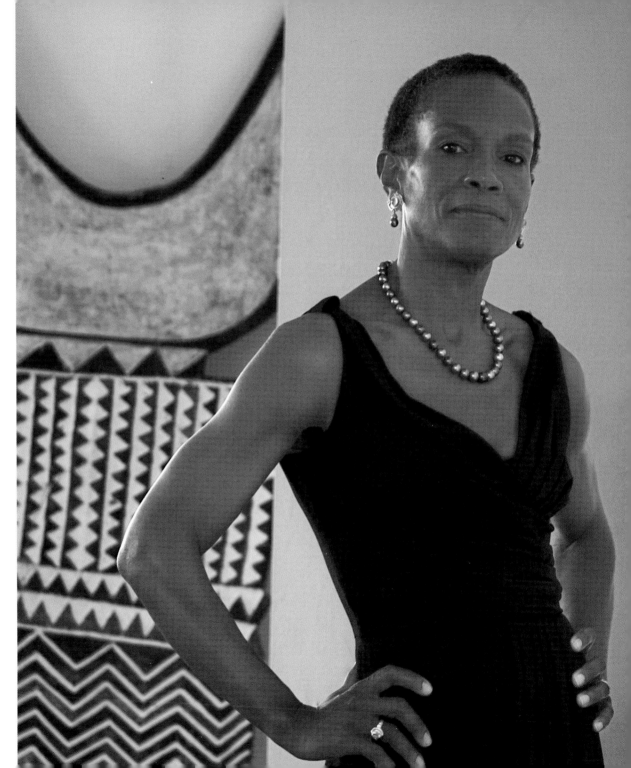

Publishing is a challenging business because it is based on opinion and taste. The composition of the industry is not representative of the general population, and it is often difficult to convince editors of the merits of authors whose experiences may be foreign to them. Frankly the industry is not diverse. One could argue, and I have said as much, that the editorial ranks are segregated. In a perfect world editors must be advocates for authors. And it's often very difficult for editors to advocate on behalf of work they neither accept nor believe in, work that doesn't conform to a limited vision of black life. Constantly I must convince people that our work has value, that it is literary, relevant, and publishable.

I am reminded again of my upbringing. I was raised in an environment of inquiry, and the worst thing you could do was dismiss something at once. That was the very definition of ignorance, and we were raised to be anything but that. Yet in the publishing industry there are ideas about who can do what, and standard ways of thinking about what constitutes African American literature, and even about how that literature is to be presented. For example, it seems that the covers of black books have to convey exactly what the content is. It's never abstract. It is as if you have to have a big red arrow over the book saying, "Hey, this is a black book."

Despite these challenges, I love what I do. In my work, I am able to satisfy my intellectual curiosity. Every day I sense that there's so much to learn. That's why I love discovering writers and why I love books and continue to read widely. I probably have five thousand books in my home. I think my floors are beginning to sag. I've been a collector just like my parents.

I don't represent African Americans exclusively. I never have.
I wanted to represent books that were wonderful in and of
themselves. I think I have done that.

I donate to libraries, and I'm always recommending books to people—my doctor, whomever. I try to get people to read things they might not have read normally, and then I see them six months later and they say, "Oh, I'm so glad you told me to read that book." That's gratifying.

To relax I practice kung fu. It gives me energy and a sense of inner calm, physical grace, and power. It's a way of making one's physical limitations into a source of strength. It teaches you to increase the power that you have.

Last year, with two other women, I started a new organization for women to help change the perception of menopause. The organization urges women to concentrate on their wisdom and to emphasize their power and creativity. A new life stage begins at age forty, and we know so much more now when we reach this point in our lives. We disseminate information for women who are poised for change.

I've had a fulfilling personal life and career. I have been fortunate in that I've been very rich. I'm not talking money. I'm talking great family—my mother, father, three siblings. My father passed away, but the family remains close. The family I formed as an adult with my husband has been another source of strength for me.

I've always had a lot of confidence. I just had to figure out how to put it all together. Part of being successful is measuring success in terms that mean something to *you* instead of using external measures. With fifty comes a kind of wisdom, and I'm very clear now about who I am, where I come from, and what I value.

I was out shopping with a friend of mine the week before Christmas, and when I got back home Paul was packing his things. It was a workday—I had taken off to go Christmas shopping—and I did not expect to see him there. I asked him why he was home, and he told me he was leaving and that he would never be back. I was surprised, but yet in a way I wasn't. Our marriage had been up and down for more than twenty-one years, with good times and bad times. For a couple of months before Paul left, there was no communication. But I didn't make too much of it. I thought it was just another phase.

When he said he was leaving that day, I figured, Okay, he's going to go. He's going to be fifty soon and he wants to live his life. This was about four and a half years ago, and I was forty-eight or forty-nine at the time. There was no adultery or anything like that, but over the last few years of our marriage, he was always talking about change. Change, change, change. Still, communication was a problem for us. We talked all the time, but we weren't talking about what we needed to talk about. Paul was very angry with me, and if you are bitter you are going to block progress. He also thought I was too hard on the children and that my mother had too much influence over me.

Toward the end of our marriage, he became more involved in the church, and he thought I wasn't spiritual enough. He said he wasn't getting anything out of our church and changed churches. He asked me to visit his new church and I did. We are both Christians, but there are different ways of practicing, and I didn't care for his church. Our two daughters also preferred our original church—they thought his was too loud—and he blamed that on me, because he thought I had influenced the girls.

After he left I panicked a little. I thought, Oh no, what am I going to do? Suddenly I was faced with taking care of the house and two teenage daughters alone. I got married five years after graduating from college, and before that I had a roommate and also lived at home with my parents. Taking care of an apartment and paying a few bills when you're in your twenties is

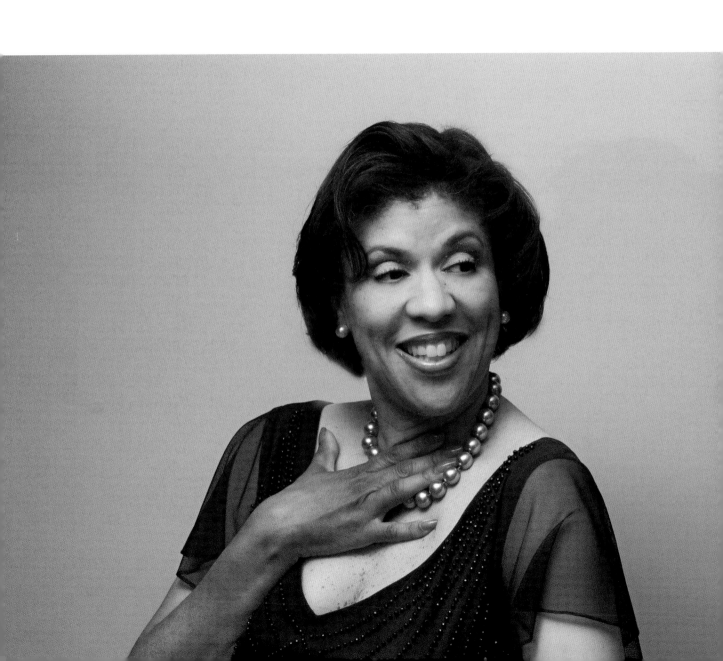

nothing like taking care of a house with a big yard and two daughters when you're approaching fifty.

Three weeks after Paul left I got pneumonia, and I was sick as a dog. I was off work for almost a month. My mother had a mild stroke just before Paul left, and she tried to help me when I got sick and got pneumonia herself. So my daughters took care of me.

My job was also in jeopardy around that time. The assistant principal at my school tried to get rid of me, and to this day I'm not sure why. We had a new principal at the time, and she didn't know me or my work, so she decided to let the assistant principal handle it. Fortunately my principal came through at the last minute and said she would give me another chance.

I survived all of that, and I am convinced it was all meant to happen. It was a challenging time, but my spiritual beliefs helped get me through it. My friends and my family also helped. I worked with two ladies who are very spiritual, and they prayed for me. I also prayed a lot, and I tried to be philosophical. I always tried to be positive.

I still believe the marriage could have worked out, but it takes two people who are willing and want to make an effort, and Paul didn't. He recently remarried, and we're cordial now for the sake of the children. Divorce is always tough on children, and the girls are still adjusting. Krystle, the oldest, followed in my footsteps and attends Hampton University in Virginia. Marissa is thinking of going to another college in the Hampton-Norfolk area.

Dating again was the last thing on my mind for a while. I was really concentrating on trying to get my marriage back together. Elmore was the electrician at the high school where I teach. We had known each other since high school but not all that well. After Paul left, Elmore would come over and help around the house. We would talk, and I began to confide in him. About three and a half years after Paul left, we started dating. If I hadn't met Elmore, I'm honestly not sure I would have dated again.

At first I wasn't sure if I ever wanted to get married again, but now I am. I like being married. Maybe I'm old-fashioned, but for spiritual reasons I'm against living together. I don't see myself changing my mind, but I guess I could. Elmore has never been married and considers himself an eternal bachelor. But I want to have the option to get married if it comes to that. I feel I'm at a fork in the road now with him. Do I go my own way with my spiritual and marital beliefs or stay with him?

I'm a work in progress. I'm happy and thankful for the things I have. I count my blessings and thank the Lord that I'm still here. I think I'm still in my right mind. It's all good.

I'm a work in progress. I'm happy and thankful for the things I have. I count my blessings and thank the Lord that I'm still here.

I remember when my agent called and told me that an editor at HarperCollins wanted to publish my first novel, *Sisters and Lovers*. At the time, I was working at Gallaudet University in Washington, DC, as a managing editor, and I had spent the past year getting up at five in the morning to work on my novel before going in to the nine-to-five. It was the first time I had ever submitted a novel to anyone, so when Victoria Sanders called to give me the news, I was beyond excited. It's always thrilling to have a book published, but nothing matches the thrill of the first one. That's when I finally realized that, no, I was not nuts. I really was a writer, and someone in the publishing industry thought enough of my work to publish it.

After I said, "You're Kidding!" a hundred times to Victoria, we hung up the phone and I ran outside my office, down the hall, and out of the building. I looked across the campus and screamed at the top of my lungs.

That was in about 1993, and I was forty years old. It's not like I had never wanted to be published before. I had dreamed of being an author for years. But when I was growing up in the sixties and seventies and climbing the career ladder in the early eighties, there were few black authors, and none of them were writing contemporary or pop fiction, which is what I saw myself writing. The novels by black authors back then were serious literary fiction and generally focused on tragedy. I greatly admired those authors—Alice Walker's *The Color Purple* is one of my favorite novels—and I was inspired by them. But I knew that not all black people struggled financially or were in abusive relationships and that we like to read stories that reflect our varying lifestyles. America had an expanding black middle class by then, but it was largely being ignored in fiction. For years, I assumed that publishers weren't willing to publish other kinds of fiction by black authors.

But as someone once said, if you have a strong urge to write it has to come out. After graduating from Hampton Institute I attempted a few short stories and even started a novel or two. I showed them to a couple of friends—some of them laughed and told me I was crazy, others

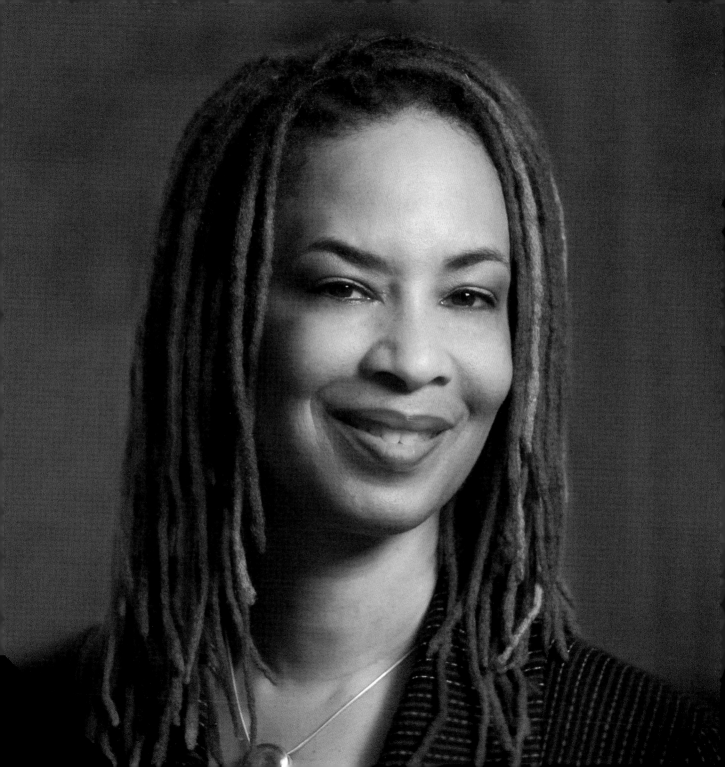

were encouraging—but I never submitted them. I think I was waiting until the time seemed right, and somehow I *knew* the time would one day be right.

Both of my parents were college educated, but they always talked about how few jobs were open to black college graduates in their time. They could be teachers, government employees, and sometimes doctors, dentists, and lawyers. But corporate America and the arts still largely shut us out until after the civil rights era. My parents always said to me and my sister Pat, "Things are much better for you than they were for us. You can do and be anything you want if you work hard for it." They said things like that so often as I was growing up that I came to believe it. Not only did I believe it, I thought I had an obligation to do more, to dream and reach higher. I felt that my parents' generation had done so much against such huge odds to open the doors for my generation that it would be almost an insult to them not to take advantage of it.

As a black woman with a hearing loss, I sometimes found the challenge daunting, but the message from my parents was that none of that was an excuse. I believe that's why I've come to feel that my hearing loss, my race, and my gender will always present special challenges, but they are challenges that I can overcome.

Then one summer in the early 1990s, I read Terry McMillan's first novel, *Mama*, while on a road trip through Quebec with a girlfriend. That first novel by McMillan dealt with the usual black themes, but it was also very funny and easy to read. I remember my roommate giving me sideways glances as I laughed out loud in the passenger seat of the car as she drove. When I closed the pages of the book, I began to think that the novel I had been forming in my head for months—about three contemporary, middle-class sisters and their problems with the men in their lives—might no longer be such a radical idea after all. Maybe the time was right.

I can honestly say that although this writing life has been a struggle at times, I wouldn't change places with anyone. I have days at the keyboard when I want to yank all my hair out, and I sometimes have what seem like impossible deadlines to meet. But I love my life as a writer. Over the past ten years, I have had a front-row seat to witness an amazing cast of characters as they prance across the stage to publishing glory. It's nothing short of remarkable,

especially when you consider how little we progressed over the previous two hundred years. Not that long ago, you knew just about every black author and book by name. Now there are more black authors and books than you can count, and they are writing in every genre imaginable and creating new ones.

Although we've come a long way over the past decade, I hope we're just getting started. I want to see more black editors, executives, and marketing people working at the top publishing houses. I want to see black-owned publishing houses that have authors appearing regularly on the bestseller lists. And I want to see more of our books segue to other media such as movies, plays, and television series.

A few years ago I had a new surgical procedure that has corrected most of my hearing loss, and it feels like a whole new world has opened back up to me. I hadn't been able to enjoy music since the days when we used to shake our booties to the Motown sound. I remember walking into one of those music superstores not long after the surgery and checking out all the new music technology. It felt like I had just woken after a long, twenty-year hibernation.

I used to think that my hearing loss was so unfair. But now I know that it made me tougher, hungrier to experience all that life has to offer, and more observant of the people and things around me. I believe it sharpened my other senses. And I know that it has made me keenly aware that we all have challenges, obstacles, or disadvantages, some of us more than others. It may not be fair, but it is what it is. Nothing should stop us from dreaming and doing whatever it takes to realize our dreams.

S ign language interpreting has taken me to places I never expected to go. On freelance assignments, I've interpreted overseas, on cruise ships, and for President Bill Clinton, Tipper Gore, and Ruby Dee. In about 1984 author Connie Briscoe hired me to be her personal interpreter, and we traveled all across America together during her book tours. But learning to sign well enough to get the top assignments was hard. I faced all sorts of obstacles along the way, and as an African American interpreter, it took me a lot longer to grow than it does most whites.

I became fascinated with sign language when I was about eight years old. I had an uncle who worked as an attendant at an Exxon gas station near Gallaudet University in Washington, DC. A lot of deaf people went to that station, and my uncle learned to sign by talking to the customers. He would come home and sign, and I would try to copy the signs. For some reason I thought it was amazing that you could communicate with only your hands and facial expressions.

Then when I was about eleven or twelve years old, I was shopping downtown and met a black street peddler who was deaf. You know the cards that have the sign language alphabet on them? She was handing those out and asking for donations. Meeting her increased my desire to learn sign language. I thought if I could learn to sign well, I could somehow work with deaf people.

I didn't know it at the time, but later I learned that those deaf peddlers have to turn most of the donations over to the people who hire them. They don't have much income and they're being exploited. When I realized that, I felt guilty and ashamed that I had contributed to the practice.

Being sensitive to the needs of others came from my mother. She was always taking people in or helping someone in need. I grew up in a household with four people, but our extended family was huge. Even when it was just the four of us, my mother would cook enough to feed

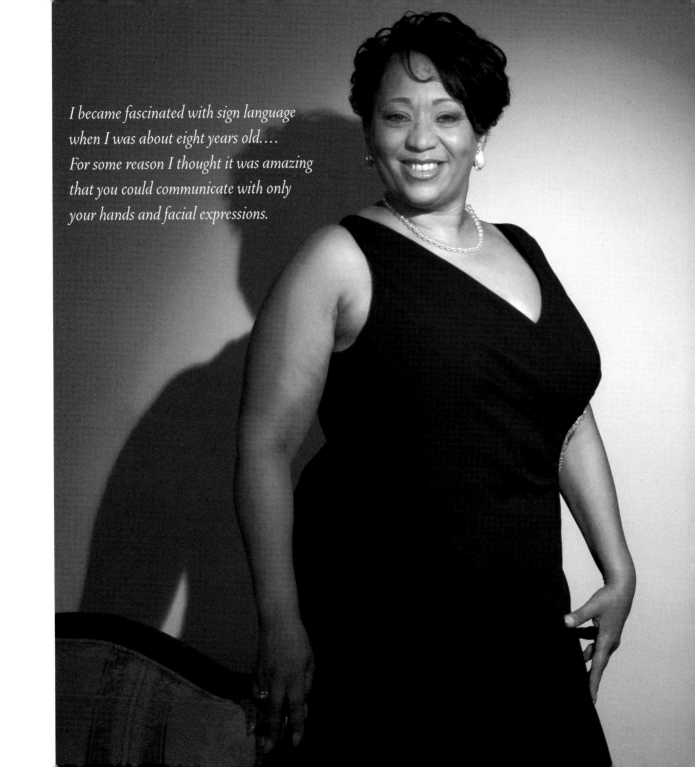

*I became fascinated with sign language
when I was about eight years old....
For some reason I thought it was amazing
that you could communicate with only
your hands and facial expressions.*

an army and give it away. Plates were prepared, wrapped, and delivered with love. We didn't have a lot, but Mom knew we had more than others. I once tried to replicate my mother's giving and decided to share her pork chops with some of the neighborhood kids. Needless to say, the members of my family were not thrilled with the idea of having only one chop left per person at dinner.

I tried for years to get a job at Gallaudet University and finally landed one in about 1979. I worked in the dean's office at Kendall Demonstration Elementary School, which is on the campus, and was able to take free sign language classes. But I worked in the administrative offices and had very little contact with deaf individuals. Then I met a woman there named Nathie, an instructor who worked after school as the sign choir director. Nathie knew that I wanted to improve my sign language skills, and she told me that the only way I would learn to sign fluently was to learn from native signers. She encouraged me to get involved with the deaf community, so I volunteered to work with the children's choir. I eventually learned to sign so well that people often thought I was deaf.

I left Gallaudet after three years for a job as an interpreter in the Prince George's County, Maryland, school system. By this time I knew that I wanted to be a sign language interpreter. I had learned that there were few black interpreters and none in the Prince George's County public schools. One black woman in the school system could sign, but she was an instructional assistant. Most of the deaf and hard of hearing students we serve are black, and they deserve to have language models who are sensitive to their culture.

After three or four months in the school system, I realized that I didn't have the skills needed as an interpreter. I was in over my head. Being an interpreter requires more than just fluency in sign language. Spoken English and sign language don't translate word for word. You have to translate phrases and meanings, and it can get tricky. I'm *still* learning, because the language is always evolving. The students at the high school where I work now keep me up to date with the hip-hop signs, like the sign for "bling-bling."

But the school system was desperate for interpreters, and they wanted me to stay. To improve my skills, I decided to do freelance work, and that was where I faced some of my biggest challenges. There's a lot of discrimination and cultural misunderstanding, since deaf

consumers, who are mainly white, often don't want a black sign language interpreter. They think we don't understand the English language well enough to be good interpreters or that we're not sufficiently trained.

This was probably my lowest point. I wanted to be an interpreter so badly, and I wanted to do it well. But I was constantly running up against roadblocks.

I decided that I would have to become certified nationally, among other things, to improve my qualifications. You don't have to become certified to work as an interpreter, but it increases your chances of being hired. For black interpreters who want to freelance, it's almost a must. We always have to be 150 percent better.

So I sat down and wrote myself a professional development prescription. It included three main steps that I would take to improve myself: take sign language classes for interpreters, find mentors, and attend conferences to network so I could become certified. This wasn't as easy as it may seem at first. I was a single mother living in Washington by then and working two jobs.

After a long search for sign language classes that I could fit into my schedule, I finally found the Bicultural Center in Maryland. I also found a mentor while on a freelance job, a white woman who really helped me along. And I discovered the active black deaf community—the DC Area Black Deaf Advocates, a chapter of the National Black Deaf Advocates, Inc. I told them of my challenges trying to become a better sign language interpreter, of having no deaf family and friends and little access to classes. They were very receptive and encouraged me to attend their meetings and to volunteer. I picked up a lot doing that and eventually became the group's interpreter. I would interpret whenever hearing people presented to the group. One of my proudest accomplishments was becoming nationally certified, and the experience I gained from interpreting for members of the Black Deaf Advocates helped a lot.

While I'm always happy to get an assignment to interpret for a celebrity, interpreting for the public school system is still my main focus. It doesn't pay much money, and I've thought of leaving and doing something else. But I'm committed to the students. I think I'm making a difference, and that's important to me. I learned from my mother that we all can make a difference in someone's life, and I'm glad I have a career that lets me do exactly that every day.

Alma Adams ◆ 59

REPRESENTATIVE, NORTH CAROLINA HOUSE OF
REPRESENTATIVES, GREENSBORO; PROFESSOR OF ART,
BENNETT COLLEGE FOR WOMEN

Politics controls everything we do. I'm trained as an educator, and I've been teaching almost thirty-five years at Bennett College for Women, the second oldest college for African American women in the United States. I'm an educator first, but what I've found is that you have to be able to influence people to get things done in the community.

I got into politics in Greensboro because I was a parent and I had issues with the school system, especially when it came to the education of African American children. Not all students can learn everything they need to in the classroom; you have to bring in the right people and resources. So in 1984 I ran for the school board and won every precinct in my district, becoming the first African American woman elected to that body. I was extremely vocal, and when you're African American and you speak out you're not labeled as a parent. You are a radical. You are everything but a concerned parent. When the majority speaks out, they're just concerned.

So there I was, a college professor on the school board, trying to make sure there was some accountability and being labeled as a rabble-rouser. I didn't feel bad about that, because the people I represented did want me.

Several years later I ran for city council and won overwhelmingly. I served for nine years on the city council. Then in 1994, after my fourth time elected to the city council, I decided that I wanted to serve at the state level. I believed it was time, and I decided to run against the incumbent representative. I knew it was going to be a tough battle, but I thought I could win it. When he died of a massive heart attack several months before the election, I was appointed to serve out the short session. I worked hard to get appointed. Out of the four people who had decided to run, I felt I was the most qualified because of my experience at the local level, and I had the greatest name recognition. I continued to campaign and won overwhelmingly in the

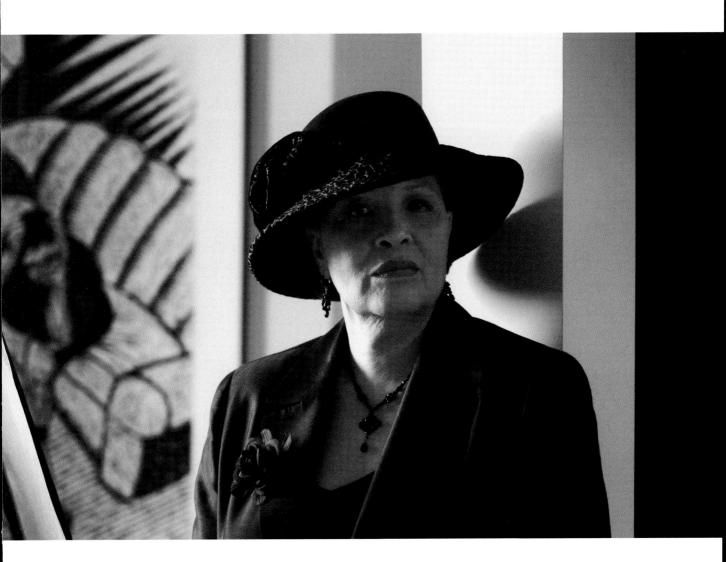

*I got into politics in Greensboro because I was a parent and
I had issues with the school system, especially when it came to
the education of African American children.*

general election in November. I've served six terms as a representative in the North Carolina House, not counting the appointed term.

I consider myself an activist for students and working families. When I was on the city council we dealt with libraries. My community had never had a library. We had lots of children but we never had a library, and one of my first acts as a city council member was to get a library opened there. I've always been the type to take on equity issues, and I thought it was atrocious not to have a library. Also, in high school the kids only had to pass three subjects if they played sports. When I tried to get that changed as a school board member, people thought I was anti-sports, and I wasn't. I believe that if you want a winning team you should have winning minds. As a legislator in the North Carolina House, I sponsored the Children's Breakfast Bill, which allowed any kindergarten child to have breakfast at school. If you haven't eaten, you're not ready to learn.

You've also got to be concerned about the adults who are supporting the children, and I am working very hard to change the state minimum wage of $5.15 an hour. That's the federal rate, and it's not a living wage. I'm trying to pass a bill to change that, but for ten years I could not even get it out of committee. We have been lobbying a long time, and last session was the first time I could even get it heard. It passed a vote in the house and is now in the senate.

I see so many inequities all around me. My background is in the arts, and there is a lot of inequity there. I started a black art gallery in 1991, and we focus on promoting African American art. We educate the community by exposing them to black artists. We bring in national artists and illustrators of children's books.

I got interested in art very young. In elementary school the teachers would let me stay in during recess because I loved to draw. I'd rather draw than play outside. I do silk-screen art and

collage. And I teach printmaking, art appreciation, and arts management classes. The arts have really been my base, and I've used that to help people in the community. As a representative, I've been a strong advocate for the arts.

I think as I look at it, education is affecting much of what I do. I grew up poor in a single-parent household in New Jersey. My mother did domestic work in white folks' houses, and even though she did not finish high school, she realized that education was important for her children. I was a first-generation college student. I always believed I was just as good as everyone else, even though I may not have had as much as everybody else.

African American funeral directors in North Carolina had never had a member sit on the funeral services board that sets policy for the industry. The biggest problem was that most of the people belonging to that association are Caucasian—three thousand members and only three hundred are African American. But in 103 years, the members of the association had never elected an African American to the board and none had ever been appointed. The African American members came to me, and I worked so hard to change this. We had a debate and we got a bill passed at about two-thirty in the morning in 2004. Two African Americans now have a seat on the board.

So I try to equalize the system a little bit. You don't have to do really big things to have a big impact. The house is basically male dominated and mostly Caucasian, and sometimes they try to diminish the involvement of women and African Americans. We have to fight to make sure that we're seen and that our issues are heard. Friends say Alma likes to fight. I guess I really do. Something inside makes me feel so uneasy when I see blatant unfairness. I don't pick the fights, but I will take on an injustice in a minute when I can see a resolution at the end.

A t this age you start asking, What can I leave behind, how can I give back? So many people reached out to support me in my times of need—actors, family, friends, and neighbors. Therefore I *have* to give back now. I don't have a choice.

When I started out, I wanted to be an opera singer, the next Leontyne Price. But when I began to work professionally, more opportunities became available to me in the theater. As a result, my love and interest in acting grew and I began to focus on that.

I was invited to join the Group Theater Workshop in New York City, started by Robert Hooks. He went on to found the Negro Ensemble Company, and I was one of the original actors in the company along with others such as Esther Rolle, Rosalind Cash, and Frances Foster. This was in the late 1960s, a period when it was all about art, creativity, and learning your craft. It was an incredible time to be black and in the theater.

I was young, but I got a chance to meet and work with some of most talented people of the times, such as Lou Gossett Jr., Al Freeman Jr., and Sidney Poitier. Ossie Davis and Ruby Dee used to come see us perform. Diana Sands was one of my mentors, and through her I met James Baldwin. Frances Foster, one of the older actors with the Negro Ensemble Company, became a teacher, friend, and sister. I developed a lot of my craft and a real appreciation of acting while working with all these talented people.

My first professional show was an off-Broadway play called *The Prodigal Son,* written by Langston Hughes. I actually met him, and through the years he was very encouraging. Being hired for this play allowed me to get my Actors' Equity card, which meant that I could act in any professional theater anywhere in the United States, including on Broadway. Some of the Broadway shows I did back then were *The Me Nobody Knows, Two Gentlemen of Verona,* and *The Tap Dance Kid.* I worked for the New York Shakespeare company as well, and acted in plays throughout the country and in Europe.

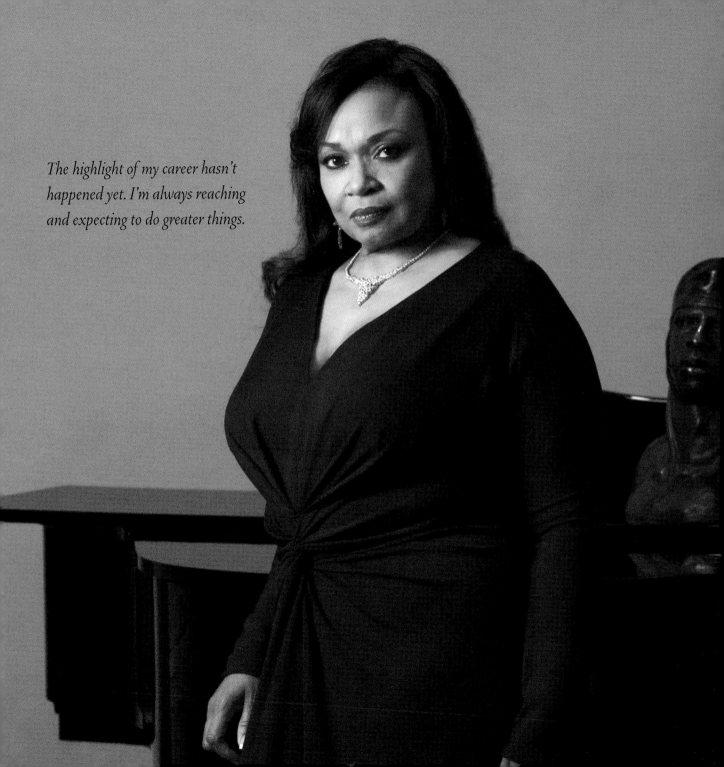

The highlight of my career hasn't happened yet. I'm always reaching and expecting to do greater things.

Civil rights were very much a part of the conversation of the time. I was with the Negro Ensemble Company at St. Mark's Playhouse in New York when Martin Luther King Jr. was assassinated. We were devastated. It was difficult for us to continue the performance that day, but we realized that the best way to honor Dr. King's memory would be to finish the play.

I grew up in segregated Mississippi, in Greenville, and my parents taught me that just because someone said something about me, that wasn't who I was. They taught me that *I* had to decide who I was, and they instilled in me a desire to go after what I wanted. There weren't many black opera singers around then, and my parents didn't quite understand why I wanted to be one. In spite of that, they told me that I could be whatever I wanted to be. I was dreaming big and they liked that. We lived in a great black neighborhood where everyone looked out for each other, and it was very nurturing. To this day there's an older lady in that community who calls me to see how I'm doing.

The most challenging time in my life was when I moved to New York City to live with family members at sixteen. Family services eventually removed me from the home because I was being abused, and I was sent to live with another family. Although that family supported me spiritually, they couldn't support me financially. I had to work while still in high school and take care of myself. That was a very trying period, but the whole experience made me stronger.

High school in New York was difficult for me since I had come from Mississippi and didn't know anyone. My music teacher was a magnificent lady and had a profound influence on me. She arranged an audition for me at Howard University, and as a result I received a full scholarship. Until the time she died, she continued to support me and came to see everything I did. She would tell other actors I introduced her to, "Oh, you were great. But Hattie was better." I would laugh and tell her to stop saying that to people, and she would say, "But it's true."

Acting technique is basically the same for all the mediums, but you have to learn to use your craft in various ways. I auditioned for everything—stage, film, voice-overs, and television. I went where the work was. Adolph Caesar helped me a lot by introducing me to voice-over acting. I didn't even know what it was, but he got me a voice-over agent, and I became one of the premier voice-over actors in New York. There were very few black females doing voice-overs at that time.

My first television series was *The Electric Company*, a PBS children's program that was produced by the same company that produced *Sesame Street*. One of the best experiences for me in television was working with Ted Danson on *Becker*. Every day was challenging and exciting because he's a gifted, generous actor and also a devoted husband and father, as well as a very spiritual and grounded person.

The highlight of my life was the birth of my daughter. She's smart and talented and she's in graduate school studying public relations. The love of my life is my husband, Harold Wheeler. We've been married for twenty-seven years, and he's my best friend. He's a renowned composer and conductor. Some of his shows include *The Wiz, Hairspray,* the Academy Awards, and *Dancing with the Stars.* He's always been supportive of my career. When I was cast in the television series *Homefront,* Harold said, "I can write music anywhere," and we packed up our belongings and moved from New York to California. My husband and daughter are the foundation of it all, the grounding of it all. If they weren't there, the rest wouldn't mean anything.

The highlight of my career hasn't happened yet. I'm always reaching and expecting to do greater things. At sixty, I discovered writing and a whole new career. I'm working on my memoirs and hope to help young girls who have to deal with abuse. So many of them don't know where to turn or what to do when that happens. I want to give back and to let them know that they can succeed in spite of what may have happened to them.

I'm acting in a play that I wrote and directed called *The Slave Narratives: A Mighty, Mighty People.* I'm very proud of it. I plan to have it produced in Los Angeles and then tour the country, because I think it can be an instrument for healing. We need to heal ourselves as a nation and as a people. Instead of thinking of ourselves only as descendants of slaves, we should think of ourselves as descendants of a mighty, mighty people who are entitled to everything this country has to offer. When doing the research for the play, I felt the spirit of the slaves whose narratives I used. We must honor them. We must never forget them. We *can't* forget them.

I am learning so much about myself and about life through my writing, and it's thrilling. So get out of my way, world. Here I come.

Photographer's Note

What you see on the preceding pages is the culmination of work by a dedicated team deter-mined to honor powerful black women over the age of fifty. These women have defied the odds and are making a difference in their communities and churches and workplaces around the world.

I asked the women to wear some sort of black formal attire for their portrait sessions for two reasons: First, I knew that the images would be striking and commanding, with a consis-tent theme throughout the book, and that black clothing would translate well using my favorite medium, black-and-white photography. Second, I wanted these women to feel very special on the day of the photo shoot, as though they were preparing to attend a gala or ball in their honor, and I brought in a makeup artist/stylist to help with the pampering. It worked! They looked beautiful, they felt beautiful. How else should a phenomenal woman feel?

I am honored to have held my camera in front of some of the most astonishing women on the planet, many of whom I already knew and others who were introduced to me for the first time.

I used a portion of the allotted time for each session—anywhere from one to three hours—to talk with and to listen to these women so that I would convey in my portraits something about who they are. I will never forget any of them; they are a part of me now. I recall the sage advice given to me by Veretta Garrison, the humor of Pamila Brown, the frank-ness of Sharon Farmer, and the history lessons learned from Eleanor Holmes Norton and Dr. Johnnetta Cole.

To all of these powerful women who opened their homes, offices, personal spaces, and hearts to me and my artistic team, thank you, again, for being a Jewel!

Special thanks to Tatiana Sweeney, a jewel no doubt, who provided makeup services to most of the women who appear in this book. Her warm spirit and gentle words helped the women get through the photo sessions. Tatiana contributed valuable time and creative energy throughout this project, offering her photography and editing skills and her expertise as a stylist, assisting the women to make sure that everything looked just right before and during the shoots, and even being called upon to fix hair at the last minute. I am tremendously blessed to call Tatiana my friend.

Thank you to Connie Briscoe for this collaboration. I am humbled to have worked with Connie. Thanks also to my agents, Victoria Sanders and Associates. Working with Victoria is a dream come true. Also thanks to Kevin Bracey; makeup artists Colleen Kelly, Olga Morales, Noelle Bonham, Kirsten Mnelzey, and Karen Robinson; Makeup by Misha; and stylist Maura McGinn. Thomas Cunningham and Kenny Brown were my photo assistants for this book.

Index of Jewels

Alma Adams, 202

Billie Allen, 71

Loretta Argrett, 58

Byllye Avery, 64

Patricia Banks, 94

Connie Briscoe, 194

Marie Dutton Brown, 136

Pamila Brown, 34

A'Lelia Bundles, 30

Dianne Caesar, 140

Linda Chastang, 144

Faith Childs, 186

Johnnetta Betsch Cole, 2

Verna Cook, 50

Ruby Davis-Jett, 14

Ruby Dee, 98

Pat Briscoe DeJarnett, 148

Starletta Dupois, 6

Marian Wright Edelman, 166

Mütter Evans, 54

Sharon Farmer, 26

Toni Fay, 102

Veretta Garrison, 128

Marilyn Gaston, MD, 124

Nikki Giovanni, 42

Marita Golden, 18

Joanne Renee Harrell, 72

Nona Hendryx, 80

Carolyn McNair, 116

S. Epatha Merkerson, 132

Sandy Mann Michael, 22

Deborah Nedab, 112

Wanda Newman, 198

Eleanor Holmes Norton, 10

Louise Rice, 108

Victoria Roberts, 88

Seret Scott, 68

Diane Singleton, 38

Karen Singleton, 39

Brenda Stubbs, 162

Ann Tanksley, 120

Romaine Thomas, 182

Gladys Gary Vaughn, 158

Clara Villarosa, 60

Gayle Washington, 190

Linda White, 76

Faye Williams, 176

Gale LeGrand Williams, 46

Hattie Winston, 206

Cheryl Woodruff, 84

About the Authors

Michael Cunningham was born in Landover, Maryland, and fell in love with photography at the age of twelve. In his more than sixteen years as a commercial photographer, his clients have included some of the world's largest corporations: Coca-Cola, RJR Tobacco, Sara Lee, and Wachovia Bank among them. Cunningham's work has also been featured in national publications, including the *New York Times* and *Ebony.*

Cunningham was the photographer for *Crowns: Portraits of Black Women in Church Hats,* which is now in its seventh printing, and *Queens: Portraits of Black Women and Their Fabulous Hair.* A calendar based on *Crowns* was produced by Workman Publishing, and a theatrical production based on the book has played to sold-out audiences across the United States and Canada.

Cunningham is the executive director of Urban Shutterbugs, a nonprofit organization that teaches photography to inner-city youth. He is a member of the Exposure Group and the American Society of Magazine Photographers. He has one daughter, Kamari, and resides in Washington, DC.

Connie Briscoe has written five novels to date, and they have appeared on the bestseller lists of the *Washington Post, Boston Globe,* and *USA Today,* as well as *Essence* magazine and many other publications. Her second novel, *Big Girls Don't Cry,* appeared on the *New York Times* bestseller list. *A Long Way from Home,* a fictional account of her matrilineal heritage, was nominated for an NAACP Image Award.

Prior to becoming a published author, Ms. Briscoe worked as an associate editor at the Joint Center for Political and Economic Studies and as managing editor of *American Annals of the Deaf.* She has been hearing-impaired much of her adult life and recently received a cochlear implant, which restored most of her hearing. She is a member of the board of trustees of the Maryland School for the Deaf. She lives in Ellicott City, Maryland, with her husband and two children.